Art and Culture

Art and Culture

CRITICAL ESSAYS

Clement Greenberg

BEACON PRESS BOSTON

For Margaret Marshall

Preface

The pieces collected in this book appeared originally in *Partisan Review, The Nation, Commentary, Arts* (formerly *Art Digest*), *Art News* and *The New Leader*. Few reappear unaltered. Where revision has not changed the substance of what is said, I have felt free to append the date of first publication alone. Where revision has affected substance, I have in some cases given both the date of first publication and that of revision; and in other, more radical cases, only the latter.

This book is not intended as a completely faithful record of my activity as a critic. Not only has much been altered, but much more has been left out than put in. I would not deny being one of those critics who educate themselves in public, but I see no reason why all the haste and waste involved in my self-education should be preserved in a book.

<div align="right">

CLEMENT GREENBERG

</div>

Contents

ix

Art in the United States

Literature

Culture in General

Avant-Garde and Kitsch

One and the same civilization produces simultaneously two such different things as a poem by T. S. Eliot and a Tin Pan Alley song, or a painting by Braque and a *Saturday Evening Post* cover. All four are on the order of culture, and ostensibly, parts of the same culture and products of the same society. Here, however, their connection seems to end. A poem by Eliot and a poem by Eddie Guest—what perspective of culture is large enough to enable us to situate them in an enlightening relation to each other? Does the fact that a disparity such as this within the frame of a single cultural tradition, which is and has been taken for granted—does this fact indicate that the disparity is a part of the natural order of things? Or is it something entirely new, and particular to our age?

The answer involves more than an investigation in aesthetics. It appears to me that it is necessary to examine more closely and with more originality than hitherto the relationship between aesthetic experience as met by the specific—not the generalized—individual, and the social and historical contexts in which that experience takes place. What is brought to light will answer, in addition to the question posed above, other and perhaps more important questions.

I

A society, as it becomes less and less able, in the course of its development, to justify the inevitability of its particular forms, breaks up the accepted notions upon which artists and

3

writers must depend in large part for communication with their audiences. It becomes difficult to assume anything. All the verities involved by religion, authority, tradition, style, are thrown into question, and the writer or artist is no longer able to estimate the response of his audience to the symbols and references with which he works. In the past such a state of affairs has usually resolved itself into a motionless Alexandrianism, an academicism in which the really important issues are left untouched because they involve controversy, and in which creative activity dwindles to virtuosity in the small details of form, all larger questions being decided by the precedent of the old masters. The same themes are mechanically varied in a hundred different works, and yet nothing new is produced: Statius, mandarin verse, Roman sculpture, Beaux-Arts painting, neo-republican architecture.

It is among the hopeful signs in the midst of the decay of our present society that we—some of us—have been unwilling to accept this last phase for our own culture. In seeking to go beyond Alexandrianism, a part of Western bourgeois society has produced something unheard of heretofore:—avant-garde culture. A superior consciousness of history—more precisely, the appearance of a new kind of criticism of society, an historical criticism—made this possible. This criticism has not confronted our present society with timeless utopias, but has soberly examined in the terms of history and of cause and effect the antecedents, justifications and functions of the forms that lie at the heart of every society. Thus our present bourgeois social order was shown to be, not an eternal, "natural" condition of life, but simply the latest term in a succession of social orders. New perspectives of this kind, becoming a part of the advanced intellectual conscience of the fifth and sixth decades of the nineteenth century, soon were absorbed by artists and poets, even if unconsciously for the most part. It was no accident, therefore, that the birth of the avant-garde coincided chronologically—and geographically, too—with the first bold development of scientific revolutionary thought in Europe.

4

True, the first settlers of bohemia—which was then identical with the avant-garde—turned out soon to be demonstratively uninterested in politics. Nevertheless, without the circulation of revolutionary ideas in the air about them, they would never have been able to isolate their concept of the "bourgeois" in order to define what they were *not*. Nor, without the moral aid of revolutionary political attitudes would they have had the courage to assert themselves as aggressively as they did against the prevailing standards of society. Courage indeed was needed for this, because the avant-garde's emigration from bourgeois society to bohemia meant also an emigration from the markets of capitalism, upon which artists and writers had been thrown by the falling away of aristocratic patronage. (Ostensibly, at least, it meant this—meant starving in a garret —although, as will be shown later, the avant-garde remained attached to bourgeois society precisely because it needed its money.)

Yet it is true that once the avant-garde had succeeded in "detaching" itself from society, it proceeded to turn around and repudiate revolutionary as well as bourgeois politics. The revolution was left inside society, a part of that welter of ideological struggle which art and poetry find so unpropitious as soon as it begins to involve those "precious" axiomatic beliefs upon which culture thus far has had to rest. Hence it developed that the true and most important function of the avant-garde was not to "experiment," but to find a path along which it would be possible to keep culture *moving* in the midst of ideological confusion and violence. Retiring from public altogether, the avant-garde poet or artist sought to maintain the high level of his art by both narrowing and raising it to the expression of an absolute in which all relativities and contradictions would be either resolved or beside the point. "Art for art's sake" and "pure poetry" appear, and subject matter or content becomes something to be avoided like a plague.

It has been in search of the absolute that the avant-garde has arrived at "abstract" or "nonobjective" art—and poetry,

too. The avant-garde poet or artist tries in effect to imitate God by creating something valid solely on its own terms, in the way nature itself is valid, in the way a landscape—not its picture —is aesthetically valid; something *given*, increate, independent of meanings, similars or originals. Content is to be dissolved so completely into form that the work of art or literature cannot be reduced in whole or in part to anything not itself.

But the absolute is absolute, and the poet or artist, being what he is, cherishes certain relative values more than others. The very values in the name of which he invokes the absolute are relative values, the values of aesthetics. And so he turns out to be imitating, not God—and here I use "imitate" in its Aristotelian sense—but the disciplines and processes of art and literature themselves. This is the genesis of the "abstract."[1] In turning his attention away from subject matter of common experience, the poet or artist turns it in upon the medium of his own craft. The nonrepresentational or "abstract," if it is to have aesthetic validity, cannot be arbitrary and accidental, but must stem from obedience to some worthy constraint or original. This constraint, once the world of common, extraverted experience has been renounced, can only be found in the very processes or disciplines by which art and literature have already imitated the former. These themselves become the subject matter of art and literature. If, to continue with

[1] The example of music, which has long been an abstract art, and which avant-garde poetry has tried so much to emulate, is interesting. Music, Aristotle said curiously enough, is the most imitative and vivid of all arts because it imitates its original—the state of the soul—with the greatest immediacy. Today this strikes us as the exact opposite of the truth, because no art seems to us to have less reference to something outside itself than music. However, aside from the fact that in a sense Aristotle may still be right, it must be explained that ancient Greek music was closely associated with poetry, and depended upon its character as an accessory to verse to make its imitative meaning clear. Plato, speaking of music, says: "For when there are no words, it is very difficult to recognize the meaning of the harmony and rhythm, or to see that any worthy object is imitated by them." As far as we know, all music originally served such an accessory function. Once, however, it was abandoned, music was forced to withdraw into itself to find a constraint or original. This is found in the various means of its own composition and performance.

6

Aristotle, all art and literature are imitation, then what we have here is the imitation of imitating. To quote Yeats:

> Nor is there singing school but studying
> Monuments of its own magnificence.

Picasso, Braque, Mondrian, Miró, Kandinsky, Brancusi, even Klee, Matisse and Cézanne derive their chief inspiration from the medium they work in.[2] The excitement of their art seems to lie most of all in its pure preoccupation with the invention and arrangement of spaces, surfaces, shapes, colors, etc., to the exclusion of whatever is not necessarily implicated in these factors. The attention of poets like Rimbaud, Mallarmé, Valéry, Éluard, Pound, Hart Crane, Stevens, even Rilke and Yeats, appears to be centered on the effort to create poetry and on the "moments" themselves of poetic conversion, rather than on experience to be converted into poetry. Of course, this cannot exclude other preoccupations in their work, for poetry must deal with words, and words must communicate. Certain poets, such as Mallarmé and Valéry,[3] are more radical in this respect than others—leaving aside those poets who have tried to compose poetry in pure sound alone. However, if it were easier to define poetry, modern poetry would be much more "pure" and "abstract." As for the other fields of literature— the definition of avant-garde aesthetics advanced here is no Procrustean bed. But aside from the fact that most of our best contemporary novelists have gone to school with the avant-garde, it is significant that Gide's most ambitious book is a novel about the writing of a novel, and that Joyce's *Ulysses* and *Finnegans Wake* seem to be, above all, as one French critic says, the reduction of experience to expression for the sake

[2] I owe this formulation to a remark made by Hans Hofmann, the art teacher, in one of his lectures. From the point of view of this formulation, Surrealism in plastic art is a reactionary tendency which is attempting to restore "outside" subject matter. The chief concern of a painter like Dali is to represent the processes and concepts of his consciousness, not the processes of his medium.

[3] See Valéry's remarks about his own poetry.

7

of expression, the expression mattering more than what is being expressed.

That avant-garde culture is the imitation of imitating—the fact itself—calls for neither approval nor disapproval. It is true that this culture contains within itself some of the very Alexandrianism it seeks to overcome. The lines quoted from Yeats referred to Byzantium, which is very close to Alexandria; and in a sense this imitation of imitating is a superior sort of Alexandrianism. But there is one most important difference: the avant-garde moves, while Alexandrianism stands still. And this, precisely, is what justifies the avant-garde's methods and makes them necessary. The necessity lies in the fact that by no other means is it possible today to create art and literature of a high order. To quarrel with necessity by throwing about terms like "formalism," "purism," "ivory tower" and so forth is either dull or dishonest. This is not to say, however, that it is to the *social* advantage of the avant-garde that it is what it is. Quite the opposite.

The avant-garde's specialization of itself, the fact that its best artists are artists' artists, its best poets, poets' poets, has estranged a great many of those who were capable formerly of enjoying and appreciating ambitious art and literature, but who are now unwilling or unable to acquire an initiation into their craft secrets. The masses have always remained more or less indifferent to culture in the process of development. But today such culture is being abandoned by those to whom it actually belongs—our ruling class. For it is to the latter that the avant-garde belongs. No culture can develop without a social basis, without a source of stable income. And in the case of the avant-garde, this was provided by an elite among the ruling class of that society from which it assumed itself to be cut off, but to which it has always remained attached by an umbilical cord of gold. The paradox is real. And now this elite is rapidly shrinking. Since the avant-garde forms the only living culture we now have, the survival in the near future of culture in general is thus threatened.

We must not be deceived by superficial phenomena and local successes. Picasso's shows still draw crowds, and T. S. Eliot is taught in the universities; the dealers in modernist art are still in business, and the publishers still publish some "difficult" poetry. But the avant-garde itself, already sensing the danger, is becoming more and more timid every day that passes. Academicism and commercialism are appearing in the strangest places. This can mean only one thing: that the avant-garde is becoming unsure of the audience it depends on—the rich and the cultivated.

Is it the nature itself of avant-garde culture that is alone responsible for the danger it finds itself in? Or is that only a dangerous liability? Are there other, and perhaps more important, factors involved?

II

Where there is an avant-garde, generally we also find a rear-guard. True enough—simultaneously with the entrance of the avant-garde, a second new cultural phenomenon appeared in the industrial West: that thing to which the Germans give the wonderful name of *Kitsch:* popular, commercial art and literature with their chromeotypes, magazine covers, illustrations, ads, slick and pulp fiction, comics, Tin Pan Alley music, tap dancing, Hollywood movies, etc., etc. For some reason this gigantic apparition has always been taken for granted. It is time we looked into its whys and wherefores.

Kitsch is a product of the industrial revolution which urbanized the masses of Western Europe and America and established what is called universal literacy.

Prior to this the only market for formal culture, as distinguished from folk culture, had been among those who, in addition to being able to read and write, could command the leisure and comfort that always goes hand in hand with cultivation of some sort. This until then had been inextricably asso-

ciated with literacy. But with the introduction of universal literacy, the ability to read and write became almost a minor skill like driving a car, and it no longer served to distinguish an individual's cultural inclinations, since it was no longer the exclusive concomitant of refined tastes.

The peasants who settled in the cities as proletariat and petty bourgeois learned to read and write for the sake of efficiency, but they did not win the leisure and comfort necessary for the enjoyment of the city's traditional culture. Losing, nevertheless, their taste for the folk culture whose background was the countryside, and discovering a new capacity for boredom at the same time, the new urban masses set up a pressure on society to provide them with a kind of culture fit for their own consumption. To fill the demand of the new market, a new commodity was devised: ersatz culture, kitsch, destined for those who, insensible to the values of genuine culture, are hungry nevertheless for the diversion that only culture of some sort can provide.

Kitsch, using for raw material the debased and academicized simulacra of genuine culture, welcomes and cultivates this insensibility. It is the source of its profits. Kitsch is mechanical and operates by formulas. Kitsch is vicarious experience and faked sensations. Kitsch changes according to style, but remains always the same. Kitsch is the epitome of all that is spurious in the life of our times. Kitsch pretends to demand nothing of its customers except their money—not even their time.

The precondition for kitsch, a condition without which kitsch would be impossible, is the availability close at hand of a fully matured cultural tradition, whose discoveries, acquisitions, and perfected self-consciousness kitsch can take advantage of for its own ends. It borrows from it devices, tricks, stratagems, rules of thumb, themes, converts them into a system, and discards the rest. It draws its life blood, so to speak, from this reservoir of accumulated experience. This is what is really meant when it is said that the popular art and literature of

today were once the daring, esoteric art and literature of yesterday. Of course, no such thing is true. What is meant is that when enough time has elapsed the new is looted for new "twists," which are then watered down and served up as kitsch. Self-evidently, all kitsch is academic; and conversely, all that's academic is kitsch. For what is called the academic as such no longer has an independent existence, but has become the stuffed-shirt "front" for kitsch. The methods of industrialism displace the handicrafts.

Because it can be turned out mechanically, kitsch has become an integral part of our productive system in a way in which true culture could never be, except accidentally. It has been capitalized at a tremendous investment which must show commensurate returns; it is compelled to extend as well as to keep its markets. While it is essentially its own salesman, a great sales apparatus has nevertheless been created for it, which brings pressure to bear on every member of society. Traps are laid even in those areas, so to speak, that are the preserves of genuine culture. It is not enough today, in a country like ours, to have an inclination towards the latter; one must have a true passion for it that will give him the power to resist the faked article that surrounds and presses in on him from the moment he is old enough to look at the funny papers. Kitsch is deceptive. It has many different levels, and some of them are high enough to be dangerous to the naive seeker of true light. A magazine like *The New Yorker*, which is fundamentally high-class kitsch for the luxury trade, converts and waters down a great deal of avant-garde material for its own uses. Nor is every single item of kitsch altogether worthless. Now and then it produces something of merit, something that has an authentic folk flavor; and these accidental and isolated instances have fooled people who should know better.

Kitsch's enormous profits are a source of temptation to the avant-garde itself, and its members have not always resisted this temptation. Ambitious writers and artists will modify their work under the pressure of kitsch, if they do not succumb to

it entirely. And then those puzzling borderline cases appear, such as the popular novelist, Simenon, in France, and Steinbeck in this country. The net result is always to the detriment of true culture, in any case.

Kitsch has not been confined to the cities in which it was born, but has flowed out over the countryside, wiping out folk culture. Nor has it shown any regard for geographical and national-cultural boundaries. Another mass product of Western industrialism, it has gone on a triumphal tour of the world, crowding out and defacing native cultures in one colonial country after another, so that it is now by way of becoming a universal culture, the first universal culture ever beheld. Today the native of China, no less than the South American Indian, the Hindu, no less than the Polynesian, have come to prefer to the products of their native art, magazine covers, rotogravure sections and calendar girls. How is this virulence of kitsch, this irresistible attractiveness, to be explained? Naturally, machine-made kitsch can undersell the native handmade article, and the prestige of the West also helps; but why is kitsch a so much more profitable export article than Rembrandt? One, after all, can be reproduced as cheaply as the other.

In his last article on the Soviet cinema in the *Partisan Review*, Dwight Macdonald points out that kitsch has in the last ten years become the dominant culture in Soviet Russia. For this he blames the political regime—not only for the fact that kitsch is the official culture, but also that it is actually the dominant, most popular culture, and he quotes the following from Kurt London's *The Seven Soviet Arts*: ". . . the attitude of the masses both to the old and new art styles probably remains essentially dependent on the nature of the education afforded them by their respective states." Macdonald goes on to say: "Why after all should ignorant peasants prefer Repin (a leading exponent of Russian academic kitsch in painting) to Picasso, whose abstract technique is at least as relevant to their own primitive folk art as is the former's

realistic style? No, if the masses crowd into the Tretyakov (Moscow's museum of contemporary Russian art: kitsch), it is largely because they have been conditioned to shun 'formalism' and to admire 'socialist realism.' "

In the first place it is not a question of a choice between merely the old and merely the new, as London seems to think —but of a choice between the bad, up-to-date old and the genuinely new. The alternative to Picasso is not Michelangelo, but kitsch. In the second place, neither in backward Russia nor in the advanced West do the masses prefer kitsch simply because their governments condition them toward it. Where state educational systems take the trouble to mention art, we are told to respect the old masters, not kitsch; and yet we go and hang Maxfield Parrish or his equivalent on our walls, instead of Rembrandt and Michelangelo. Moreover, as Macdonald himself points out, around 1925 when the Soviet regime was encouraging avant-garde cinema, the Russian masses continued to prefer Hollywood movies. No, "conditioning" does not explain the potency of kitsch.

All values are human values, relative values, in art as well as elsewhere. Yet there does seem to have been more or less of a general agreement among the cultivated of mankind over the ages as to what is good art and what bad. Taste has varied, but not beyond certain limits; contemporary connoisseurs agree with the eighteenth-century Japanese that Hokusai was one of the greatest artists of his time; we even agree with the ancient Egyptians that Third and Fourth Dynasty art was the most worthy of being selected as their paragon by those who came after. We may have come to prefer Giotto to Raphael, but we still do not deny that Raphael was one of the best painters of his time. There has been an agreement then, and this agreement rests, I believe, on a fairly constant distinction made between those values only to be found in art and the values which can be found elsewhere. Kitsch, by virtue of a rationalized technique that draws on science and industry, has erased this distinction in practice.

Let us see, for example, what happens when an ignorant Russian peasant such as Macdonald mentions stands with hypothetical freedom of choice before two paintings, one by Picasso, the other by Repin. In the first he sees, let us say, a play of lines, colors and spaces that represent a woman. The abstract technique—to accept Macdonald's supposition, which I am inclined to doubt—reminds him somewhat of the icons he has left behind him in the village, and he feels the attraction of the familiar. We will even suppose that he faintly surmises some of the great art values the cultivated find in Picasso. He turns next to Repin's picture and sees a battle scene. The technique is not so familiar—as technique. But that weighs very little with the peasant, for he suddenly discovers values in Repin's picture that seem far superior to the values he has been accustomed to find in icon art; and the unfamiliar itself is one of the sources of those values: the values of the vividly recognizable, the miraculous and the sympathetic. In Repin's picture the peasant recognizes and sees things in the way in which he recognizes and sees things outside of pictures—there is no discontinuity between art and life, no need to accept a convention and say to oneself, that icon represents Jesus because it intends to represent Jesus, even if it does not remind me very much of a man. That Repin can paint so realistically that identifications are self-evident immediately and without any effort on the part of the spectator—that is miraculous. The peasant is also pleased by the wealth of self-evident meanings which he finds in the picture: "it tells a story." Picasso and the icons are so austere and barren in comparison. What is more, Repin heightens reality and makes it dramatic: sunset, exploding shells, running and falling men. There is no longer any question of Picasso or icons. Repin is what the peasant wants, and nothing else but Repin. It is lucky, however, for Repin that the peasant is protected from the products of American capitalism, for he would not stand a chance next to a *Saturday Evening Post* cover by Norman Rockwell.

Ultimately, it can be said that the cultivated spectator de-

rives the same values from Picasso that the peasant gets from Repin, since what the latter enjoys in Repin is somehow art too, on however low a scale, and he is sent to look at pictures by the same instincts that send the cultivated spectator. But the ultimate values which the cultivated spectator derives from Picasso are derived at a second remove, as the result of reflection upon the immediate impression left by the plastic values. It is only then that the recognizable, the miraculous and the sympathetic enter. They are not immediately or externally present in Picasso's painting, but must be projected into it by the spectator sensitive enough to react sufficiently to plastic qualities. They belong to the "reflected" effect. In Repin, on the other hand, the "reflected" effect has already been included in the picture, ready for the spectator's unreflective enjoyment.[4] Where Picasso paints *cause,* Repin paints *effect.* Repin predigests art for the spectator and spares him effort, provides him with a short cut to the pleasure of art that detours what is necessarily difficult in genuine art. Repin, or kitsch, is synthetic art.

The same point can be made with respect to kitsch literature: it provides vicarious experience for the insensitive with far greater immediacy than serious fiction can hope to do. And Eddie Guest and the *Indian Love Lyrics* are more poetic than T. S. Eliot and Shakespeare.

III

If the avant-garde imitates the processes of art, kitsch, we now see, imitates its effects. The neatness of this antithesis is more than contrived; it corresponds to and defines the tremendous interval that separates from each other two such simultaneous cultural phenomena as the avant-garde and kitsch.

[4] T. S. Eliot said something to the same effect in accounting for the shortcomings of English Romantic poetry. Indeed the Romantics can be considered the original sinners whose guilt kitsch inherited. They showed kitsch how. What does Keats write about mainly, if not the effect of poetry upon himself?

This interval, too great to be closed by all the infinite gradations of popularized "modernism" and "modernistic" kitsch, corresponds in turn to a social interval, a social interval that has always existed in formal culture, as elsewhere in civilized society, and whose two termini converge and diverge in fixed relation to the increasing or decreasing stability of the given society. There has always been on one side the minority of the powerful—and therefore the cultivated—and on the other the great mass of the exploited and poor—and therefore the ignorant. Formal culture has always belonged to the first, while the last have had to content themselves with folk or rudimentary culture, or kitsch.

In a stable society that functions well enough to hold in solution the contradictions between its classes, the cultural dichotomy becomes somewhat blurred. The axioms of the few are shared by the many; the latter believe superstitiously what the former believe soberly. And at such moments in history the masses are able to feel wonder and admiration for the culture, on no matter how high a plane, of its masters. This applies at least to plastic culture, which is accessible to all.

In the Middle Ages the plastic artist paid lip service at least to the lowest common denominators of experience. This even remained true to some extent until the seventeenth century. There was available for imitation a universally valid conceptual reality, whose order the artist could not tamper with. The subject matter of art was prescribed by those who commissioned works of art, which were not created, as in bourgeois society, on speculation. Precisely because his content was determined in advance, the artist was free to concentrate on his medium. He needed not to be philosopher, or visionary, but simply artificer. As long as there was general agreement as to what were the worthiest subjects for art, the artist was relieved of the necessity to be original and inventive in his "matter" and could devote all his energy to formal problems. For him the medium became, privately, professionally, the content of his art, even as his medium is today the public

content of the abstract painter's art—with that difference, however, that the medieval artist had to suppress his professional preoccupation in public—had always to suppress and subordinate the personal and professional in the finished, official work of art. If, as an ordinary member of the Christian community, he felt some personal emotion about his subject matter, this only contributed to the enrichment of the work's public meaning. Only with the Renaissance do the inflections of the personal become legitimate, still to be kept, however, within the limits of the simply and universally recognizable. And only with Rembrandt do "lonely" artists begin to appear, lonely in their art.

But even during the Renaissance, and as long as Western art was endeavoring to perfect its technique, victories in this realm could only be signalized by success in realistic imitation, since there was no other objective criterion at hand. Thus the masses could still find in the art of their masters objects of admiration and wonder. Even the bird that pecked at the fruit in Zeuxis' picture could applaud.

It is a platitude that art becomes caviar to the general when the reality it imitates no longer corresponds even roughly to the reality recognized by the general. Even then, however, the resentment the common man may feel is silenced by the awe in which he stands of the patrons of this art. Only when he becomes dissatisfied with the social order they administer does he begin to criticize their culture. Then the plebeian finds courage for the first time to voice his opinions openly. Every man, from the Tammany alderman to the Austrian housepainter, finds that he is entitled to his opinion. Most often this resentment toward culture is to be found where the dissatisfaction with society is a reactionary dissatisfaction which expresses itself in revivalism and puritanism, and latest of all, in fascism. Here revolvers and torches begin to be mentioned in the same breath as culture. In the name of godliness or the blood's health, in the name of simple ways and solid virtues, the statue-smashing commences.

17

IV

Returning to our Russian peasant for the moment, let us suppose that after he has chosen Repin in preference to Picasso, the state's educational apparatus comes along and tells him that he is wrong, that he should have chosen Picasso—and shows him why. It is quite possible for the Soviet state to do this. But things being as they are in Russia—and everywhere else—the peasant soon finds that the necessity of working hard all day for his living and the rude, uncomfortable circumstances in which he lives do not allow him enough leisure, energy and comfort to train for the enjoyment of Picasso. This needs, after all, a considerable amount of "conditioning." Superior culture is one of the most artificial of all human creations, and the peasant finds no "natural" urgency within himself that will drive him toward Picasso in spite of all difficulties. In the end the peasant will go back to kitsch when he feels like looking at pictures, for he can enjoy kitsch without effort. The state is helpless in this matter and remains so as long as the problems of production have not been solved in a socialist sense. The same holds true, of course, for capitalist countries and makes all talk of art for the masses there nothing but demagogy.[5]

[5] It will be objected that such art for the masses as folk art was developed under rudimentary conditions of production—and that a good deal of folk art is on a high level. Yes, it is—but folk art is not Athene, and it's Athene whom we want: formal culture with its infinity of aspects, its luxuriance, its large comprehension. Besides, we are now told that most of what we consider good in folk culture is the static survival of dead formal, aristocratic, cultures. Our old English ballads, for instance, were not created by the "folk," but by the post-feudal squirearchy of the English countryside, to survive in the mouths of the folk long after those for whom the ballads were composed had gone on to other forms of literature. Unfortunately, until the machine-age, culture was the exclusive prerogative of a society that lived by the labor of serfs or slaves. They were the real symbols of culture. For one man to spend time and energy creating or listening to poetry meant that another man had to produce enough to keep himself alive and the former in comfort. In Africa today we find that the culture of slave-owning tribes is generally much superior to that of the tribes that possess no slaves.

Where today a political regime establishes an official cultural policy, it is for the sake of demagogy. If kitsch is the official tendency of culture in Germany, Italy and Russia, it is not because their respective governments are controlled by philistines, but because kitsch is the culture of the masses in these countries, as it is everywhere else. The encouragement of kitsch is merely another of the inexpensive ways in which totalitarian regimes seek to ingratiate themselves with their subjects. Since these regimes cannot raise the cultural level of the masses—even if they wanted to—by anything short of a surrender to international socialism, they will flatter the masses by bringing all culture down to their level. It is for this reason that the avantgarde is outlawed, and not so much because a superior culture is inherently a more critical culture. (Whether or not the avantgarde could possibly flourish under a totalitarian regime is not pertinent to the question at this point.) As a matter of fact, the main trouble with avant-garde art and literature, from the point of view of fascists and Stalinists, is not that they are too critical, but that they are too "innocent," that it is too difficult to inject effective propaganda into them, that kitsch is more pliable to this end. Kitsch keeps a dictator in closer contact with the "soul" of the people. Should the official culture be one superior to the general mass-level, there would be a danger of isolation.

Nevertheless, if the masses were conceivably to ask for avant-garde art and literature, Hitler, Mussolini and Stalin would not hesitate long in attempting to satisfy such a demand. Hitler is a bitter enemy of the avant-garde, both on doctrinal and personal grounds, yet this did not prevent Goebbels in 1932-1933 from strenuously courting avant-garde artists and writers. When Gottfried Benn, an Expressionist poet, came over to the Nazis he was welcomed with a great fanfare, although at that very moment Hitler was denouncing Expressionism as *Kulturbolschewismus*. This was at a time when the Nazis felt that the prestige which the avant-garde enjoyed among the cultivated German public could be of advantage to

them, and practical considerations of this nature, the Nazis being skillful politicians, have always taken precedence over Hitler's personal inclinations. Later the Nazis realized that it was more practical to accede to the wishes of the masses in matters of culture than to those of their paymasters; the latter, when it came to a question of preserving power, were as willing to sacrifice their culture as they were their moral principles; while the former, precisely because power was being withheld from them, had to be cozened in every other way possible. It was necessary to promote on a much more grandiose style than in the democracies the illusion that the masses actually rule. The literature and art they enjoy and understand were to be proclaimed the only true art and literature and any other kind was to be suppressed. Under these circumstances people like Gottfried Benn, no matter how ardently they support Hitler, become a liability; and we hear no more of them in Nazi Germany.

We can see then that although from one point of view the personal philistinism of Hitler and Stalin is not accidental to the political roles they play, from another point of view it is only an incidentally contributory factor in determining the cultural policies of their respective regimes. Their personal philistinism simply adds brutality and double-darkness to policies they would be forced to support anyhow by the pressure of all their other policies—even were they, personally, devotees of avant-garde culture. What the acceptance of the isolation of the Russian Revolution forces Stalin to do, Hitler is compelled to do by his acceptance of the contradictions of capitalism and his efforts to freeze them. As for Mussolini—his case is a perfect example of the *disponibilité* of a realist in these matters. For years he bent a benevolent eye on the Futurists and built modernistic railroad stations and government-owned apartment houses. One can still see in the suburbs of Rome more modernistic apartments than almost anywhere else in the world. Perhaps Fascism wanted to show its up-to-dateness, to conceal the fact that it was a retrogression; perhaps it

wanted to conform to the tastes of the wealthy elite it served. At any rate Mussolini seems to have realized lately that it would be more useful to him to please the cultural tastes of the Italian masses than those of their masters. The masses must be provided with objects of admiration and wonder; the latter can dispense with them. And so we find Mussolini announcing a "new Imperial style." Marinetti, Chirico, *et al.,* are sent into the outer darkness, and the new railroad station in Rome will not be modernistic. That Mussolini was late in coming to this only illustrates again the relative hesitancy with which Italian Fascism has drawn the necessary implications of its role.

Capitalism in decline finds that whatever of quality it is still capable of producing becomes almost invariably a threat to its own existence. Advances in culture, no less than advances in science and industry, corrode the very society under whose aegis they are made possible. Here, as in every other question today, it becomes necessary to quote Marx word for word. Today we no longer look toward socialism for a new • culture—as inevitably as one will appear, once we do have socialism. Today we look to socialism *simply* for the preservation of whatever living culture we have right now.

1939

The Plight of Culture

T. S. Eliot has done a good deal to expose the superficialities accompanying the popularization of liberal ideas, but he has done so by attacking habits of feeling rather than ideas as such. And in the beginning his quarrel does not seem to have been so much with liberalism in particular as with deadness of sensibility in general. Only in the 1920s, after his religious conversion—and when he had begun to follow that precedent, set in the eighteenth century, according to which the eminent writer, finding in middle age that literature is not enough, aspires to the larger role of sage or prophet—only then did his position solidify into a consciously antiliberal one. But it was then, too, that Eliot's own sensibility began to show symptoms of the same malady he had been diagnosing. His weakness for attitudes he might honestly mean, but had not honestly come by, became more marked; and a note of involuntary parody crept here and there into his prose. He began to pronounce more frequently on social and political as well as religious matters—with a gravity that was increasingly prim, relieved by a facetiousness that became increasingly uneasy. He made statements in the reading of which one found it hard to believe one's eyes.

All this is by way of explaining just how seriously I think Eliot's latest book, *Notes Towards the Definition of Culture*, should be taken. We are conscious of who its author is on every page, and for this reason are all the more shocked by certain things in it. That Eliot can be callow when away from literature is no news, but he has never before shown himself so callow, or even silly, as here.

The book abounds in such truisms as: ". . . it may be argued that complete equality means universal irresponsibility"

and "A democracy in which everybody had an equal responsibility for everything would be oppressive for the conscientious and licentious for the rest." A paragraph begins with the sentence: "The colonization problem arises from migration." Mention is made of the "oriental cast of the Russian mind" and of "vast impersonal forces." American movies are referred to as "that influential and inflammable article the celluloid film." A paragraph ending with the phrase, "destroying our ancient edifices to make ready the ground upon which barbarian nomads of the future will encamp in their mechanized caravans," is apologized for as an "incidental flourish to relieve the feelings of the writer and perhaps a few of his more sympathetic readers"—in seeming unawareness of what a threadbare piece of journalistic cant that flourish is. We are more than shocked; we are dismayed by the following statement: "I do not approve of the extermination of the enemy: the policy of exterminating or, as is barbarously said, liquidating enemies, is one of the most alarming developments of modern war and peace, from the point of view of those who desire the survival of culture. One needs the enemy."

Yet, despite all that is inconsistent, mindless and even soulless in this book, it gives further evidence of Eliot's flair for the right issue at the right time. He faces up to a large problem that many more liberal or enlightened thinkers prefer to evade, and he states some of the limits within which this problem has to be dealt with. And when all his *gaffes* and the entire extent of his intellectual irresponsibility are taken into account, there is still enough left over to take seriously.

The title itself, *Notes Towards the Definition of Culture*, is misleading, for Eliot simply hands down a definition and lets it go at that. Culture "includes all the characteristic activities of a people: Derby Day . . . the pin table . . . boiled cabbage cut into sections . . . nineteenth-century Gothic churches and the music of Elgar." And "what is part of our culture is also a part of our *lived* religion." As Eliot uses the terms,

23

"civilization" seems to be much more inclusive than "culture," but he also tends to make the two interchangeable, with consequences for himself and for his argument that are embarrassing.

In his introductory chapter he writes:

The most important question that we can ask, is whether there is any permanent standard, by which we can compare one civilization with another, and by which we can make some guess at the improvement or decline of our own. We have to admit, in comparing one civilization with another, and in comparing the different stages of our own, that no one society and no one age of it realizes all the values of civilization. Not all of these values may be compatible with each other: what is at least as certain is that in realizing some we lose the appreciation of others. Nevertheless, we can distinguish between advance and retrogression. We can assert with some confidence that our own period is one of decline; that the standards of culture are lower than they were fifty years ago; and that the evidences of this decline are visible in every department of human activity. I see no reason why the decay of culture should not proceed much further, and why we may not even anticipate a period, of some duration, of which it is possible to say that it will have *no* culture. Then culture will have to grow again from the soil; and when I say it must grow again from the soil, I do not mean that it will be brought into existence by any activity of political demagogues. The question asked by this essay, is whether there are any permanent conditions, in the absence of which no higher culture can be expected.

Eliot makes no further reference to a "permanent standard" of comparison, though it is "the most important question that we can ask." We are left to wonder how "Nevertheless, we can distinguish between higher and lower cultures . . . between advance and retrogression," and just where the "some confidence" comes from with which it is asserted that evidences of a decline in cultural standards are "visible in every department of human activity" today.

Surely, the preponderant evidence would show the opposite of *cultural* decline in science and scholarship, healing and

engineering, over the last fifty years. Most of the Western world eats eats better prepared food and lives in pleasanter interiors than it used to; and whatever the rich may have lost in formal graces, those less than rich are certainly gentler than they used to be. Eliot's assertion is not only exaggerated; it is also unnecessary. Had he confined himself to saying that standards were in decline on the highest levels of disinterested culture one would not have to take leave of common sense in order to assent, as I myself would do (though no better able than he to set up a "permanent standard" of comparison). And granted that there has been a certain improvement on the middle levels of culture, I am sure that we would all agree that no amount of improvement there can compensate for deterioration on its uppermost levels.

The weight of *Notes* is laid on a description of three of the "permanent conditions, in the absence of which no higher culture can be expected." Eliot does not propose that one set about immediately to establish or restore these; he doubts whether it will be possible to do so in the conceivable future; he hopes only to dissipate popular illusions about the effectiveness of *ad hoc* measures.

The first of the three conditions is an

organic (not merely planned, but growing) structure such as will foster the hereditary transmission of culture within a culture; this requires the persistence of social classes. The second is the necessity that a culture should be analyzable, geographically, into local cultures: this raises the problem of "regionalism." The third is the balance of unity and diversity in religion—that is, universality of doctrine with particularity of cult and devotion.

These are not "all the necessary conditions for a flourishing culture," but "so far as my observation goes, you are unlikely to have a high civilization where these conditions are absent."

Here again, Eliot's argument is better founded than it might look. Whether the second and third of the conditions he describes were present whenever and wherever culture flourished

in the past, can be disputed, but there is no question about the first condition. We have no record of any civilization, or urban culture, without class divisions. This happens to be the strongest point in the whole conservative argument. But it is no stronger than the precedents which support it, and if other precedents could be found that overrode these, then this point might be considerably weakened. And if this point were weakened, the discussion of the plight of contemporary culture would have to be extended beyond the limits to which Eliot confines it.

As it is, the limits within which liberals discuss the same problem are hardly any broader. Eliot's book reminds me of this once again, but it also reminds me of the omnipresence of Marx, without which Eliot himself would not have been able perhaps to formulate the conservative position as cogently as he has. Marx made the only real beginning in the discussion of the problem of culture, and neither conservatives nor liberals seem yet to have gone beyond that beginning—or even to have caught up with it. It is to Marx, and to him alone, that we have to return in order to restate the problem in such a way that it has a chance of receiving fresh light. Eliot's little book has the merit of sending us back to Marx and his beginning. And when we try to go beyond his beginning, we find ourselves still proceeding along lines that he laid down.

Marx was the first to point out that what made class divisions necessary to civilization was the low material productivity so far of even the most advanced societies. This is why the vast majority have had to work full time in order to provide both for their own necessities and for the leisure and ease of the minority that carried on the activities by which civilization is distinguished. Marx assumed that scientific technology—industrialism—would eventually do away with class divisions because it would produce enough material goods to exempt every one from full-time work. Whether he was right or wrong, he did at least appreciate the enormous change in the *shape* of

civilized society that technological revolution was bound to bring about in one way or another. Eliot, however, along with Spengler and Toynbee, implies that technological change, no matter how extensive, is powerless to affect the formal or "organic" basis of civilization; and that industrialism, like rationalism and hugeness of cities, is but another of the "late" phenomena that ordinarily accompany and accelerate the decline of culture. There is the further implication that when and if culture revives, it will have to be under the same conditions, by and large, as in the past.

Those who slight the technological factor in this way are able to do so with a certain plausibility because they generalize from a delimited, urban past that saw no sweeping changes in technology until quite lately. When we turn our eyes back four or five thousand years and more (with Alfred Weber and Franz Borkenau) to the remoter, pre-urban and early urban past, this plausibility fades. We discover not only that the effects of technological revolution have seldom been transient, but that technological progress has been cumulative and irreversible in the long run. And there seems to be no reason why industrialism should form an exception to this rule, even though it is so much more dependent on abstruse knowledge than any past system of technology.

We also discover that the first effects of technological innovation have usually been unsettling and destructive—politically and socially as well as culturally. Inherited forms lose their relevance, and there is a general breakdown until more apposite forms arise—forms that are usually unanticipated and unprecedented. This circumstance would be enough of itself to account for the present decline of high culture, without bringing in the surmise that Western civilization has now reached a "late" stage like that of Classical civilization under the Roman Empire.

The industrial revolution is not only the first *full-scale* technological revolution that civilization has experienced since its very beginnings; it is also the greatest and most thorough-

going one since the agricultural revolution that went on all through the Neolithic age in the Middle East and which was capped by the "metal" revolution that ushered in city life. In other words, the industrial revolution marks a great turning point in history in general and not just in the history of Western civilization. It happens also to be the most rapid and concentrated of all the technological revolutions.

This may help explain why our culture, on its lower and popular levels, has plumbed abysses of vulgarity and falsehood unknown in the discoverable past; not in Rome, not in the Far East or anywhere else has daily life undergone such rapid and radical change as it has in the West in the last century and a half. But at the same time there have been beneficial consequences, as I have tried to point out, which seem to be equally novel, at least in their scale.

Admittedly, the situation is so new, especially as affecting culture, that it defeats most generalizations based on familiar historical experience. But the question still remains whether it is really novel enough to have put into serious doubt that first condition which Eliot deems required for a high civilization, namely the "persistence of social classes." I think that the only answer to which this question is now susceptible is one that, as Marx says of historical "answers" in general, destroys the question or problem itself. If technological progress is irreversible, then industrialism is here to stay, and under industrialism the kind of high civilization Eliot has in mind—the kind known from the past four thousand years—cannot survive, much less be restored. If high civilization as such is not to disappear, a new type of it will have to be developed that satisfies the conditions set by industrialism. Among those conditions will be in all likelihood a classless society, or at least a society in which social classes no longer persist in the old way, since they will no longer be sanctioned by economic necessity. Marx, I feel, will be proved right in this part of his prophecy (which is not to say that the disappearance of traditional class divisions will bring about utopia).

But until this new industrial type of high civilization emerges, Eliot's conservative position will continue to be tenable. It is a fact that the source of the gravest threat the present technological revolution offers to the continuity and stability of high culture is a vastly accelerated rate of upward social— more accurately, material and economic—mobility. The traditional facilities of urban culture cannot accommodate themselves to a steadily growing *population*—not merely class—of newcomers to comfort and leisure, without suffering deterioration. To the very extent that industrialism promotes social welfare, it attacks traditional culture; at least, this has been the case so far. The conservative solution would be to check social mobility by checking industrialization. But industrialism and industrialization are here to stay. Their benefits are too well recognized by now for humanity to be turned from the pursuit of them by anything short of cosmic violence. Thus, we see that, however plausible the conservative diagnosis of the plight of culture may remain, the remedy implied in it has become highly unreal. One puts Eliot's book down with the feeling, finally, that it is a little beside the point.

The opposed solution, the socialist and Marxist one, is to intensify and extend industrialism, on the assumption that it will eventually make well-being and social dignity universal, at which time the problem of culture will solve itself of itself. This expectation may not be quite as utopian as are the proposals of the ideologues of "tradition," but it remains a very distant one. In the meantime, the hope of liberals—that the greater leisure made possible by industrialism can be turned to the benefit of culture here and now—seems more reasonable. But precisely in this hope, most liberals show the extent to which they, too, fail to appreciate the novelty of industrialism and the scope of the changes it makes in life. While it is generally understood that the quality of leisure is determined by its social and material circumstances, it is not understood that its quality is determined in even larger part by the quality of the activity that sets it off: in other words, that leisure is both

a function and a product of work, and that it changes as work itself changes. This unforeseen aspect of leisure is typical of what is unforeseen in general in the consequences of industrialization. For this and other reasons, the matter is worth going into at some length.

Before industrialism, the general feeling was that leisure was life's positive aspect and the condition for the realization of its highest ends, while work constituted its negative aspect. This feeling was all the more implicit and pervasive because it was so seldom put into words. At the same time, work was not separated nearly so unequivocally from leisure in terms of time or attitude as it is now, and this permitted some of the disinterested attitudes of leisure, and of culture itself, to carry over into and dilute work. How much less of an affliction work was rendered thereby is hard to say, but we can be reasonably sure that work used to take a lighter toll of the nerves, if not of the muscles, than it does now. If working people led more brutish lives in the past, it was due less to the absence of labor-saving devices than to the scarcity of material goods, which was itself due to the fact that they did not work hard enough—that is, rationally and efficiently enough.

On the other hand, the leisure that was enjoyed, along with comfort and dignity, by a relative few was rendered all the more positive—and the better able to be turned to the benefit of culture—by the fact that it was not felt as being so antithetical to work. Then as now, most of the rich spent their time away from interested activity in dissipation and sport, but these do not seem to have "killed" time or been so far removed from genuine culture as now. Everybody, including the poor, would have subscribed in principle, as not everybody would now, to what Aristotle says (in *Politics*, VIII):

. . . the first principle of all action is leisure. Both are required, but leisure is better than work and is its end. . . . Leisure as such gives pleasure and happiness and enjoyment of life; these are experienced, not by the busy man, but by those who have leisure. . . .

There are branches of learning and education which we must study merely with a view to leisure spent in intellectual activity, and these are to be valued for their own sake.

Perhaps the greatest change that industrialism (along with Protestantism and rationalism) has made in daily life is to separate work from leisure in a radical and almost absolute way. Once the efficacy of work began to be more clearly and fully appreciated, work had to become more efficacious in itself —that is, more efficient. To this end, it had to be more sharply separated from everything that was not work; it had to be made more concentratedly and purely itself—in attitude, in method and, above all, in time. Moreover, under the rule of efficiency, seriously purposeful activity in general tended to become assimilated to work. The effect of all this has been to reduce leisure to an occasion more exclusively of passivity, to a breathing spell and interlude; it has become something peripheral, and work has replaced it as the central as well as positive aspect of life, and as the occasion for the realization of its highest ends. Thus leisure has become more purely leisure— nonactivity or aimless activity—as work has become more purely work, more purely purposeful activity.

The shortening of working hours has changed little in this equation. The rich themselves are no longer free from the domination of work; for just as they have lost their monopoly on physical comfort, so the poor have lost theirs on hard work. Now that prestige goes more and more to achievement rather than to social status, the rich themselves begin to resent old-fashioned, undistracted leisure as idleness, as something too remote from serious reality, therefore demoralizing. The rich man may be less "alienated" from his job than the poor man, and may not work as hard or under as onerous conditions, but his soul is likewise oppressed by the rule of efficiency, whether he heeds it or not. Once efficiency is universally accepted as a rule, it becomes an inner compulsion and weighs like a sense of sin, simply because no one can ever be efficient *enough,*

just as no one can ever be virtuous enough. And this new sense of sin only contributes further to the enervation of leisure, for the rich as well as the poor.

The difficulty of carrying on a leisure-oriented tradition of culture in a work-oriented society is enough of itself to keep the present crisis in our culture unresolved. This should give pause to those of us who look to socialism alone as the way out. Efficient work remains indispensable to industrialism, and industrialism remains indispensable to socialism. Nothing in the perspective of socialism indicates that it will easily dissipate anxiety about efficiency and anxiety about work, no matter how much the working day is shortened or how much automation takes over. Nothing, in fact, in the whole perspective of an industrialized world—a perspective that contains the possibility of both good and bad alternatives to socialism—affords any clue as to how work under industrialism can be displaced from the central position in life it now holds.

The only solution for culture that I can conceive of under these conditions is to shift its center of gravity away from leisure and place it squarely in the middle of work. Am I suggesting something whose outcome could no longer be called culture, since it would not depend on leisure? I am suggesting something whose outcome I cannot imagine. Even so, there is the glimpse of a precedent; a very uncertain glimpse, it is true, but a glimpse nevertheless. Once again, it lies in the remoter, pre-urban past—or in that part of it which survives in the present.

In societies below a certain level of economic development, everybody works; and where this is so, work and culture tend to be fused in a single functional complex. Art, lore and religion then became barely distinguishable, in either intention or practice, from the techniques of production, healing and even war. Rite, magic, myth, decoration, image, music, dance and oral literature are at one and the same time religion, art, lore, defense, work and "science." Five thousand years of civilization have separated these areas of activity from one another

and specialized them in terms of their verifiable results, so that we now have culture and art for their own sake, religion for the sake of things unknowable (or, like art, for the sake of states of mind) and work for the sake of practical ends. It would seem that these things have now become separated from one another forever. Yet we discover that industrialism is bringing about a state of affairs in which, once again, everybody will work. We are coming full circle (as Marx predicted, though not quite in the way he hoped), and if we are coming full circle in one respect, may we not be doing so in others? With work becoming universal once more, may it not become necessary—and because necessary, feasible—to repair the estrangement between work and culture, or rather between interested and disinterested ends, that began when work first became less than universal? And how else could this be done but through culture in its highest and most authentic sense?

Beyond such speculation, which is admittedly schematic and abstract, I cannot go. Nothing in these ideas suggests anything that could be sensibly hoped for in the present or near future. But at least it helps if we do not have to despair of the ultimate consequences for culture of industrialism. And it also helps if we do not have to stop thinking at the point where Spengler and Toynbee and Eliot do.

1953

Art in Paris

The Later Monet

The first impulse is to back away from a vogue, even when one's own words may have contributed to it. But the righting of a wrong is involved here, though that wrong, which was a failure in appreciation, was perhaps inevitable and even necessary at a certain point in the course of modernist painting. Fifty years ago Monet seemed to have nothing to tell ambitious young artists except how to persist in certain blunders of conception and taste. Even his own taste began to question his art. In 1912 he wrote to the elder Durand-Ruel:

> And today more than ever I realize how factitious the unmerited [sic] success is that has been accorded me. I always hope to arrive at something better, but age and troubles have exhausted my strength. I know very well in advance that you will find my canvases perfect. I know that they will have great success when shown, but that's indifferent to me, since I know they are very bad and am sure of it.

In another three years he was to begin working on the Orangerie murals.

Monet turned out many bad pictures in middle and old age. He also turned out more than a few very good ones. Neither the larger public, which admired him unreservedly, nor the avant-garde of that time, which wrote him off, seems to have been able to tell the difference. After 1918, as we know, enlightened public—as well as critical—esteem went decidedly to Cézanne, Renoir and Degas, and to Van Gogh, Gauguin and Seurat. The "orthodox" Impressionists—Monet, Pissarro, Sisley—fell under a shadow. It was then that the "amorphousness" of Impressionism became an accepted idea; and it was forgotten that Cézanne himself had belonged to, and with, Impressionism as he had to nothing else. The righting of the

balance started only during the last (1939) war with the growing appreciation of the works of Pissarro's last decade, when our eyes seemed to become less insensitive to a general graying tone that attenuated contrasts of light and dark. But Pissarro still built a rather clearly articulated illusion in depth, which led critics hypnotized by Cézanne to exempt him from many of the charges they continued to bring against Monet and Sisley. The general pallor, or else the general dusk, to which Monet became addicted in his later years permitted only hints and notations of such an illusion; and these came through in what seemed, and often was, an uncontrolled way. Atmosphere gave much in terms of color but took away even more in terms of three-dimensional form. Nothing could have more alienated the best taste of the decades dominated by Matisse and Picasso.

Sixty and seventy years ago Monet's later manner both stimulated and met a new appetite for close-valued, flat effects in pictorial art—as did Bonnard's and Vuillard's first mature works. Monet was then much admired by *fin de siècle* aesthetes like Proust, even though his diaphanous iridescences were already going into the creation of that new, candy-box ideal of beauty which supplanted the Victorian chromo-lithographic one in popular favor. Never before or after the 1900s, apparently, did the precious so quickly become the banal. By 1920, Monet's later art had acquired a period flavor even for eyes not offended by what the avant-garde found wrong with it. Only now—when the interwar period with its repudiation of everything popular before 1914, is beginning to be repudiated in its own turn—have these period associations begun to fade.

Worldly success came earlier to Monet, and in larger measure, than to any of the other master Impressionists. Most of them wanted, and needed, that kind of success. Their attitude was never really an intransigent one: they worried about how to make an impression on the art market and were not above trying, within certain limits, to satisfy the demands of prospective buyers. As we know, Cézanne never stopped yearning for admission to the official salon, and only one or two of his

fellows would have refused official honors. And yet, even after their "consecration," the Impressionists continued to remain revolutionary artists.

By 1880, Monet had already marked himself off as a publicity seeker and a shrewd, self-promoting businessman. This he continued to be till he died—he who had been the most poverty-stricken of all of them in the beginning; his sense of timing in raising his prices was better than that of his dealers. This does not mean that he compromised in his art, or that he ever got enough satisfaction from success to feel satisfied with himself. On the contrary, after 1880, when the original momentum of Impressionism slackened, even as its products were beginning to win acceptance, he fell prey to increasing doubts.

The Impressionist masters were neither worldly nor innocent; they transcended these alternatives, as only people of ripened individuality can. It is remarkable how few airs they gave themselves, how little of the *panache* of artists. Formed by the 1860s—that great school in radicalism and tough-mindedness—they retained a certain hardness of head that prevailed over personal eccentricities, even in the cases of Cézanne and Degas.

At this distance, Monet, Pissarro and Cézanne seem to form a group of their own, less by reason of art or personal association than by way of life and working habits. We see them—all three of them stocky, bearded—setting out each day to paint in the open air, to apply themselves to their "motifs" and their "sensations." They go about their work with fanatical patience and regularity; they become prolific artists in the high nineteenth-century style. They are fundamentally cultivated and sophisticated (Monet has the least formal education of the three), but by middle age they have all become a little countrified as well as weatherbeaten, lacking social and almost every other kind of grace—yet how un-naive.

The personalities of painters and sculptors seldom get as pointedly reported as those of writers. But Monet dead may

be easier to approach than Monet living. We get the impression of someone almost as moody as Cézanne but more self-controlled; given to fits of discouragement and to brooding and fretting over details; absolutely unpretentious and without phrases, indeed without very many ideas, but with definite and firm inclinations. Supposedly a programmatic painter and the leading spirit of Impressionism, he had even less than Sisley to put into words—much less theory—about his art. There was a kind of force in him that was also a kind of inertia: unable to pause once he was at work, he found it equally difficult, by his own confession, to resume work after he had stopped. Usually it was the weather that interrupted him; he was more dependent on it than a farmer. Only Sisley was a more confirmed landscapist.

Like most of the Impressionists, Monet was not in the habit of waiting for the right mood; he turned out painting as steadily as Balzac turned out prose. Yet he knew little of the comforts of routine: each new day and each new picture brought renewed doubts and a renewed struggle. Only at the very beginning and the very end of his career did he undertake works with the character of planned and pondered masterpieces or set pieces; otherwise it was simply day-in, day-out painting. Certainly he produced too much, and it belonged to his way of work that the bad should come out along with the good, and in greater quantity. At times he even looked inept, yet it was to the eventual benefit of his art that he did not settle at any point into a manner that might have guaranteed him against clumsiness. The prophetic greatness he finally attained required much unrealized painting as a propaedeutic. Because he proceeded as if he had nothing to lose, Monet remained, in the long run, as daring and "experimental" as Cézanne.

That he had no capacity for self-criticism was also to his advantage. A nice taste can alienate an artist from his own originality. Not that Monet did not try to exercise taste: he would fuss endlessly with pictures before letting them go, and he rarely finished one to his own satisfaction. Contrary to what

he pretended, he did not stop painting when he turned away from the motif in nature; he would spend days and weeks retouching canvases in his studio. The excuse he gave Durand-Ruel at first was that he had to meet the taste of collectors for "finished" pictures, but it was his own conception of the finished that he really tried to satisfy. One can well imagine that more pictures were spoiled than improved in the process—given that self-doubts of the kind preying on Monet tended to edit out spontaneity when he was away from the direct stimulus of the motif. When, on the other hand, he stopped correcting himself and became slapdash, his canvases generally gained in unity.

It was not with truly doctrinaire intent that Monet drew the most radical conclusions of Impressionism. Impressionism was his personal sensibility and his personal experience, doctrine or no doctrine. The quasi-scientific aim he set himself in the 1890s—to record the effects of light on the same subject at different times of day and in different weather—may have involved a misconception of the purposes of art; but it was also, and more fundamentally, part of an effort to find a new principle of consistency for art. He seems to have been unable to believe in, or at least to use, the Old Masters as Cézanne and Renoir did. What he found in the end was, however, not so much a new as a more comprehensive principle; and it lay not in Nature, as he thought, but in the essence of art itself, in art's "abstractness." That he himself could not recognize this makes no difference.

Monet's example shows as well as any how abysmally untrustworthy a mistress Nature can be for the artist who would make her his only one. He first stumbled into prettiness when he tried to capture the brilliant effects of Mediterranean light with color keyed according to the Impressionist method. An incandescent violet asked to be enhanced by an incandescent yellow, an incandescent green by an incandescent pink. Complementaries, outbidding one another in brightness in the effort to approximate that of the motif, were fused finally in an

effect which may have conveyed the truth of subtropical air and sun as never before, and revealed hitherto unimagined capacities of oil pigment; but the result as *art* was cloying. Elsewhere, the result became a monotonous one because of its literal fidelity to an overconfined subject—like a row of equidistant poplars of the same shape and height, or two or three lily pads in a pond—that offered too little variety in the way of design.

An adventurous spirit, rather than an active imagination, was what prompted him in his moments of success. The literalness with which Monet registered his "sensations" could become an hallucinated literalness and land him on the far side of expected reality, in a region where visual fact turned into phantasmagoria that became all the more phantasmagorical because it was without a shred of fantasy. (Observe how literal, conventional, Monet's *drawing* remained, for all its simplifications.) Nature, prodded by an eye obsessed with the most naive kind of exactness, responded in the end with textures of color that could be managed on canvas only by invoking the autonomous laws of the medium—which is to say that Nature became the springboard for an almost abstract art.

For a long while after the close of his "classical," Argenteuil period, Monet's main difficulty was *accentuation*. Concern with "harmony" and the desire to reproduce the equity with which Nature bestowed her illumination could lead him to accent a picture too repetitiously, especially in terms of color, now that emphasis on light and dark had been renounced. Monet would be too ready to give "equivalences" of tone precedence over "dominants," or else to make dominants altogether too dominant. The luminosity or intensity of color for which he strove could become an unmodulated, monotonous intensity and could end by canceling itself out, as in some of the paintings of the Rouen cathedral. At other times, however, the motif itself would solve this problem: the sudden red of a field of poppies could explode the complementaries and the

equivalences into a higher, recovered unity. But he seems to have become increasingly afraid of such "discords."

There were many reasons for his (and Pissarro's) concern about unity. The broken, prismatic color of full-blown Impressionism (which became full-blown only after 1880, and only in Monet's and Sisley's art) tended to make the balance between the illusion in depth and the design on the surface precarious. Anything too definite, like a jet of solid color or an abrupt contrast of values, could throw it off; to prevent this, it was necessary to emphasize the general tone or "dominant," or else to infiltrate more thoroughly each color area with reflections of surrounding colors. At times Monet painted as if his chief task were to resolve everything into statements of equilibrium, and too many of his pictures ended up as resolutions of things already resolved: as monotonously woven tissues of dabs of paint or, especially later on, as mere curtains of opalescent gray distilled from local colors and their atmospheric reflections. The main fault in the *effect* was a lack of immediacy: the rendered motif looked as though it lay buried in amber, or like a photograph that had been covered with a veil of paint. Image and paint surface seemed to exist on separate levels of perception in a way far more apparent than in the glaze-and-scumble textures of the Old Masters.

The dilemma could be solved only by impaling oneself on one or the other of its horns: either the illusion in depth had to be strengthened at the expense of the surface (which was the step Pissarro finally took) or vice versa. In 1886, Pissarro himself observed that Monet was a "decorator without being decorative." Lionello Venturi explains what Pissarro meant: decorative painting has to stay close to the surface if it is to have unity, but Monet's painting, while in effect staying there, betrayed velleities toward a fully imagined illusion of depth in which three-dimensional forms asked to be more solidly indicated than they actually were. Monet's decorative art failed, in short, not because it was decorative but because it was not imaginatively completed. This is well said, but it is not the last word

on the art of Monet's middle and old age. In a number of works that are not so infrequent as to be exceptional—and not all of which came just at the end—he found solutions that permitted him to keep the weight of the picture safely on the surface without ceasing thereby to report Nature. It was already noticeable in the 1880s that his foregrounds had a conviction, and a broad and rich intensity of color, that the more graphic and specific handling of his backgrounds could not match in pictorial quality. Toward the end of his life, Monet began to make his pictures all foreground.

Meanwhile, the Cubists, led by Cézanne, were returning painting to the surface in a quite different way. In their very solicitude for three-dimensionality, they so emphasized the sculptural means by which it was traditionally attained that these reacted against themselves and undid their intended effect. By dint of being exaggerated, light and dark contrasts rose to the picture surface to become patterns rather than descriptive configurations. Monet, the arch-Impressionist, had started from the opposite direction—by narrowing and even suppressing value contrasts—and where the Cubists arrived at the *skeleton* of a traditional painting, he arrived at the *shadow* of one.

Neither of these paths to what became abstract art was inherently superior to the other in sheerly pictorial quality. Just as Picasso, Braque and Léger found the right kind of color for their various purposes, so Monet developed the right kind of "architecture" he needed for his. What the avant-garde missed in Late Impressionism was light-and-dark structure; but there is nothing in artistic experience which says that chromatic, "symphonic" structure cannot take its place. Sixty years of modernist painting have finally brought this home to us, now that the first seed of modernism, planted by the Impressionists, has turned out to be the most radical of all.

Venturi, writing in 1939, called Monet the "victim and grave-digger of Impressionism." At that time Monet still appeared to have nothing more to say to the avant-garde. But only a few years later, several Americans who were to become

the most advanced of advanced painters were enthusiastically rediscovering him. They had not even seen, outside reproductions, those huge close-ups which are the last *Water Lilies;* but they were already learning from Monet, as well as from Matisse, that a lot of sheerly physical space was needed for the development of a strong pictorial idea that did not involve an illusion of more than shallow depth. Monet's broad, slapped-on daubs of paint and his scribbles were telling them, further, that paint on canvas had to be able to breathe; and that when it did breathe, it exhaled color first and foremost—color in fields and areas, rather than in shapes; and that this color had to be *solicited* from the surface as well as applied to it. It was under the tutelage of Monet's later art that these same young Americans began to reject sculptural drawing—"drawing-drawing"—as finicking and petty, and turn instead to "area" drawing, "antidrawing" drawing.

It used to be said that Monet had outlived himself, that by the time of his death in 1926 he was an anachronism. Now, however, those great summations which are the last *Water Lilies* begin to belong to our age in a way that Cézanne's own attempts at summations (in his two large *Bathers*) no longer do. The twenty-five years' difference in dates of execution between the *Bathers* and the *Water Lilies* of the Orangerie turns out not to be meaningless after all, and the twenty years by which Monet outlived Cézanne not to have been in vain.

Meanwhile, Monet's rehabilitation is having an unsettling effect on art opinion, as well as on art itself. It makes us realize, and helps us clarify, a certain dissatisfaction with Van Gogh, just as it confirms our impatience with the uncritical adoration of Cézanne. Van Gogh was a great artist, but Monet's example serves even better than Cézanne's to remind us that he lacked a settled largeness of view. In Monet we find a world of art, with the variety and spaciousness and ease of a *world;* in the short-lived Van Gogh, we find only the glimpse of one.

<div align="right">1956
1959</div>

Renoir

My reactions to Renoir keep changing. One day I find him almost powerful, another day almost weak; one moment brilliant, the next merely flashy; one day quite firm, another day soft. The extraordinary sensitivity of his pictures—even, and sometimes especially, the late ones—to the lighting under which they are seen has, I feel sure, something to do with this. Supposedly, the Impressionist aesthetic made lighting and distance all-important factors in the viewing of a picture— but only supposedly. None of the Impressionists themselves seems actually to have made any more of a case about viewing conditions than artists usually do, and successful Impressionist pictures will generally declare their success under the same conditions as other successful pictures. That Renoir's should form such an exception would seem to be due to Renoir himself rather than to Impressionism.

I think part of the explanation may lie in the very special way in which he handled light and dark, making their contrasts seem just barely to coincide with contrasts of pure color; it may be for this reason that his contrasts tend to fade under a direct and bright light or when seen too near. But the un-Impressionist variety of Renoir's subject matter may also help explain the fluctuations in one's response to the quality of his art. Landscape, still life, portrait, figure, group and even anecdote—he went from one to another easily and often, if not always with success. Even the best of his landscapes, which came around 1880, lack a certain finality, and so do the famous group scenes of earlier date. With the single figure, the still life and the flower piece—things he could see with an un-Impressionist closeness—he could at that time succeed more consistently. On the other hand, some of the best pictures of his

old age—thus some of the very best of all his pictures—are group compositions.

Twenty years ago there was less question among professionals about Renoir's standing. Simplification, broadness, directness, as perceived in the later Monet, and in Matisse too, are what excite us at this moment, and we begin to feel that Renoir and even Cézanne can often be a little niggling. Renoir could execute broadly and directly; but in conceiving he was guided by the ordinary, self-evident, anecdotal complicatedness of nature, which he acknowledged as much in his later as in his earlier works. The main difference toward the end was that he rid himself of the picturesque, which had entered his art in the late 1870s, and let his Impressionist technique arrive at ends more consonant with itself.

The picturesque means the picture as a result and as little else but a result—a sure-fire effect. The picturesque means all that is viable, transmittable, liftable without risk, in the ingredients of proven art. In Renoir's case it meant eighteenth-century French and early Romantic painting, but also the popular art that was so speedily fashioned from these sources. He was not alone among the advanced artists of his time in his susceptibility to the popular. Affinities with popular images are apparent in Seurat's handling of figures in an interior and also in a certain compactness of design and color that can be found as well in Pissarro, Van Gogh and even Gauguin. Reminiscences of contemporaneous post-card art will creep into Monet and even into certain things of Cézanne's. But Renoir was the only one with whom the picturesque—if not exactly the popular—settled down for a long stay, to bring him relatively early financial success as well as to contribute to the genuine felicity of more than a few of his pre-1900 pictures. The Impressionist slice of nature, unmanipulated by "human interest" and uniform in emphasis from edge to edge of the canvas, was in Renoir's art given a sweeter but also a crisper unity. Without that, his lushness might have spilled over into a suffocating kind of decorativeness, given that he had even

less appetite in the beginning for sculptural definition than Monet and was never quite sure of himself in articulating an illusion of really deep space. Always, after the middle 1870s, he tended to half-identify broad planes with the picture plane itself and to deal with them in terms of color texture rather than spatial function, dissolving large surfaces into dappled, swirling iridescences. But he would preserve enough of the motif's actuality to keep the eye from questioning the picture as a representation of three-dimensional forms; here the picturesque, with its manipulation of the motif in terms of anecdotal interest and set patterns of design, could serve to firm up the whole and impose coherence. The result often verged on prettiness, but it is perhaps the most valid prettiness ever seen in modernist art.

In the last decades of his life Renoir won through to a new handling of three-dimensional form. He achieved this in two ways: by throwing the entire emphasis of his color on warmth —his adherence to a bas-relief organization of the picture, in which solid forms were lined up on a single frontal, therefore advancing plane (as in Titian), permitted him to do this with plausibility—and by modeling throughout with white highlights and correspondingly light and translucent coppery reds and silvery grays. It is above all to this high-keyed, aerated modeling that Renoir owes the triumphs of his later nudes, portraits and figure compositions. Paradoxically, it was by dint of becoming more sculptural, after having at last tried his hand at actual sculpture, that he joined the Venetians and Rubens on the heights of painterly painting. But wherever he went into deeper space, the outcome still remained doubtful. His later landscapes often tend to be sketchy in a bad sense, and in these alone does his increasing addiction to madders and alizarins really become a mannerism.

Perhaps we are still too close to Renoir fully to appreciate his uniqueness. The current notion of what constitutes paint quality and highly finished painting derives very largely from his art, which in its own time was reproached, like that of

the other Impressionists, for crudeness of *facture* and lack of finish; and this notion is a compromising one. At the same time, his method of high-keyed modeling has become a staple of academic modernism. What perhaps we still do not appreciate correctly is the essential vision that animates Renoir's technique, the vision behind his vision of the aims of art. There is a disjunction here which he just succeeded in overcoming late in life, with the fading of the desire to please, and with the abandonment of preconceptions about "good" or even polite painting. The less Renoir tried to conceal what I can only call his coarseness, the less there remained in it to be ashamed of.

1950

Cézanne

Cézanne's art may no longer be the overflowing source of modernity it was thirty years back, but it endures in its newness and in what can even be called its stylishness. There remains something indescribably racy and sudden for all its familiarity by now, in the way his crisp blue line can separate the contour of an object from its mass. Yet how distrustful Cézanne himself was of bravura, speed—all the apparent concomitants of stylishness. And how unsure at bottom of where he was going.

He was on the verge of middle age when he had the crucial revelation of his artist's mission. Yet what he *thought* was revealed was largely inconsistent with the means he had already developed to meet and fulfill his revelation, and the problematic quality of his art—the source perhaps of its unfading modernity—came from the ultimate necessity of revising his intentions under the pressure of a method that evolved as if in opposition to them. He was making the first pondered and conscious attempt to save the key principle of Western painting—its concern for an ample and literal rendition of stereometric space—from the effects of Impressionist color. He had noted the Impressionists' inadvertent silting up of pictorial depth; and it was because he tried so hard to reexcavate that space without abandoning Impressionist color, and because this effort, while vain, was so profoundly conceived, that his art became the discovery and turning point it did. Like Manet, and with almost as little real appetite for the role of a revolutionary, he changed the direction of painting in the very effort to return it by new paths to its old ways.

Cézanne accepted his notion of pictorial unity, of the realized, final effect of a picture, from the Old Masters. When

he said that he wanted to redo Poussin after nature and "make Impressionism something solid and durable like the Old Masters," he meant apparently that he wanted to impose a composition and design like that of the High Renaissance on the "raw" chromatic material provided by the Impressionist registration of visual experience. The parts, the atomic units, were still to be supplied by the Impressionist method, which was held to be truer to nature; but these were to be organized into a whole on more traditional principles.

The Impressionists, as consistent in their naturalism as they knew how to be, had let nature dictate the over-all design and unity of the picture along with its component parts, refusing in theory to interfere consciously with their optical impressions. For all that, their pictures did not lack structure; insofar as any single Impressionist picture was successful, it achieved an appropriate and satisfying unity, as must any successful work of art. (The overestimation by Roger Fry and others of Cézanne's success in doing exactly what he said he wanted to do is responsible for the cant about the Impressionist lack of structure. What is missed is geometrical, diagrammatic and sculptural structure; in its stead, the Impressionists achieved structure by the accentuation and modulation of points and areas of color and value, a kind of "composition" which is not inherently inferior to or less "structural" than the other kind.) Committed though he was to the motif in nature in all its givenness, Cézanne still felt that it could not of its own accord provide a sufficient basis for pictorial unity; what he wanted had to be more emphatic, more tangible in its articulation and therefore, supposedly, more "permanent." And it had to be *read* into nature.

The Old Masters had assumed that the members and joints of pictorial design should be as clear as those of architecture. The eye was to be led through a rhythmically organized system of convexities and concavities in which manifold gradations of dark and light, indicating recession and salience, were marshaled around points of interest. To accommodate the

weightless, flattened shapes produced by the flat touches of Impressionist color to such a system was obviously impossible. Seurat demonstrated this in his *Sunday Afternoon on Grand Jatte Island,* as well as in most of his other completed group compositions, where the stepped-back planes upon which he set his figures serve—as Sir Kenneth Clark has noted—to give them the quality of cardboard silhouettes. Seurat's pointillist, hyper-Impressionist method of filling color in could manage a plausible illusion of deep space, but not of mass or volume within it. Cézanne reversed the terms of this problem and sought—more like the Florentines than like the Venetians he cherished—to achieve mass and volume first, and deep space as their by-product, which he thought he could do by converting the Impressionist method of registering variations of light into a way of indicating the variations in planar direction of solid surfaces. For traditional modeling in dark and light, he substituted modeling with the supposedly more natural—and Impressionist—differences of warm and cool.

Recording with a separate pat of paint each larger shift of direction by which the surface of an object defined the shape of the volume it enclosed, he began in his late thirties to cover his canvases with a mosaic of brushstrokes that called just as much attention to the physical picture plane as the rougher dabs or "commas" of Monet, Pissarro and Sisley did. The flatness of that plane was only further emphasized by the distortions of Cézanne's drawing, which started out by being temperamental (Cézanne was never able to master a sculptural *line*) but turned into a method, new in extent rather than in kind, of anchoring fictive volumes and spaces to the surface pattern. The result was a kind of pictorial tension the like of which had not been seen in the West since Late Roman mosaic art. The overlapping little rectangles of pigment, laid on with no attempt to fuse their edges, brought depicted form toward the surface; at the same time, the modeling and shaping performed by these same rectangles drew it back into illusionist depth. A vibration, infinite in its terms, was set up between

the literal paint surface of the picture and the "content" established behind it, a vibration in which lay the essence of the Cézannian "revolution."

The Old Masters always took into account the tension between surface and illusion, between the physical facts of the medium and its figurative content—but in their need to conceal art with art, the last thing they had wanted was to make an explicit point of this tension. Cézanne, in spite of himself, had been forced to make the tension explicit in his desire to rescue tradition from—and at the same time with—Impressionist means. Impressionist color, no matter how handled, gave the picture surface its due as a physical entity to a much greater extent than had traditional practice.

Cézanne was one of the most intelligent painters about painting whose observations have been recorded. (That he could be rather intelligent about many other things has been obscured by his eccentricity and the profound and self-protective irony with which he tried, in the latter part of his life, to seem the conformist in matters apart from art.) But intelligence does not guarantee the artist a precise awareness of what he is doing or really wants to do. Cézanne overestimated the degree to which a conception could precipitate itself in, and control, works of art. Consciously, he was after the most exact communication of his optical sensations of nature, but these were to be ordered according to certain precepts for the sake of art as an end in itself—an end to which naturalistic truth was but a means.

To communicate his optical sensations exactly meant transcribing, however he could, the distance from his eye of every part of the motif, down to the smallest facet-plane into which he could analyze it. It also meant suppressing the texture, the smoothness or roughness, the hardness or softness, the tactile associations of surfaces; it meant seeing prismatic color as the exclusive determinant of spatial position—and of spatial position above and beyond local color or transient effects of light. The end in view was a *sculptural* Impressionism.

Cézanne's habits of seeing—his way, for instance, of telescoping middleground and foreground, and of tilting forward everything in the subject that lay above eye level—were as inappropriate to the cavernous architectural schemes of the Old Masters as were Monet's habits of seeing. The Old Masters elided and glided as they traveled through space, which they treated as the loosely articulated continuum that common sense finds it to be. Their aim in the end was to create space as a theater; Cézanne's was to give space itself a theater.

His focus was more intense and at the same time more uniform than the Old Masters'. Once "human interest" had been excluded, every visual sensation produced by the subject became equally important. Both the picture as picture, and space as space, became tighter and tauter—distended, in a manner of speaking. One effect of this distention was to push the weight of the entire picture forward, squeezing its convexities and concavities together and threatening to fuse the heterogeneous content of the surface into a single image or form whose shape coincided with that of the canvas itself. Thus Cézanne's effort to turn Impressionism toward the sculptural was shifted, in its fulfillment, from the structure of the pictorial illusion to the configuration of the picture itself as an object, as a flat surface. Cézanne got "solidity," all right; but it is as much a two-dimensional, literal solidity as a representational one.

The real problem would seem to have been, not how to do Poussin over according to nature, but how to relate—more carefully and explicitly than Poussin had—every part of the illusion in depth to a surface pattern endowed with even superior pictorial rights. The firmer binding of the three-dimensional illusion to a decorative surface effect, the integration of plasticity and decoration—this was Cézanne's true object, whether he said so or not. And here critics like Roger Fry read him correctly. But here, too, his expressed theory contradicted his practice most. As far as I know, not once in his recorded remarks does Cézanne show any concern with the

decorative factor except—and the words are the more revelatory because they seem offhand—to refer to two of his favorite Old Masters, Rubens and Veronese, as "the decorative masters."

No wonder he complained till his last day of his inability to "realize." The effect toward which his means urged was not the one he had conceived in his desire for the organized maximum of an illusion of solidity and depth. Every brush-stroke that followed a fictive plane into fictive depth harked back—by reason of its abiding, unequivocal character as a mark made by a brush—to the physical fact of the medium; and the shape and placing of that mark recalled the shape and position of the flat rectangle which was being covered with pigment that came from tubes. (Cézanne wanted an "elevated" art, if anyone ever did, but he made no bones about the tangibility of the medium. "One has to be a painter through the very qualities of painting," he said. "One has to use coarse materials.")

For a long while he overpacked his canvases as he groped along, afraid to betray his sensations by omission, afraid to be inexact because incomplete. Many of his reputed masterpieces of the later 1870s and the 1880s (I leave to one side the proto-expressionist feats of his youth, some of which are both magnificent and prophetic) are redundant, too cramped, lacking in unity because lacking in modulation. The parts are felt, the execution is often exact, but often there is too little of the kind of feeling that precipitates itself in an instantaneous whole. (No wonder so many of his unfinished paintings are among his best.) Only in the last ten or fifteen years of Cézanne's life do pictures whose power is complete as well as striking and original come from his easel with real frequency. Then the means at last fulfills itself. The illusion of depth is constructed with the surface plane more vividly, more obsessively in mind; the facet-planes may jump back and forth between the surface and the images they create, yet they are one with both surface and image. Distinct yet summarily applied, the square pats of paint vibrate and dilate in a rhythm that embraces the

illusion as well as the flat pattern. The artist seems to relax his demand for exactness of hue in passing from contour to background, and neither his brushstrokes nor his facet-planes remain as closely bunched as before. More air and light circulate through the imagined space. Monumentality is no longer secured at the price of a dry airlessness. As Cézanne digs deeper behind his broken contours with ultramarine, the whole picture seems to unsheathe and then re-envelop itself. Repeating its rectangular enclosing shape in every part of itself, it seems also to strain to burst the dimensions of that shape.

Had Cézanne died in 1890, he would still be enormous, but more so in innovation than in realization. The full, triumphant unity that crowns the painter's vision, the unity offered like a single sound made by many voices and instruments—a single sound of instantaneous yet infinite variety— this kind of unity comes for Cézanne far more often in the last years of his life. Then, certainly, his art does something quite different from what he said he wanted it to do. Though he may think as much as before about its problems, he thinks much less into its execution. Having attracted young admirers, he expands a little, has his remarks taken down and writes letters about his "method." But if he did not then confuse Emile Bernard, Joachim Gasquet and others among his listeners, he confuses us today, who can only read what he had to say. I prefer, however, to think with Erle Loran (to whose *Cézanne's Composition* I am indebted for more than a few insights into the essential importance of Cézanne's drawing) that the master himself was more than a little confused in his theorizing about his art. But did he not complain that Bernard, with his appetite for theories, forced him to theorize unduly? (Bernard, in his turn, criticized Cézanne for painting *too much* by theory.)

To the end, he continued to harp on the necessity of modeling, and of completeness and exactness in reporting one's "sensations." He stated his ideal, with more than ordinary self-awareness, as a marriage between *trompe-l'oeil* and the

laws of the medium, and lamented his failure to achieve it. In the same month in which he died, he still complained of his inability to "realize." Actually, one is more surprised, in view of the gathering abstractness of his last great paintings, to hear Cézanne say that he had made a "little progress." He condemned Gauguin and Van Gogh for painting "flat" pictures: "I have never wanted and will never accept the lack of modeling or gradation: it's an absurdity. Gauguin was not a painter; he only made Chinese pictures." Bernard reports him as indifferent to the art of the primitives of the Renaissance; they, too, apparently, were too flat. Yet the path of which Cézanne said he was the primitive, and by following which he hoped to rescue Western tradition's pledge to the three-dimensional from both Impressionist haze and Gauguinesque decoration, led straight, within five or six years after his death, to a kind of painting as flat as any the West had seen since the Middle Ages.

The Cubism of Picasso, Braque and Léger completed what Cézanne had begun. Its success divested his means of whatever might have remained problematical about them. Because he had exhausted so few of his insights, Cézanne could offer the Cubists all the resources of a new discovery; they needed to expend little effort of their own in either discovery or rediscovery. This was the Cubists' luck, which helps explain why Picasso, Léger and Braque, between 1909 and 1914, were able to turn out a well-nigh uninterrupted succession of "realizations," classical in the sufficiency of their strength, in the adjustment of their means to their ends.

Cézanne's honesty and steadfastness are exemplary. Great painting, he says in effect, ought to be produced the way it was by Rubens, Velasquez, Veronese and Delacroix; but my own sensations and capacities don't correspond to theirs, and I can feel and paint only the way I must. And so he went at it for forty years, day in and out, with his clean, careful *métier*, dipping his brush in turpentine between strokes to wash it, and then depositing each little load of paint in its determined

place. It was a more heroic artist's life than Gauguin's or Van Gogh's, for all its material ease. Think of the effort of abstraction and of eyesight necessary to analyze every part of every motif into its smallest negotiable plane.

Then there were the crises of confidence that overtook Cézanne almost every other day (he was also a forerunner in his paranoia). Yet he did not go altogether crazy: he stuck it out at his own sedentary pace, and his absorption in work rewarded him for premature old age, diabetes, obscurity and the crabbed emptiness of his life away from art. He considered himself a weakling, a "bohemian," frightened by the routine difficulties of life. But he had a temperament, and he sought out the most redoubtable challenges the art of painting could offer him in his time.

1951

Picasso at Seventy-Five

Picasso entered art as one of a generation of great painters in or of France following on several such generations. During the 1920s his art, like that of other eminent painters of his own and the previous generation, was overtaken by a crisis. Braque, who experienced his crisis earliest—during the 1914 war—half-recovered from it in the years between 1928 and 1932. Matisse emerged from his, which came shortly before 1930, only after the 1939 war, in the very last years of his life. Léger, for whom the crisis came in 1925 or 1926, did not recover at all. Nor do I find that Picasso has yet recovered from his. On the contrary, his crisis has through all its fluctuations only deepened since it first set in, in 1927 or 1928. And in 1939 it deepened, as it would now seem, radically.

Over the twenty-odd years from 1905, the start of his Blue Period, until 1926 or 1927, when his Cubism ceased being High, Picasso produced art of stupendous quality, stupendous alike in conception and in realization, in searchingness of invention and in consistent rightness of execution. A radical, exact and invincible loyalty to certain insights into the relation between artistic and nonartistic experience animates everything he did in that period. Even the few unsuccessful works continue to declare that absolute quality is at stake, and nothing less. The sureness of hand and eye is like a miracle, outlasting amazement to amaze even more. In 1927 execution and resolution begin to falter, but loftiness of conception remains for another ten years; and much of the particular interest of Picasso's art in the 1930s lies precisely in this discordance.

Not until he paints things like the *Still Life with Black Bull's Head* (November 1938) does his aspiration itself begin to flag. This particular picture "sits" right and is successful in its own terms, but the bland rightness of its plastic conception

opposes rather than reinforces its illustrative intention. The depicted ominousness remains merely depicted, and the painting pleases without moving. Here, in effect, Picasso begins for the first time to derive from himself and "make" art.

In the last twenty years, Picasso has brought off pictures more frequently than he did in the 1930s, but only because their level of conception has been lowered. At the same time he has painted a great many bad pictures, and of a more downright badness than before. During the thirties his art had continued to develop in a fundamental sense; it stopped doing so only when its crisis shifted, and deepened, from one of resolution and realization to one of conception.

Once a master, always—to some extent—a master. Almost everything Picasso does has a certain pungency or, at worst, piquancy. And his graphic work has maintained a level that exempts it from many if not all of the objections that can be made to his oils, gouaches and sculpture of recent years. But even so: just as there are few complete masterpieces among the oil paintings he did after 1926, and none at all after 1938, so the highly conceived and fully realized things among his prints and finished drawings become fewer and fewer after the 1920s. Recoveries as well as losses come after 1938, but neither in his graphic work nor in his paintings does Picasso regain his former absoluteness of quality.

The period from 1950 to 1953 is one of marked weakness in which, as so often before, Picasso resorts to sculpture in order to work things out. The sculpture is lamentable; but the paintings get much better in 1954, and in 1956 there is a new blossoming under Matisse's influence, which Picasso seems ready to accept with pastiche-like abjection now that the older master is dead. Yet the blossoming remains undeveloped, static, and the blossoms are by way of being artificial.

Not that Picasso has become facile or perfunctory; on the contrary, he has for years now shown a distrust of his facility and its promptings, and he seems to try to avoid anything that might suggest its presence. But the real consequence of

this distrust is perverseness: he too deliberately makes things crabbed and clumsy, as a matter of effect rather than of cause, of choice rather than necessity. Under all the changes of theme and manner, one senses the will of a virtuoso of ambition who seeks felicities of contrivance rather than inspired solutions. A kind of excitement persists, but the old plenitude and exhilaration are gone; the substance of major art is no longer what is at stake, only the look of it.

During most of the 1930s, Picasso had kept abreast of advanced art in general, and in some respects had continued to lead the way. The very contradictions and frustrations in which his painting then abounded proved more immediately fruitful for younger painters than the perfect and perhaps more exalted works which Mondrian was producing during those same years. What few things Picasso did realize completely at that time were realized absolutely, even if they were not major in format. I think of the little *Bullfight* of 1934 (now owned by Henry P. McIlhenny) and of a series of pen drawings in a kind of *Fraktur* style, done in the spring and summer of 1938, which are for me the swan song of his greatness.

Perhaps the waning of the halcyon modernism of the first quarter of the century had to be, in the nature of things, Picasso's waning too. It would seem, anyhow, that no more than about twenty years, consecutive or intermittent, of absolute realization have been granted to even the greatest of painters since Ingres. But whereas the Impressionists and post-Impressionists, including Cézanne and Matisse, could in their very best years still realize fully only one work in several, Picasso was able to bring off almost everything he put his hand to during the two decades of his prime. And though the same can be said of Mondrian from 1914 to 1936, the latter's production was not so varied by far (nor did it include sculpture).

Until the middle 1920s, Picasso had the kind of certainty that enables an artist to lead toward his strengths and, at the same time, capitalize upon his weaknesses. A painting done in

1925, the striking *Three Dancers,* where the will to illustrative expressiveness appears ambitiously for the first time since the Blue Period, is the first evidence of a lessening of this certainty. In this Cubist work, it is not at all a question of the artist satisfying his inveterate appetite (or nostalgia) for sculptural volume, as it was in the neo-Classical paintings of a short time before, where the thing illustrated remained a sincerely felt object of pictorial vision amid all the archaicisms. Now illustration addresses nature, not in order to make art say something through nature, but in order to make nature itself say something—and say it loudly. Yet the *Three Dancers* goes wrong, not just because it is literary (which is what making nature speak through art comes to), but because the theatrical placing and rendering of the head and arms of the center figure cause the upper third of the picture to wobble. (Literature as such has never yet hurt a work of pictorial art; it is only literary *forcing* which does that.)

Surrealism made its first formal appearance in Paris a year before the *Three Dancers* was painted, at a time when the avant-garde seemed to be losing its prewar confidence in the self-sufficient rightness of color and shape. Perhaps the painters who had come up before 1914 felt that it was time now to declare their filiation with the past more unmistakably—as if Dada, with its rejection of the aesthetic, had threatened to deprive modernism of its place in the continuity of art. There was also the contrary feeling among certain younger artists that the past had to be more expressly repudiated than ever, but by parodying its achievements rather than by turning directly away from them (which it was impossible to do in any case). Picasso, ever sensitive to and dependent upon the currents around him, began to think in art-historical terms and to hanker for the first time after a "grand," epic manner. The evidence is in the projects for monuments and other kinds of sculpture that he undertook in the late twenties; in his new interest in the subject of artist and model; in the studies he

did for a *Crucifixion*; and in still other things done around that time. But out of this came little that was resolved, little that transcended the interesting.

It might be said that it had to be either the grand style for Picasso or a retreat to minor art once he had abandoned Cubism. But has he really ever abandoned Cubism since 1907? Cubist simplifications and a Cubist flattening underlie his Neo-Classical pictures and are felt in every excursion into semi-academic naturalism he has made since. His arabesque, "metamorphic" manner of the early thirties, and that which he adopted in *Guernica*, are no less essentially Cubist than the more obvious neo-Cubism of the 1940s and after. It was not a question, then, of finding or inventing a grand style but of converting Cubism into one. Yet Cubism was already as valid a grand style in its own right as our time was capable of producing within the limits of easel painting, and it could not be approximated to the museum and Michelangeloesque idea of a grand style without being travestied. This is pretty much what Picasso did, later on, in such pictures as *Night Fishing at Antibes* (1939), *Korean Massacres* (1951) and *War and Peace* (1952). These works are all the more misconceived because of that innate lack of capacity for *terribilità* which had already frustrated Picasso's attempts at Surrealist profundity. They confirm, moreover, what the two *Three Musicians* (1921) and *Guernica* had previously shown: he could not make a success of a large canvas with Cubistically flattened forms. (Even the *Demoiselles of Avignon,* superb as it is, lacks conclusive unity.)

Cubism is more than travestied, it is caricatured in such late pictures as *Winter Landscape* (1950) and *Chimneys* of *Vallauris* (1951), both of which become somewhat ridiculous despite—and at the same time because of—the crispness of their unity. It is not simply a question of Picasso's lack of feeling for landscape; he once did, after all, paint the wonderful Gosol *Landscape* (1906). Something more compromising than a lack of feeling for a particular kind of subject has intervened.

Indeed I suspect that posterity will find a lot more that is truly ridiculous in Picasso's recent art than we can.

Like any other authentic style, Cubism had its own inherent laws of development, which seemed in the late 1920s to be driving toward abstraction. Mondrian drew the extreme consequences of this tendency, while Klee and Miró were able in the same period to produce art of a substantial originality by renouncing, not nature as such, but its *integrity*.

It was Picasso's double insistence on the schematic integrity of every image he took from nature—and he has always taken every image from nature—and on a minimal illusion of three-sided space, that began in the 1930s to interfere with the fulfillment of his art. Even when he loaded the surface with purely decorative space-fillers, his new will to illustrative expressiveness made it almost a matter of doctrine that he shun a "merely" decorative unity. That the distinction between the purely decorative and the pictorial had already been deprived of much of its old force by Matisse, and by Picasso's own Cubism, made no difference. Picasso refused to draw the lessons of his own experience. Matisse did: in the last years of his life, while remaining just as dependent on the alphabet of nature as Picasso, he arranged leaf motifs in huge and apparently sheerly decorative panels that, as *pictures*, surpass almost anything else done in Europe since the thirties. Picasso, trying to turn decoration too much against itself—notably in his Matisse-influenced works of the early thirties—succumbed in the end to unities whose real impact, if not their intended one, was truly decorative in the pejorative sense.

Before *Guernica,* Picasso had tried to compel an essentially decorative flatness or shallowness, and an almost equally decorative rectilinear and curvilinear regularity of design, to transcend themselves by carrying out illustrative functions: everything in the picture had to be assignable to a source in nature, even if that source were only an invented wallpaper pattern. But the ornamental power of the arabesques of the

female figure he painted repeatedly in the early thirties was such as to require for its full realization a break with nature, on behalf of the flat surface, almost as radical as that which Miró had already made in the late twenties. It is mainly because he rejected this break that Picasso's more ambitious paintings of the early thirties fall short of conclusive success. For one thing, the decorative treatment of the human physiognomy generates rococo associations that no amount of abstract rightness can now overcome. It is no accident that in the later painting of both Picasso and Matisse, full success comes much oftener, on almost any level, when the human figure is absent—or when, given its presence, the features of the face are omitted or alluded to only schematically (with Matisse even this tended to be too much).

Guernica is the last major turning point in the evolution of Picasso's art. Bulging and buckling as it does, this huge painting reminds one of a battle scene from a pediment that has been flattened under a defective steam-roller. It is as though it had been conceived within an illusion of space deeper than that in which it was actually executed. The preliminary studies for *Guernica* bear out this impression, being much more illusionistic than the completed picture. The composition studies in particular (and most particularly two done in pencil on gesso, dated May 1 and 2, respectively) are far more convincing simply as compositions, for all their naturalism, than the final version with its welter of flat blacks, grays and whites. And the exclusively linear first state of even the final version is much more successful, so far as one can tell from photographs, than any of the later stages it went through.

It is as if Picasso became aware of the nature of the difficulties he had faced in *Guernica*, for in 1938 he overhauled his style in an effort to loosen up Cubist space. Since then he has kept his backgrounds more distinctly separated from the shapes in front of them, and he has tended to compromise more between those distortions which are compelled by the pressure of shallow space and those which are solely illustrative and

65

expressionistic. This has had the consequence, however, of making form and expression diverge more than ever. Now Cubist design and articulation seem to be added on to, and not to coincide with, the original impulse of the picture. The decorative intervenes once again in its inferior sense.

The decorative (as Matisse has eminently shown us) can transcend this sense when it conveys a *vision*, but not when it is merely a question of handling, which is what the decorative has largely become for Picasso. And his Cubism, too, once the incarnation of a vision in which many things that were otherwise quintessentially decorative were able to attain a maximum of expressiveness, has degenerated for him into a mere question of treatment. Now he seeks expression as an *escape* from Cubism, as a *relief* from it; yet he continues to finish his paintings in its terms, which have become those of something applied rather than inspired.

Applied Cubism, Cubism as finish, acts to convert the picture into a decorated object. One feels the picture rectangle as something into which shapes and colors have been jammed— neatly or not, as the case may be, but always by an effort of uninspired will. This is true even—and perhaps particularly —of the relatively large black-and-white *Kitchen* (1948), the most adventurous as well as the most abstract work of Picasso I know of (except for a 1926 series of untitled dot-and-line drawings, to which *The Kitchen* itself is not unrelated). *The Kitchen* is, to the best of my knowledge, the strongest and most interesting oil painting he has executed since 1938, or even earlier—not because it is the most abstract, but because the great liberties it takes with nature are almost entirely in the interest of the free unity and resonance of the whole. Yet this picture still betrays a slightly disturbing deliberateness, a heavy exactness; and the tightness and weight with which its four sides grip its exclusively linear physiognomy make for a boxed-in, over-enclosed effect. Also, it is as if every trace of immediate

creation had been edited out of this work in order to render it a more finished and self-contained *object*.[1]

"Object" is exactly the word. Modernist pictorial art, with its more explicit decorativeness, calls more attention to the immediate physical qualities of painting. But like any other kind of picture, the modernist one still assumes that its identity as a picture shuts out awareness of its identity as an object. Otherwise it becomes, at best, sculpture; at worst, a *mere* object. Picasso is as alive to this problem as any one has ever been, but apparently he can no longer help himself: he is committed to a notion of painting that leaves nothing further to explore—a notion which rests on a set of conventions that restrict, rather than liberate, inventiveness. Inspiration, and the spontaneity that goes with it, can no longer enter effectively into the unifying conception of a work, but are confined to nuances, trimmings, elaborations. The picture gets itself finished, in principle, before it is started; and in its actual finishing, it becomes a replica of itself. All difficulties turn into difficulties of craft, to be solved by craftsmanship. And with craftsmanship, the idea of *object* forces itself all the more to the fore: the idea of polishing, tooling and finishing, and the idea, above all, of the expected.

The satisfaction to be gotten from even the best of Picasso's post-1938 paintings is adulterated, for the most part, by the expectedness of their conceptions. It is derived too much from the virtuosity of handling, whether toward crabbedness or grace, which expectedness leaves room for. The three beautifully Matissean paintings of 1956: *Woman in Rocking Chair, The Studio* and *Woman by a Window*; the almost great Lamlike version "L" and the solidly Picassoid version "N" in the 1955 *Women of Algiers* series; a 1946 gouache, *Pastoral*—all these are brilliant, but with a brilliance that smacks too much of the performed and the made. (Nor is "brilliant" a word we

[1] *The Kitchen* reminds me very much of the "pictographs" that Adolph Gottlieb, the American painter, used to make. Picasso is said to have been much struck by reproductions of these that he saw in 1948.

67

really like to apply to great art. That it comes so readily to mind here is significant in itself.) And the faults of certain other post-1938 paintings that just miss success are too evidently mistakes of performance, or errors of craft, rather than faults of *creation*. This is true, for example, of the unfortunate reds in *Woman in Green* (1943) and the cartoon-like obtrusiveness of the profiled head of the seated figure in *Serenade* (1942). The earlier Picasso could not be taken apart so easily.

Picasso has, or had, the makings of a formidable sculptor, and he has produced some of the greatest as well as most revolutionary sculpture of this century. It is possible to think that a greater commitment to this medium might have solved his crisis in the 1930s, if only because diagrammatic fidelity to nature would have cost him less in a less illusionistic medium. Perhaps the decision did hang in the balance for a while. Kahnweiler says (as quoted in Edgar's and Maillard's book on Picasso): "In 1929 he was thinking of huge monuments which could be both houses for living in and enormous sculptures of women's heads, and which could be set up along the Mediterranean coast; 'I have to be content with painting them, because nobody will give me a commission for one,' he tells me." Whatever one might conclude from this about the nature of Picasso's will to sculpture, the fact remains that he has never devoted himself to it for very long periods.

After 1931 he abandoned the quasi-Constructivist direction to which his ventures in sculpture had been confined since 1912 and returned to modeling and the monolith—as if that were more in harmony with the general yearning for a grand manner he had begun to feel at that time. Significantly, it was only then, ten years after they had entered his painting, that archaizing tendencies first entered his sculpture—and this delayed entrance may help explain why Picasso continued to be a completely successful sculptor for ten years after he ceased to be a completely successful painter. During most of the thirties, his work in the round was as fertile in invention, and also as problematic, as his painting during those same years;

68

and it had a similar influence. Then, at about the same time that the level of aspiration of his painting dropped, that of his sculpture did too. Perhaps it dropped even further. Nothing in his painting strikes me as being quite so forced or pretentious as some of the larger bronzes he has done within the last twenty years. (The tallest figure in *The Bathers* of 1958, on the other hand, is a stronger work than any picture he has made within that time.)

Just as he has rarely been able to use color positively, and just as he lacks feeling for the texture of paint, so Picasso has always lacked "touch," a sense of surface, in sculpture. But just as he was able for a long time to make color serve his purpose negatively, so he was able to discount his lack of tactile feeling in sculpture by "drawing in air"—that is, by constructing instead of modeling or carving. Only when he began to try for sculpture on the antique and Rodinesque pattern—and, in his painting, for color that was positive like Matisse's—did he begin to lead to his weaknesses instead of his strengths.

Perhaps Picasso has succumbed to the myth of himself that too many of his admirers have propagated: that he is a demi-god who can do anything and therefore is not entitled to weaknesses. But whether he is or is not taken in by this, the more likely explanation is that he has succumbed to the ordinary limitations of human activity and existence. Though less a prisoner of his first maturity than most people are, Picasso remains such a prisoner nonetheless—much more of one than Matisse was. *Time* reports that "he believes a work should be constructed, is distressed by the work of many abstract expressionists, once grabbed an ink-stained blotter, shoved it at a visitor and snapped 'Jackson Pollock!'" The term "constructed"—which has proved to be a highly relative one in art—was the slogan under which the Cubists set out fifty years ago to repair the supposed damage done to painting by the Impressionists.

1957

Collage

Collage was a major turning point in the evolution of Cubism, and therefore a major turning point in the whole evolution of modernist art in this century. Who invented collage—Braque or Picasso—and when is still not settled. Both artists left most of the work they did between 1907 and 1914 undated as well as unsigned; and each claims, or implies the claim, that his was the first collage of all. That Picasso dates his, in retrospect, almost a year earlier than Braque's compounds the difficulty. Nor does the internal or stylistic evidence help enough, given that the interpretation of Cubism is still on a rudimentary level.

The question of priority is much less important, however, than that of the motives which first induced either artist to paste or glue a piece of extraneous material to the surface of a picture. About this, neither Braque nor Picasso has made himself at all clear. The writers who have tried to explain their intentions for them speak, with an unanimity that is suspect in itself, of the need for renewed contact with "reality" in face of the growing abstractness of Analytical Cubism. But the term "reality," always ambiguous when used in connection with art, has never been used more ambiguously than here. A piece of imitation-woodgrain wallpaper is not more "real" under any definition, or closer to nature, than a painted simulation of it; nor is wallpaper, oilcloth, newspaper or wood more "real," or closer to nature, than paint on canvas. And even if these materials were more "real," the question would still be begged, for "reality" would still explain next to nothing about the actual *appearance* of the Cubist collage.

There is no question but that Braque and Picasso were concerned, in their Cubism, with holding on to painting as an

art of representation and illusion. But at first they were more crucially concerned, in and through their Cubism, with obtaining *sculptural* results by strictly nonsculptural means; that is, with finding for every aspect of three-dimensional vision an explicitly two-dimensional equivalent, regardless of how much verisimilitude might suffer in the process. Painting had to spell out, rather than pretend to deny, the physical fact that it was flat, even though at the same time it had to overcome this proclaimed flatness as an aesthetic fact and continue to report nature.

Neither Braque nor Picasso set himself this program in advance. It emerged, rather, as something implicit and inevitable in the course of their joint effort to fill out that vision of a "purer" pictorial art which they had glimpsed in Cézanne, from whom they also took their means. These means, as well as the vision, imposed their logic; and the direction of that logic became completely clear in 1911, the fourth year of Picasso's and Braque's Cubism, along with certain contradictions latent in the Cézannian vision itself.

By that time, flatness had not only invaded but was threatening to swamp the Cubist picture. The little facet-planes into which Braque and Picasso were dissecting everything visible now all lay parallel to the picture plane. They were no longer controlled, either in drawing or in placing, by linear or even scalar perspective. Each facet tended to be shaded, moreover, as an independent unit, with no legato passages, no unbroken tracts of value gradation on its open side, to join it to adjacent facet-planes. At the same time, shading had itself been atomized into flecks of light and dark that could no longer be concentrated upon the edges of shapes with enough modeling force to turn these convincingly into depth. Light and dark in general had begun to act more immediately as cadences of design than as plastic description or definition. The main problem at this juncture became to keep the "inside" of the picture—its content—from fusing with the "outside"—its literal surface. *Depicted* flatness—that is, the facet-planes—had to be

kept separate enough from *literal* flatness to permit a minimal illusion of three-dimensional space to survive between the two.

Braque had already been made uncomfortable by the contraction of illusioned space in his pictures of 1910. The expedient he had then hit upon was to insert a conventional, *trompe-l'-oeil* suggestion of deep space *on top* of Cubist flatness, between the depicted planes and the spectator's eye. The very un-Cubist graphic tack-with-a-cast-shadow, shown transfixing the top of a 1910 painting, *Still Life with Violin and Pitcher,* suggests deep space in a token way, and destroys the surface in a token way. The Cubist forms are converted into the illusion of a picture within a picture. In the *Man with a Guitar* of early 1911 (in the Museum of Modern Art), the line-drawn tassel-and-stud in the upper left margin is a similar token. The effect, as distinct from the signification, is in both cases very discreet and inconspicuous. Plastically, spatially, neither the tack nor the tassel-and-stud *acts* upon the picture; each suggests illusion without making it really present.

Early in 1911, Braque was already casting around for ways of reinforcing, or rather supplementing, this suggestion, but still without introducing anything that would become more than a token. It was then, apparently, that he discovered that *trompe-l'oeil* could be used to undeceive as well as to deceive the eye. It could be used, that is, to declare as well as to deny the actual surface. If the actuality of the surface—its real, physical flatness—could be indicated explicitly enough in certain places, it would be distinguished and separated from everything else the surface contained. Once the literal nature of the *support* was advertised, whatever upon it was not intended literally would be set off and enhanced in its nonliteralness. Or to put it in still another way: depicted flatness would inhabit at least the semblance of a semblance of three-dimensional space as long as the brute, undepicted flatness of the literal surface was pointed to as being still flatter.

The first and, until the advent of pasted paper, the most important device that Braque discovered for indicating and

separating the surface was imitation printing, which automatically evokes a literal flatness. Block letters are seen in one of his 1910 paintings, *The Match Holder;* but being done rather sketchily, and slanting into depth along with the depicted surface that bears them, they merely allude to, rather than state, the literal surface. Only in the next year are block capitals, along with lower-case letters and numerals, introduced in exact simulation of printing and stenciling, in absolute frontality and outside the representational context of the picture. Wherever this printing appears, it stops the eye at the literal plane, just as the artist's signature would. By force of contrast alone—for wherever the literal surface is not explicitly stated, it seems implicitly denied—everything else is thrust back into at least a memory of deep or plastic space. It is the old device of the *repoussoir,* but taken a step further: instead of being used to push an illusioned middleground farther away from an illusioned foreground, the imitation printing spells out the real paint surface and thereby pries it away from the illusion of depth.

The eye-undeceiving *trompe-l'oeil* of simulated typography supplements, rather than replaces, the conventional eye-deceiving kind. Another literally and graphically rendered tassel-and-stud imbeds flattened forms in token depth in Braque's *Portuguese* (1911), but this time the brute reality of the surface, as asserted by stenciled letters and numerals, closes over both the token illusion of depth and the Cubist configurations like the lid on a box. Sealed between two parallel flatnesses—the depicted Cubist flatness and the literal flatness of the paint surface—the illusion is made a little more present but, at the same time, even more ambiguous. As one looks, the stenciled letters and numerals change places in depth with the tassel-and-stud, and the physical surface itself becomes part of the illusion for an instant: it seems pulled back into depth along with the stenciling, so that once again the picture plane seems to be annihilated—but only for the fraction of another instant. The abiding effect is of a constant shuttling between surface

73

and depth, in which the depicted flatness is "infected" by the undepicted. Rather than being deceived, the eye is puzzled; instead of seeing objects in space, it sees nothing more than —a picture.

Through 1911 and 1912, as the Cubist facet-plane's tendency to adhere to the literal surface became harder and harder to deny, the task of keeping the surface at arm's length fell all the more to eye-undeceiving contrivances. To reinforce, and sometimes to replace, the simulated typography, Braque and Picasso began to mix sand and other foreign substances with their paint; the granular texture thus created likewise called attention to the reality of the surface and was effective over much larger areas. In certain other pictures, however, Braque began to paint areas in exact simulation of wood graining or marbleizing. These areas by virtue of their abrupt density of pattern, stated the literal surface with such new and superior force that the resulting contrast drove the simulated printing into a depth from which it could be rescued—and set to shuttling again—only by conventional perspective; that is, by being placed in such relation to the forms depicted within the illusion that these forms left no room for the typography except near the surface.

The accumulation of such devices, however, soon had the effect of telescoping, even while separating, surface and depth. The process of flattening seemed inexorable, and it became necessary to emphasize the surface still further in order to prevent it from fusing with the illusion. It was for this reason, and no other that I can see, that in September 1912, Braque took the radical and revolutionary step of pasting actual pieces of imitation-woodgrain wallpaper to a drawing on paper, instead of trying to simulate its texture in paint. Picasso says that he himself had already made his first collage toward the end of 1911, when he glued a piece of imitation-caning oilcloth to a painting on canvas. It is true that his first collage looks more Analytical than Braque's, which would confirm the date he assigns it. But it is also true that Braque was the consistent

pioneer in the use of simulated textures as well as of typography; and moreover, he had already begun to broaden and simplify the facet-planes of Analytical Cubism as far back as the end of 1910.

When we examine what each master says was his first collage we see that much the same thing happens in each. (It makes no real difference that Braque's collage is on paper and eked out in charcoal, while Picasso's is on canvas and eked out in oil.) By its greater corporeal presence and its greater extraneousness, the affixed paper or cloth serves for a seeming moment to push everything else into a more vivid *idea* of depth than the simulated printing or simulated textures had ever done. But here again, the surface-declaring device both overshoots and falls short of its aim. For the illusion of depth created by the contrast between the affixed material and everything else gives way immediately to an illusion of forms in bas-relief, which gives way in turn, and with equal immediacy, to an illusion that seems to contain both—or neither.

Because of the size of the areas it covers, the pasted paper establishes undepicted flatness *bodily*, as more than an indication or sign. Literal flatness now tends to assert itself as the main event of the picture, and the device boomerangs: the illusion of depth is rendered even more precarious than before. Instead of isolating the literal flatness by specifying and circumscribing it, the pasted paper or cloth releases and spreads it, and the artist seems to have nothing left but this undepicted flatness with which to finish as well as start his picture. The actual surface becomes both ground and background, and it turns out—suddenly and paradoxically—that the only place left for a three-dimensional illusion is in *front* of, *upon*, the surface. In their very first collages, Braque and Picasso draw or paint *over* and *on* the affixed paper or cloth, so that certain of the principal features of their subjects *as depicted* seem to thrust out into real, bas-relief space—or to be about to do so—while the rest of the subject remains imbedded in, or flat upon, the

75

surface. And the surface is driven back, in its very surfaceness, only by this contrast.

In the upper center of Braque's first collage, *Fruit Dish* (in Douglas Cooper's collection), a bunch of grapes is rendered with such conventionally vivid sculptural effect as to lift it practically off the picture plane. The *trompe-l'oeil* illusion here is no longer enclosed between parallel flatnesses, but seems to thrust through the surface of the drawing paper and establish depth *on top* of it. Yet the violent immediacy of the wallpaper strips pasted to the paper, and the only lesser immediacy of block capitals that simulate window lettering, manage somehow to push the grape cluster back into place on the picture plane so that it does not "jump." At the same time, the wallpaper strips themselves seem to be pushed into depth by the lines and patches of shading charcoaled upon them, and by their placing in relation to the block capitals; and these capitals seem in turn to be pushed back by *their* placing, and by contrast with the corporeality of the woodgraining. Thus every part and plane of the picture keeps changing place in relative depth with every other part and plane; and it is as if the only stable relation left among the different parts of the picture is the ambivalent and ambiguous one that each has with the surface. And the same thing, more or less, can be said of the contents of Picasso's first collage.

In later collages of both masters, a variety of extraneous materials are used, sometimes in the same work, and almost always in conjunction with every other eye-deceiving and eye-undeceiving device they can think of. The area adjacent to one edge of a piece of affixed material—or simply of a painted-in form—will be shaded to pry that edge away from the surface, while something will be drawn, painted or even pasted over another part of the same shape to drive it back into depth. Planes defined as parallel to the surface also cut through it into real space, and a depth is suggested optically which is greater than that established pictorially. All this expands the

oscillation between surface and depth so as to encompass fictive space in front of the surface as well as behind it. Flatness may now monopolize everything, but it is a flatness become so ambiguous and expanded as to turn into illusion itself—at least an optical if not, properly speaking, a pictorial illusion. Depicted, Cubist flatness is now almost completely assimilated to the literal, undepicted kind, but at the same time it reacts upon and largely transforms the undepicted kind—and it does so, moreover, without depriving the latter of its literalness; rather, it underpins and reinforces that literalness, re-creates it.

Out of this re-created literalness, the Cubist subject re-emerged. For it had turned out, by a further paradox of Cubism, that the means to an illusion of depth and plasticity had now become widely divergent from the means of representation or imaging. In the Analytical phase of their Cubism, Braque and Picasso had not only had to minimize three-dimensionality simply in order to preserve it; they had also had to *generalize* it—to the point, finally, where the illusion of depth and relief became abstracted from specific three-dimensional entities and was rendered largely as the illusion of depth and relief *as such:* as a disembodied attribute and expropriated property detached from everything not itself. In order to be saved, plasticity had had to be isolated; and as the aspect of the subject was transposed into those clusters of more or less interchangeable and contour-obliterating facet-planes by which plasticity was isolated under the Cubist method, the subject itself became largely unrecognizable. Cubism, in its 1911-1912 phase (which the French, with justice, call "hermetic") was on the verge of abstract art.

It was then that Picasso and Braque were confronted with a unique dilemma: they had to choose *between* illusion and representation. If they opted for illusion, it could only be illusion per se—an illusion of depth, and of relief, so general and abstracted as to exclude the representation of individual ob-

jects. If, on the other hand, they opted for representation, it had to be representation per se—representation as image pure and simple, without connotations (at least, without more than schematic ones) of the three-dimensional space in which the objects represented originally existed. It was the collage that made the terms of this dilemma clear: the representational could be restored and preserved only on the flat and literal surface now that illusion and representation had become, for the first time, mutually exclusive alternatives.

In the end, Picasso and Braque plumped for the representational, and it would seem they did so deliberately. (This provides whatever real justification there is for the talk about "reality.") But the inner, formal logic of Cubism, as it worked itself out through the collage, had just as much to do with shaping their decision. When the smaller facet-planes of Analytical Cubism were placed upon or juxtaposed with the large, dense shapes formed by the affixed materials of the collage, they had to coalesce—become "synthesized"—into larger planar shapes themselves simply in order to maintain the integrity of the picture plane. Left in their previous atom-like smallness, they would have cut away too abruptly into depth; and the broad, opaque shapes of pasted paper would have been isolated in such a way as to make them jump out of plane. Large planes juxtaposed with other large planes tend to assert themselves as *independent* shapes, and to the extent that they are flat, they also assert themselves as silhouettes; and independent silhouettes are apt to coincide with the recognizable contours of the subject from which a picture starts (if it does start from a subject). It was because of this chain-reaction as much as for any other reason—that is, because of the growing independence of the planar unit in collage as a *shape*—that the identity of depicted objects, or at least parts of them, re-emerged in Braque's and Picasso's *papiers collés* and continued to remain more conspicuous there—but only as flattened silhouettes—than in any of their paintings done wholly in oil before the end of 1913.

Analytical Cubism came to an end in the collage, but not conclusively; nor did Synthetic Cubism fully begin there. Only when the collage had been exhaustively translated into oil, and transformed by this translation, did Cubism become an affair of positive color and flat, interlocking silhouettes whose legibility and placement created allusions to, if not the illusion of, unmistakable three-dimensional identities.

Synthetic Cubism began with Picasso alone, late in 1913 or early in 1914; this was the point at which he finally took the lead in Cubist innovation away from Braque, never again to relinquish it. But even before that, Picasso had glimpsed and entered, for a moment, a certain revolutionary path in which no one had preceded him. It was as though, in that instant, he had felt the flatness of collage as too constricting and had suddenly tried to escape all the way back—or forward— to literal three-dimensionality. This he did by using utterly literal means to carry the forward push of the collage (and of Cubism in general) *literally* into the literal space in front of the picture plane.

Some time in 1912, Picasso cut out and folded a piece of paper in the shape of a guitar; to this he glued and fitted other pieces of paper and four taut strings, thus creating a sequence of flat surfaces in real and sculptural space to which there clung only the vestige of a picture plane. The affixed elements of collage were extruded, as it were, and cut off from the literal pictorial surface to form a bas-relief. By this act he founded a new tradition and genre of sculpture, the one that came to be called "construction." Though construction-sculpture was freed long ago from strict bas-relief frontality, it has continued to be marked by its pictorial origins, so that the sculptor-constructor Gonzalez, Picasso's friend, could refer to it as the new art of "drawing in space"—that is, of manipulating two-dimensional forms in three-dimensional space. (Not only did Picasso found this "new" art with his paper guitar of 1912, but he went on, some years afterwards, to make some of the strongest as well as most germinative contributions to it.)

Neither Picasso nor Braque ever really returned to collage after 1914. The others who have taken it up have exploited it largely for its shock value, which collage had only incidentally —or even only accidentally—in the hands of its originators. There have been a few exceptions: Gris notably, but also Arp, Schwitters, Miró, E. L. T. Mesens, Dubuffet and, in this country, Robert Motherwell and Anne Ryan. In this context, Gris's example remains the most interesting and most instructive.

Braque and Picasso had obtained a new, self-transcending kind of decoration by reconstructing the picture surface with what had once been the means of its denial. Starting from illusion, they had arrived at a transfigured, almost abstract kind of literalness. With Gris it was the opposite. As he himself explained, he started out with abstract flat shapes, to which he then fitted recognizable images and emblems of three-dimensionality. And whereas Braque's and Picasso's subjects were dissected in three dimensions in the course of being transposed into two, Gris's first Cubist subjects tended—even before they were fitted into the picture, and as if preformed by its surface—to be analyzed in two-dimensional and purely decorative rhythms. It was only later that he became more aware of the fact that Cubism was not a question of decorative overlay and that the resonance of its surfaces derived from an abiding concern with plasticity and illusion which informed the very renunciation of plasticity and illusion.

In his collages almost more than anywhere else, we see Gris trying to solve the problems proposed by this fuller awareness. But his collages also show the extent to which his awareness remained incomplete. Because he continued to take the picture plane as given and therefore not needing to be re-created, Gris became perhaps too solicitous about the illusion. He used pasted paper and *trompe-l'oeil* textures and lettering to assert flatness, but he almost always completely sealed the flatness inside an illusion of conventional depth by allowing images rendered with relatively sculptural vividness to occupy,

unambiguously, too much of both the nearest and farthest planes.

Because he shaded and modeled more abundantly and tended to use more explicit color under his shading, Gris's collages seldom declare their surfaces as forthrightly as Picasso's and Braque's collages do. Their total *presence* is thus less immediate and has something about it of the removedness, the closed-off presence, of the traditional picture. And yet, because their decorative elements function to a greater extent solely as decoration, Gris's collages also seem more conventionally decorative. Instead of the seamless fusion of the decorative with the plastic that we get in Picasso and Braque, there is an alternation, a collocation, a mere juxtaposition of the two; and whenever this relation goes beyond juxtaposition, it leads more often to confusion than to fusion. Gris's collages have their merits, but only a few of them deserve the unqualified praise they have received.

But many of Gris's oils of 1915-1918 do deserve their praise. In all justice, it should be pointed out that his paintings of those years demonstrate, perhaps more clearly than anything by Braque or Picasso, something which is of the highest importance to Cubism and to the collage's effect upon it: namely, the liquidation of sculptural shading.

In Braque's and Picasso's very first *papiers collés,* shading stops being pointillist and suddenly becomes broad and incisive again, like the shapes it modifies. This change in shading also accounts for the bas-relief effects, or the velleities to bas-relief, of the first collages. But large patches of shading on a densely or emphatically patterned ground, such as woodgrain or newsprint, tend to take off on their own when their relation to the model in nature is not self-evident, just the way large planes do under the same circumstances. They abandon their sculptural function and become independent shapes constituted by blackness or grayness alone. Not only did this fact contribute further to the ambiguity of the collage's surface; it also

served further to reduce shading to a mere component of surface design and color scheme. When shading becomes that, all other colors become more purely *color*. It was in this way that positive color re-emerged in the collage—recapitulating, curiously enough, the way "pure" color had emerged in the first place for Manet and the Impressionists.

In Analytical Cubism, shading as shading had been divorced from specific shapes while retaining in principle the capacity to inflect generalized surfaces into depth. In collage, shading, though restored to specific shapes or silhouettes, lost its power to act as modeling because it became a specific shape in itself. This is how and why shading, as a means to illusion, disappeared from the collages of Braque and Picasso, and from their Cubism, never really to reappear. But it was left to Gris, in his pictures of 1915-1918, to elucidate this process and its consequences for all to see—and, in doing so, to produce, finally, triumphant art. Gris's Cubism in this period—which is almost as much Analytical as it is Synthetic—separated, fixed and immobilized, in oil on wood or canvas, some of the overlapping stages of the transformation that Cubism had already undergone in Braque's and Picasso's glued and pasted pictures. The cleanly and simply contoured solid black shapes on which Gris relied so much in these paintings represent fossilized shadows and fossilized patches of shading. All the value gradations are summed up in a single, ultimate value of flat, opaque black—a black that becomes a color as sonorous and pure as any spectrum color and that confers upon the silhouettes it fills an even greater weight than is possessed by the lighter-hued forms which these silhouettes are supposed to shade.

In this phase alone does Gris's art, in my opinion, sustain the main tenor of Cubism. Here, at last, his practice is so completely informed by a definite and steady vision that the details of execution take care of themselves. And here, at last, the decorative is transcended and transfigured, as it had already been in Picasso's, Braque's and Léger's art, in a monumental unity. This monumentality has little to do with size. (Early

and late, and whether in Picasso's hands or Braque's, Cubism has never lent itself with entire success to an outsize format. Even Léger's rather splendid big pictures of the late 1910s and early 1920s do not quite match the perfection of his smaller-scale Cubism of 1910-1914.) The monumentality of Cubism in the hands of its masters is more a question of a vision and attitude—an attitude toward the immediate physical means of pictorial art—thanks to which easel paintings and even "sketches" acquire the self-evident self-sufficiency of architecture. This is as true of the Cubist collage as of anything else in Cubism, and perhaps it is even truer of the collage than of anything else in Cubism.

1959

Georges Rouault

The taste which finds that the Cubists sacrificed feeling to "intellectualism" sees the redemption of modernist art in Rouault. Rouault looks like, and may even be, a remarkable phenomenon, but it ought to be clear by now that he is not a great or major artist. He is, on the contrary, a rather limited one who masks a conventional sensibility behind modernist effects, and a certain studiedness behind attitudes of spontaneity. I myself must confess a real distaste for the artistic personality I discern in his pictures, and I must also confess that I tend to suspect the unconscious motives of those who praise him. Only guilt about emotional impotence could make one accept uncritically such strident assertions of deep and intense feeling as his art makes.

Rouault takes few real chances. He methodically exploits complementary colors, and keeps the ostensible, strength-signifying rawness of his pigment well in hand under a formula of heavy black and umber lines. Interventions of black or brown (as well as gray), as most painters know, offer a safe way of guaranteeing the harmony of other colors. Rouault's real insecurity is further betrayed by his habitually dead-centered and symmetrical design, which contributes—though it need not—to what even some of his admirers will agree is the repetitiousness of his art.

He did his best work in his thirties, when he confided his *fougue* to more tenuous mediums like water color, gouache, pastel and oil on paper. A paper or cardboard support makes it difficult to work over and "finish" the result, hence elicits the most of whatever freshness the artist's conception has in it—provided he does not let himself become facile enough on paper to form a hard and fast manner (as so many Anglo-Saxon

water-colorists have done). Some of the nudes Rouault painted in water color before the 1914 war have real quality, especially when they stay close to nature. We notice only that his sense of surface pattern is fundamentally more academic than Daumier's, not to mention Degas', by both of whom he was then much influenced.

Around 1913, when Rouault applied himself in a consistent way to putting the weight of oil on canvas, his interest in paint texture increased. It was then that the thick, compartmentalizing lines that section off the human anatomy first appear in his pictures—in answer, perhaps, as James Thrall Soby suggests, to the influence of Cubism. Interpenetrating layers of viscous paint begin to emphasize the surface in a declamatory way. Rouault seemed to be settling the conflict between pattern and illusion in favor of the immediate, sensuous effect of the former—but it was only seeming. The unifying conception of the picture remains oriented toward a standard illusion in depth, and the result, for all its ornamental accents, remains essentially conventional in the in-and-out movement of its lights and darks, and in the obviousness with which the subject is illustrated.

His art evolves very little after 1916, under its apparent changes of mood. But lack of evolution is not all there is to the impression of repetitiousness. It is also that Rouault's manner seems to have a life independent of the subjects to which it is applied. We come away remembering *paint* instead of single pictures. This does not make it any the less a fact that paint is the weakest side of Rouault's art—a diagnosis borne out by the considerable improvement displayed by those of his canvases which have been translated into tapestry, where such strength of design as they have comes through more lucidly—and less decoratively.

It develops that this passionate, selfless religious artist is really a narrow virtuoso who favors a certain kind of content mainly for the sake of style—unlike Matisse and Picasso and Mondrian, who work at style in order to *achieve* content.

Rouault's subjects are as exhibited and as explicit as they are because they must support, and force, a manner. That Rouault, pictorial exponent of the pornographic, sadomasochistic, "avant-garde" Catholicism of Léon Bloy, should be hailed as the one profoundly religious painter of our time is one of the embarrassments of modernist art. And the fact that Bloy himself rejected Rouault's art in its earliest mature phase—which was all he knew of it before his death—makes no difference. "Profound" that art remains—and "profundity" is the term that gets associated with religiosity in these days, like a guarantee. Religion may not put one "in the truth," but it is the surest way of attaining depth. However, as the philosopher Edmund Husserl once said, "Profundity may be chaos."

1945

Braque

It has not become clear yet whether the decisive initiatives in the first years of Cubism belonged to Braque or Picasso. They themselves are not altogether trustworthy in the dating, mostly retrospective, of the works they did at that time. Braque appears to have been the first to introduce *trompe-l'oeil,* sanded paint and collage, but Picasso appears to have taken the lead more often in matters of fundamental approach. I have the impression, at any rate, that by the end of 1913 Braque was already beginning to lose some of that certainty which had enabled him, along with Picasso, to produce an almost uninterrupted succession of masterpieces, large and small, in the three previous years. Picasso retained this certainty for another decade and more, and continued to be enterprising for an even longer time. Only for a moment did his hand waver before the mid-twenties—in some of his first brightly colored Synthetic Cubist still lifes, painted in the summer of 1914, which are, despite their greater originality, inferior in sheer quality to what Braque was doing at the same time.

Picasso says that his relations with Braque and Derain were never the same again after the latter two went off to war in August 1914. But we also hear that he had had a quarrel with Braque shortly before that, and certainly they have been rather cool to one another in all the years since then. Braque was wounded in May 1915 and mustered out of the army a little more than a year later. When he resumed painting he was no longer a leader of Cubism and had to orient himself at first by accepting (as Henry Hope says) the influence of Gris, whom he himself had led—and at what a distance!—before the war. Meanwhile Picasso had been able to continue working in Paris, and in 1915 and 1916 had done some of the strongest

and most original things of his Synthetic Cubist phase, pictures in bright colors, and broadly and simplifiedly geometrical in design.

Whether or not it was the war that made the real difference in Braque's subsequent development—or lack of it—we shall never be able to tell. Inventiveness does seem to have abandoned him after that, and from then on he does follow Picasso's lead more or less. When Picasso began doing still lifes in a less abstract way, Braque, as well as Gris, began doing them in that way too. When Picasso drew some schematized and rather expressionistic nudes, Braque again followed suit, at an interval of a few years. When, after 1930 or 1931, Picasso went in for Baroque design and sumptuous color, Braque could be seen trying to do something similar a short while later. Not that he followed Picasso abjectly; his sensibility, aside from the fact that he always has had a better command of color and of paint quality than Picasso, has remained more independent than his style itself. But between the two wars he did tend to rely on Picasso for cues, and during that period he did usually fall short of Picasso in power and originality, if not always in felicity.

All this the big Braque retrospective at the Museum of Modern Art (in late Spring 1949) seemed to make quite clear. From the high plateau of three ravishing early Cubist paintings —*Still Life with Violin and Pitcher* (1909-1910) and especially the gray and silvery-white *Portuguese* and *Man with Guitar* (1911)—and the very pure and monumental collages of 1912, 1913 and 1914, there is a steady decline—through a series of smallish still lifes in dark tones that started in 1917—until 1928. In that year Braque makes a pronounced recovery with a succession of larger and higher-keyed vertically oriented still lifes, of great magnificence, which take off from an idea first stated by Picasso in the early twenties. He continues unevenly in this vein through the early thirties, after which decline sets in again. And as before, it makes itself particularly evident in faults that pertain to the *distribution,* as distinct from specific han-

dling, of color—blacks, for instance, will deaden a picture, not because they are black, but because they are spread over too large areas.

In all these years Braque's main subject remains the still life, whereas Picasso's far broader repertory corresponds to the greater breadth of his invention. Braque remains more consistently and literally a Cubist throughout, under the common conception of Cubism arrived at in the early twenties by Picasso, Gris and Léger, as well as by himself. This Cubism, the final fruit of its Synthetic phase, is a canon enjoining trued, quasi-geometrical drawing, earth colors and interlocked and overlapping silhouettes. Picasso, while remaining no less essentially a Cubist, takes greater liberties with this canon than any of the others except Léger; whereas Braque, as Bernard Dorival has pointed out, becomes humbler, more conscious of his personal limitations, and infinitely less impatient with those dictated by the temper of the time.

But has Braque's respect for his own limitations been altogether the same thing as loyalty to himself? Since the early thirties he has followed the course of an artist in a period of decadence, when personal gifts are no longer borne up and extended by the circulation of new ideas and new challenges, and when the work of art (and especially of visual art) tends to become a luxury article. Yet the period has not really been that decadent, not as decadent by far as the kind of art Braque turned out in the late thirties and the forties, when he tried to go back almost beyond Cubism to something like Bonnard's and Vuillard's Late Impressionism, in search of a kind of charm and ornateness not rightly his.

There are those who would explain Braque's decline, as they would not Picasso's, by deficiencies already perceptible in his earlier works—in his Fauve and even High Cubist periods. Perhaps. But how, on the other hand, explain those sudden flashes of invention and prophecy that come in certain hallucinatory smallish landscapes, figure paintings and still lifes of the early fifties, to unsettle one's whole idea of Braque?

89

These broadly and emphatically treated pictures, murky yet pungent in color, adumbrate new and very un-Cubist ideas of design as well as of color, ideas that are more original and also more relevant than anything discoverable in Picasso since 1939. They demonstrate how radically independent Braque has it somewhere in himself to be. And yet these pictures—which come closer to "abstract expressionism" than to anything else— remain only flashes: fugitive and haphazard somehow in their realization, as if sensibility and craft could not do justice to the message received from imagination.

One wonders whether Braque's loyalty to Cubism has not deprived him in the long run of more than it gave. He may have remained more recognizably a Cubist than Picasso in recent years, but the latter is the one to whose gift Cubism seems always to have been more congenial. Picasso has the native equipment of a sculptor-draftsman; Braque, that of a colorist and paint-handler—and landscapist. Had he been able to break with the Cubist canon, who knows but that he might not have gone on toward a "purer," more painterly painting that harked back to his Fauvism: a kind of painting whose painterliness would have been structural and organic, not merely laid on, as it is in pictures like *The Stove* or even the *Billiard Table*. We can ask whether Braque has not misunderstood himself since 1914.

1949
1956

Marc Chagall

The large retrospective exhibition of Marc Chagall's art at the Museum of Modern Art (Spring 1946) makes it clear that his natural endowment, if not his actual accomplishment, enrolls him among the very great artists of our time. Some become painters by controlling or deflecting their gifts—and even attain greatness—but Chagall was born into paint, into the canvas, into the picture, with his clumsiness and all.

The earliest paintings in the show, executed before 1910—under the influence, it seems to me, of German Expressionism and Munich—establish what remains narrowly and distinctively Chagall's color. The first picture to establish his style, however, is *The Wedding* (1910)—one of the best works in the entire exhibition, for all its maladroitness—which already reveals the dominating influence of Cubism, then hardly born. Henceforth, Chagall's development is synchronized with that of the School of Paris. Cubism gives him his style, his plastic conception, his aesthetic discipline, and the effects of Cubism remain even when all visible sign of it seems to have disappeared. Matisse, in the course of time, teaches him how to unify his color. But Chagall clings to the dark-and-light modeling of Cubism even when his color is purest, flattest and most immediate; rectilinear in his earlier and best pictures, this modeling changes later into soft undulations of warm and cool color along the axes of volumes and planes. And in his most recent paintings there still linger ghostly traces of those patterns of right-angled, open triangles, cutting across volumes and space, that more conspicuously governed his design in the beginning. Chagall is original in his plastic conceptions as well as his iconography, but he is unthinkable without Cubism.

He understands Picasso and Matisse much better than do all

the other non-Latin emulators of the School of Paris contemporary with him. Together with Mondrian, Chagall furnishes the best evidence of the School of Paris' capacity to assimilate foreign strains of no matter what provenance, and enrich and realize them.

Chagall's strongest work and his greatest frequency of success came between 1910 and 1920, the period in which Matisse, Picasso, Braque and Gris were also at their peak. A new conception of reality and a new accumulation of creative energy, opened up and progressively organized since 1900, had on the eve of the First World War ripened into a great historic style that decisively reversed the direction of Western pictorial art. The premise of illusion and representation was canceled out, and it was asserted that the genesis and process of the work of art were what was to be most prominently offered to the spectator's attention.

Since this aesthetic repudiated finish, polish, surface grace, Chagall's initial clumsiness became in this period a factor to be capitalized upon. And indeed the frank and unconcerned exposure of his *gaucherie* was an element indispensable to the power of the paintings of his best period. Coarse surfaces, caked paint, crude design in crisscrosses and diamonds, glaring contrasts of harsh and silky, of black or earth tones with complementary primaries—all these added up to virtue, just as a similar if lesser clumsiness in the same time and place added up to the grace of Juan Gris.

Chagall's clumsiness was in part a function of his situation, balanced as he was between the culture that had formed him as an individual and that which was shaping his art. Ease and facility are attained either by growing up inside the dominant culture or, if you are an immigrant to it, by surrendering and denying yourself without reserve. If you are an East European in Paris, and if you remain one no matter what sort of art you practice, then you are committed to errors of taste—good and bad errors alike. Chagall abounds in both. His "surnaturalism," with its dislocation of gravity, anatomy and opac-

ity, is, like the early coarseness of his *métier,* an error all to the good, though it might have struck the first observers as excessively declamatory and theatrical. But Chagall was also capable of knocking off post-card views and snapshots of romantic couples under the illusion, apparently, that these constituted lyric poetry in the approved Western manner. And the provincial and gifted quaintness of these post cards—whose spirit is so surprisingly in harmony with the commercial ones of that period—only reinforces their bad taste.

In the 1920s, Chagall set himself to assimilating French cuisine and suavity with the obsessiveness of a clumsy and sentimental man learning to dance. He overcame the provincial harshness that had once been such an asset. He polished, softened and refined his art; and at the same time, he sentimentalized and prettified it—relatively. By this time he was sophisticated enough to avoid bad taste. And yet in spite of the many beautiful paintings in royal blue, red, green, pink and white— the still lifes that a sweeter Matisse could have painted, and the bridal couples hovering in luscious bouquets—Chagall has never recompensed himself with anything nearly as valuable as the roughness he sacrificed. His painting ceased to be an adventure in the sense that Picasso's and even Matisse's still are; it settled down to a routine on the order of Segonzac's, Vlaminck's, Derain's, Utrillo's.

However, it must be pointed out in partial excuse for Chagall that he was also the victim of a general tendency that overtook many other masters of the School of Paris after 1925 or so. At that moment Picasso too became softer and somewhat disoriented; Braque began to repeat himself with increasing "sweetness"; Matisse, as his influence spread, took to recapitulating his past; even Gris, before he died in 1927, had toned down his initial vigor; and Léger, becoming more and more eclectic, was departing from the high standard he had set in such canvases as *La ville* and *Le grand déjeuner.* (Bonnard, Mondrian and Miró, however, continued to progress.) The heroic age of modern art was over; its heroes had come to

93

terms with the pessimistic hedonism then reigning in society itself, and the younger aspirants of the School of Paris had turned to Surrealism and Neo-Romanticism. Chagall was simply part of the general phenomenon. But like Chirico in those same years, he went in for "paint quality" in addition to poetry.

The large *White Crucifixion* (1939) and *The Cello Player* (1939) are strong pictures—particularly the latter—and the more recent *Revolution* (not in this 1946 show) demonstrates an amazing unity. But the bulk of Chagall's later production suffers chronically from the lack of concentration and pressure. We are given painterly qualities, but not whole works of art, not intense unities that start from *an* experience rather than from experience in general and subordinate all general qualities to the total particular impression.

In the last analysis Chagall's accomplishment is incommensurate with his truly enormous gifts. Even in his earlier and best phase he failed to deliver himself of rounded, final, conclusive statements. His masterpieces, unlike many of Matisse's, Picasso's and Gris's of the same period, leave something still to be said in their own terms; either they lack ultimate and inevitable unity, or else they achieve it only by a relaxation of level, by academic softening.

Chagall's early maladroitness, at the same time that it signified power, represented something impure—he went too far in emphasizing the uniqueness of his personality and he did not know at what point to humble himself and modify and discipline his expression so that it might become eligible to take its place in the social order called beauty. After a time the artist has to stop saying: "Take me as I am." But even in his "sweet" period Chagall could not stop saying it—could not stop asking us to take sheer unorganized quality as works of art.

So much for his painting. His work in black and white is another story. Chagall is altogether great in his etchings and drypoints, a master for the ages in the way he places his drawings on the page and distributes his darks and lights. Here

his unpurged academicism stands him in good stead; nor is awkwardness any longer a necessary concomitant of the force of his personality. Here his work emerges fresh, pure—and humble. Its passionate severity, its willingness to accept discipline have no parallel in his oils. It may be in part because the black-and-white medium depends on a tradition which Chagall understands more instinctively than he does the tradition of Western painting—of the latter he has in general too operatic a notion.

It must not be forgotten that when Chagall first came to Paris he had to assimilate the past and present of Western painting simultaneously, whereas he was already familiar with the past of graphic art through reproductions. And also, black and white has, since Impressionism, always remained somewhat behind painting and therefore more responsive to academic tendencies. The revolution of post-Impressionism was necessary to enable Chagall to publish his genius as a *Maler*, but no revolution at all was needed to prepare his way as a draftsman in black and white.

In any case and in spite of all reservations, Chagall's art remains a feat, in oil as well as in black and white. That a man from the Jewish enclave in the provinces of Eastern Europe should have so quickly and so genuinely absorbed and transformed Parisian painting into an art all his own—and one that retains the mark of the historically remote culture from which he stems—that is an heroic feat which belongs to the heroic age of modern art.

1946

Master Léger

For a while Léger was overlooked. The conscious preoccupations of the younger New York painters during the 1940s were with other modernist masters. And then, so few of his 1910-1913 pictures were known. He was over here during most of the war, and what he showed us at that time was not impressive. Nor—but let this be said to his credit—did he try to impress us with his personality. Now we begin to know better. Léger's full-scale retrospective at the Museum of Modern Art (Fall 1953) reveals him as a major fountainhead of contemporary style, along with Matisse, Picasso and Mondrian.

The sequence of promise, fulfillment and decline that the exhibition unfolds is much like that which we already saw in the Matisse, Picasso and Braque retrospectives at the Museum of Modern Art, and the dates likewise site the chronological contour lines of ambitious painting in Paris over the last fifty years. Fulfillment came for Matisse between 1910 and 1920; for Braque between 1910 and 1914; for both Picasso and Léger between 1910 and 1925. None of the four was ever, before and after these years, as consistent in quality and seldom as high.

Michel Seuphor calls 1912 "perhaps the most beautiful date in the whole history of painting in France." That was the great year for Cubism. And Léger was one of the three artists who led Cubism, even if he did not paint with "cubes." The year 1913 was another "beautiful" date, perhaps even more so for him, if not for Picasso or Braque. In 1914, Léger went to war, and the few paintings he finished while in the army are rather faltering, if not exactly uninteresting. He regained his level as soon as he had the chance to work regularly again, and the works he turned out from 1917 until at least 1922 are just as original as those done before 1914, and perhaps even more

seminal, even if they do not quite come up to the pure, the utter finality, the poised strength of his 1911-1913 work—just as Picasso's art between 1914 and 1925, while manifesting a new kind of perfection, rarely attains the transcendent, clarified kind it knew before.

The four years from the middle of 1910 to the middle of 1914 were the special ones then. But just what made them that? A trio of geniuses—Picasso, Braque, Léger—born within a year of one another, were then in their early thirties; Matisse, approaching his peak, was already in his forties. More of the answer may be given by something that lay outside biographical circumstance. In France as elsewhere, the generation of the avant-garde that came of age after 1900 was the first to accept the modern, industrializing world with enthusiasm. Even poets—thus Apollinaire—saw, at least for a moment, aesthetic possibilities in a streamlined future, a vaulting modernity. A mood of secular optimism replaced the secular pessimism of the Symbolist generation. Here, for once, the avant-garde had been anticipated by the philistines, even though it proceeded to draw aesthetic conclusions at which the philistines balked. Yeats, Joyce, Eliot, Proust, Mann, Valéry, Rilke, George, Hofmannsthal, Kafka, Stravinsky, Schönberg, Wright, Gropius, Mies van der Rohe, Freud, Dewey, Wittgenstein, Husserl, Russell, Einstein—all developed or matured in the years of that mood, which supported and encouraged even those who rejected, or professed to reject, it. Professional tradition in painting, having long been distinctively secular (what great painter after El Greco was a fundamentally religious man?), now received new, and perhaps special, confirmation from its public.

Thus, it was that one of the greatest of all moments in painting arrived on the crest of a mood of "materialistic" optimism. And of all the optimists, materialists and yea-sayers, none was more whole-heartedly all these things than Fernand Léger. He has told us about, as well as shown us, his enthusiasm for machine forms; but we also see in his art all the ab-

stract qualities that are conventionally associated with "materialism": weight, excessive looseness or else excessive rigidity of form, crassness, simplicity, complacency, even a certain obtuseness—and yet how much else that redeems and exploits these qualities. Léger's art has, for the time being, succeeded better than any other, I daresay, in making the rawness and inertness of matter wholly relevant to human feeling.

Cubism was more than a certain response to a certain historical moment. It was also the outcome of previous events in painting, and an understanding of these is necessary to an understanding of Cubism as an event in itself. In Renaissance and pre-Impressionist pictorial space the depicted object always stood, in Aristotelian distinction from everything not itself, in front of or behind something else. Cézanne was the first to worry consciously about how to pass from the outlining contour of an object to what lay behind or next to it, without violating either the integrity of the picture surface as a flat continuum or the represented three-dimensionality of the object itself (which Impressionism had threatened). The Cubists inherited Cézanne's problem, and solved it, but—as Marx would say—only by destroying it; willingly or unwillingly, they sacrificed the integrity of the object to that of the flat surface.

Picasso and Braque began as Cubists by modeling the depicted object in little facet-planes that they took from Cézanne's last manner. By this means they hoped to define volume more vividly, yet at the time to relate it more firmly to the flatness of the picture plane. The threatened outcome of this procedure was, however, to detach the object from its background like a piece of illustrated sculpture. So, eliminating broad color contrasts and confining themselves to small touches of yellow, brown, gray and black, Picasso and Braque began to model the background too in facet-planes—the way Cézanne in his last years had modeled cloudless skies. Soon, to make a less abrupt transition from object to background, and from plane to plane inside the object, the facet-planes were opened up, and at the same time rendered more frontal—whence the *truncated*

rectangles, triangles and circles that made up the characteristic vocabulary of Picasso's and Braque's Analytical Cubism. The contour and silhouetting lines of the depicted object became increasingly blurred, and the space inside the object faulted through into surrounding space, which, in turn, could be seen as infiltrating the object. All pictorial space became as one, neither "positive" nor "negative," insofar as occupied space was no longer clearly differentiated from unoccupied space. The depicted object was not so much formed as precipitated in clusters of facet-planes out of an indeterminate background of facet-planes—which in their turn could be conceived of as formed by the vibrating and expanding echoes of the depicted objects. By means of design and drawing, the Cubists brought to a culmination what the Impressionists, when they let forms emerge as clots of color touches from an ambiance of color touches, had begun: the old distinction between object-in-front-of-background and background-behind-and-around-object was obliterated—obliterated at least as something felt rather than merely read. The dissolution of solid form which the anti-Impressionist avant-garde had so much feared was thus brought about in a much more conclusive way than Monet could have imagined.

Picasso and Braque started Cubism; Léger joined it. He too was influenced by Cézanne after 1906, but had at first used the influence for ends closer to those of Futurism, analyzing the object to show how it might move rather than how it presented a closed and turning surface to the eye. But by 1912 the main thing for him, as for Picasso and Braque, had become to assert the difference between pictorial and three-dimensional space. Though Léger's vocabulary, with its larger units, remained different throughout, his grammar became like theirs, one of straight lines and faired curves. The curves may have predominated in his case, but the sketchy black lines which traced them left Léger's planar forms almost as open in effect as Picasso's and Braque's truncated facets. And the way Léger modeled his roundnesses—with primary blues, reds or greens

swatched around highlighted axes of crusty white laid on so dry and summarily that the burlap ground showed through— caused these roundnesses to be felt simultaneously as both curved and flattened planes. The different directions in which the cylindrical or conical forms slanted; the interspersed cubes and rectangles; the balance of colors, all of the same intensity; the sense of volumes compressed in ambiguous space and always presenting their broadest surfaces to the eye—all this worked in Léger's case, too, to overcome the distinction between object and background, object and ambiance. Objects, or their components, seem to well into visibility out of a background of similar, interchangeable elements; or it was as if the surface were repeating itself, *as surface,* in depth. The first and decisive impression is of a welter of overlapping planes. To sort these into cones, cylinders and cubes is easy enough for the eye, but to assemble them into recognizable objects demands almost as much effort as to read Picasso's and Braque's last-phase Analytical Cubism.

The method of Léger's analysis is nevertheless simpler than theirs. He dissects more broadly, articulating objects into anatomical units of volume that remain larger, and more obvious in their reference, than the little facet-planes into which the Picasso and Braque of 1910-1914 chip solid surfaces. Perhaps it was this simplicity itself which let Léger, in 1913, abandon recognizable objects altogether and do several completely abstract paintings (all with the same title, *Contrast of Forms*) exhibiting planes enclosing cylinders and cones that stand for nothing else, and rectangles that define nothing else. Léger, alone of the three master Cubists, drove Analytical Cubism to its "logical" conclusion in outright abstraction. Not that he arrived at a semblance of utter flatness, as Mondrian was to do, or that he approached even the flatness that collage sometimes achieved; he always retained some sort of sculptural illusion. But he did, for a moment, accept an implication of Analytical Cubism that Picasso and Braque consistently refused: namely, that the breaking up of the depicted object into more or less

interchangeable unit-parts of modeling had to destroy its identity and that, as long as relief and depth remained the major concern of Cubism, the means to these could form the only real subject of a Cubist picture (see page 76).

Léger's arrival at abstract art (and his subsequent abandonment of it) should also be seen, however, in terms more particular to himself. His predilection for weight and decorative balance, and a *horror vacui* as great as Picasso's, led him—again in 1913—to begin packing the picture toward margins previously left vague, and to muster his plane-units with a density and compactness for which there was no precedent in nature: that is, the plane-units multiplied in complete independence of the laws under which surfaces and their planes materialized in nonpictorial reality. But since these proliferating planes were not kept strictly frontal, the effect verged on the illustration of abstract sculpture, and Léger drew back. After the war, he did a few more nonrepresentational pictures, intermittently and not as a settled practice, and then returned, like Picasso and Braque, to what was at least a silhouetted nature. And to this he has clung ever since.

Cézanne's discovery that the eye, by closely following the direction of surfaces, could resolve all visual substance into a continuum of frontal planes had given painters a new incentive to the exploration of both nature and their medium—and a rule, at the same time, to guarantee the coherence of the result. Picasso, Braque and Léger were able to apply this rule fully in terms of their own temperaments, and for three or four years all three artists turned out a well-nigh unbroken series of works that were flawless in their unity and abundant in their matter, works in which there was a fusion of power and elegance that abated neither. Then, for them, the matter of Analytical Cubism was exhausted and the rule lapsed. Henceforth, neither they nor any other artist could expand taste by quite the same means; to continue using these meant depending on taste instead of creating it.

Synthetic Cubism produced a tight picture-object in which the illusion of depth was given by overlapping and up-and-down placing but hardly ever by shading (which had reached both its apotheosis and its exhaustion in Analytical Cubism). Bright color came back, but as almost absolutely flat color. The priority of the picture plane was now asserted in a more radical way. The depicted object was no longer disintegrated by the pressure of shallow space, but rolled flat in flat space—or at least space that was felt, if not read, as flat. In this flattening-out process Picasso found another new rule of coherence that, for him, was almost as fruitful as the previous one, and it took him another ten years to exhaust its application.

Léger embarked on his own version of Synthetic Cubism after his discharge from the army in 1917. In the large *City*, which he finished in 1919, foreground and background, object and ambiance, are alike cut up into strips, discs and rectangles, which are recombined on, or close to, the surface in a grandiose montage. Léger had not had to practice collage in order to learn from it. He still shaded, in more outspoken lights and darks now—not in the primary colors of his Analytical period —but it was more for decorative structure than for an illusion of volumes as such; the contrast of shaded forms with large and small areas of flat color achieved the effect of a kind of impermeable facade. The factor of rhythm became far more obvious, and remained so, as Léger veered away from a course parallel to Picasso's and began to take hints from Matisse's large canvases of 1916 with their discontinuities of imagined space and abrupt, cadenced juxtapositions of broad vertical bands of color. (Such orchestrations of design were to remain largely foreign to Picasso, whose unrivaled capacity as a composer-designer was tied to a certain traditionalism that excluded large and emphatically decorative rhythms.)

As far as I know, Léger's last complete masterpiece is the largest version of *Three Women,* also called *Le grand déjeuner* (1921), which is in the collection of the Museum of Modern Art, a picture that improves with time (and which one tends

to remember as much larger than it actually is). Later on, Léger will secure unity only by elimination and simplification, but here he secures it by the addition, variation and complication of elements that are rather simple in themselves. First, staccato stripings, checkerings, dottings, curvings, anglings—then a massive calm supervenes; tubular, nude forms, limpid in color and firmly locked in place, with their massive contours stilling the clamor around them—these own the taut canvas as no projection of a more earnestly meant illusion could.

For Léger, as for Picasso, the impetus of Cubism gave out in the later 1920s. Since then nothing in Léger's art has equaled the breadth and finality it had before. It was only then that his firm, heavy, simplifying hand began to reveal its liabilities as well as its assets. The coherence into which machined contours and rawly decorative color froze became an increasingly mechanical one. Color—truly Léger's secret weapon—never goes quite as dead as it does for Picasso and Braque in these later years, but the difference is hardly to his advantage. The heraldic, suspended clusters of signs and objects that he produced so monotonously in the 1930s and 1940s hang limp with the limpness of paint; one feels a designer's rather than a painter's hand; the oil medium seems to go stale for Léger (an impression borne out—as in Rouault's case—by the great improvement conferred on one of his 1950 pictures by its translation into tapestry).

Still, not all the things Léger has done since the 1920s are to be put on the debit side. There are certain small still lifes; there is the final and largest version of the *Bicyclist* series of 1944-1945, which has an old-fashioned popular-print kind of picturesqueness and compactness that is satisfying if not quite moving; there is also the large *Three Musicians* (1944), whose solidity likewise pleases even if it is a little too bland; which can be said, too, of the masterfully undulating chiaroscuro in the large *Adam and Eve* (1939). No one but an artist who

had, or once had had, greatness in him could have painted any of these pictures.

Léger's decline, like Picasso's, has been the more marked precisely because he has refused to repeat himself. He had once created taste, and he still strives to do so, and if the results are found wanting, it is most of all because they have to be referred to standards that Léger himself set.

1954

Jacques Lipchitz

Lipchitz is a great, sometimes very great, sculptor who presents the critic with a peculiarly difficult problem. His retrospective at the Museum of Modern Art (Summer 1954) states the ambiance of greatness but offers relatively few individual great works—that is, relatively little of what makes one apply the word "greatness" to Lipchitz' art is precipitated *as* the unity and completeness of single works.

Almost everything in the show, from the earliest pieces—under Bourdelle's influence or that of Russian-style Art Nouveau —even to the impossibly bathetic *Virgins* done in connection with a recent commission for a baptismal font for a French church, spoke of an enormous capacity. When I say "capacity," I mean more than promise; I mean *potentiality*—not promise that awaits the capacity to realize, but the already displayed capacity for realization. In Lipchitz the disproportion between his powers and what actually gets realized by them is too large to be taken as part of the "usual waste" attending upon ambitious effort in art.

Like Chagall and Soutine, Lipchitz arrived in Paris in the halcyon years just before 1914 and immediately joined the avant-garde. But Paris also meant, for these artists from Jewish Eastern Europe, their first real look at the museum art of the West; and none of the three ever got over this. Soutine, the last to come, embarked immediately on an effort to reconcile modernist with pre-Impressionist painting. Lipchitz began to think of a similar reconciliation in the 1920s, when the general mood in Paris was tending to encourage partial returns to the past; and Picasso and Léger, as well as Matisse and Derain, were engaged in what was thought to be the "consolidation of their experiments." But whereas these French and Spanish artists

had been born into the museum so to speak, and could take it more or less for granted, whether in return or departure, the three Jewish artists appeared to feel that they had to prove their title to the museum and to tradition by a more declared, more express effort.

Henry Hope, in his catalogue for the Museum of Modern Art exhibition, quotes Lipchitz as saying that he aspires to continue the "great stream of European sculpture from Michelangelo and Bernini to Rodin." Just as Lipchitz has tried to cast his artistic personality in the "titanic" mold set aside since the nineteenth century for culture heroes like Michelangelo, Rembrandt, Beethoven, so he has sought to achieve in his art itself a contemporary version of the grand and epic manner. This latter he has conceived, however, in terms that are more than necessarily trite. That his art has endured as well as it has over the last quarter century under the burden of pedantic, not to say academic, ambitions is perhaps further evidence of his fundamental powers.

The Cubist sculptures in the round and in bas-relief of Lipchitz' first period of maturity, from 1914 to 1925, seldom fall short of a satisfying unity, even if it is at the price of confinement to a narrow repertory of forms translated literally from the painted Cubism of Picasso and Gris. Particularly successful are the bronze *Bather* and the wood *Dancer* (1915), (both pointing toward a new kind of nonmonolithic sculpture that Lipchitz was not to attempt again for another ten years), and in a somewhat less adventurous direction, the stone pieces *Standing Personage* (1916), *Standing Half-Length Figure* (1916) and *Man with Mandolin* (1917). His most consistently original and powerful work came, however, between 1925 and 1930, after the close of his Cubist period proper. Having by then abandoned the literal vocabulary of painted Cubism but still subscribing to Cubism's general aims, and understanding these more profoundly and personally, he was able, paradoxically, to make its syntax more effectively and intrinsically sculptural by making it even more pictorial. Instead of trans-

posing the curved and angled planes of Cubist painting into solid polygonal volumes, he now began to feel them in terms of line as line, and of surface as a thing separate from mass.

The best works of this period are small, near-abstract bronzes, none more than twenty inches high, whose thin, perforated surfaces and calligraphic straps and cords of metal state the new draftsman's language of modernist sculpture even more clearly in some ways than do Picasso's earlier Cubist constructions. Several of these little bronzes are among the most rightly felt works of sculpture our time can boast of; yet they also offer some of the first evidence, if only indirectly, of Lipchitz' arrogant, almost perverse badness of taste or judgment. For almost every one of them cries out for monumental enlargement, the proof of which is given by the most splendid of all of Lipchitz' works: the *Figure* (1926-1930), which is the only large sculpture he has ever done in a manner like that of the small bronzes. As it is, these latter are often, despite their calligraphic "transparency," modeled with a heaviness that does not suit their size; their strength and intricacy can seem cramped, even a little clumsy because of their smallness, and sometimes they can even begin to look like *objets d'art.* Such superb pieces as *Chimène* and *Melancholy* (both 1930) are therefore perhaps best appreciated in photographs that give the eye a chance to imagine them as much larger than they actually are. Lipchitz has turned out more "transparent" bronzes from time to time since 1930, and though very few of them are quite as inspired as the earliest, they still generally manage to be superior in quality to his monumental sculpture over the same years.

Except for the *Figure,* completed in 1930, the larger works which Lipchitz did between 1925 and that year were in massive forms that had little affinity with anything in the "transparent" bronzes. It was as if he felt that monumental sculpture called for unambiguously monumental forms. Yet the *Figure* was there to show him how much more convincingly he, for one, could achieve monumental effects with nonmonumental means,

and how much righter for *him* this seeming disparity between means and ends was than their logical and academic equation. All the other large sculptures of 1925 to 1930 in the exhibition at the Museum of Modern Art are uniformly inferior in quality to the small ones; and in bronzes like *Joie de vivre* (1927), *Mother and Child* (1929-1930) and *Return of the Prodigal Son* (1931) there already appear those bloated volumes, coarse contours and arbitrary elaborations which have marred most of the successes and confirmed almost all the failures of Lipchitz' larger-scale sculpture since then.

Cubism had once impelled him toward "construction"—toward an open, linear sculpture. But then the mirage of the grand style began to loom before his eyes (as it began to do at almost the same time, but for rather different reasons, before Picasso's). Great and instinctive modeler though he was and is, Lipchitz began to model excessively, self-indulgently, over-eloquently. The bad old notion of sculpture as statuary, as something declamatory and bombastic, replaced the implicitly modernist (and also medieval) notion of it as direct and self-evident.

Just as Soutine tried to combine the light-and-dark handling of the Old Masters with the ungraded color of post-Impressionist painting, so Lipchitz has tried, in his larger works since 1927, to find some kind of compromise between the monolith and chiaroscuro of traditional sculpture on the one hand, and the open, linear, two-dimensional forms of Cubist and Late Cubist construction on the other. Neither artist would have attempted to do what he did had he possessed more of that elementary sophistication which tells other artists, even lesser ones, that most things in art cannot be obtained without sacrificing others. It is, I feel, a basic lack of sophistication that explains Lipchitz' too deliberately grandiose aims and his insistence (as we can see from the difference between his plaster and terra cotta maquettes and their muscle-bound final versions) on complicating instead of purifying his first conceptions.

How well, nonetheless, Lipchitz can still do whatever he addresses himself to straightforwardly is shown by two relatively recent smaller bronzes, *Flight* (1940) and *Arrival* (1941). Intended to evoke the feelings of a Jewish refugee from Hitler, they both owe much to Rodin in conception as well as in the fingering of their surfaces, yet they transcend almost every note of derivativeness by their expressive clarity and dramatically controlled silhouetting. A good deal of the same can be said of the equally Rodinesque *Bull and Condor* (1932) and *Rape of Europe III* (1938); while in the great *Jacob Wrestling with the Angel* (1932), as in *Embrace* (1934), Rodin is taken merely as a premise from which to draw a sinuous bulkiness that is radically and triumphantly different from the older master's flickering decomposition of masses. Nor should mention be omitted of the splendid *Song of Songs* among the works of the 1940s.

Actually, influences tend to obtrude most as influences where Lipchitz seems to be most deliberately asserting himself. An intentionally idiosyncratic approach turns out often to be the most patently borrowed one. Thus, Picassoid conceptions and even mannerisms are too easily recognized in the ambitiously swollen sausage forms and telescoped anatomy of *Benediction I* (1942), and in the bulbous topknots and horsetails of both *Hagar* (1948) and *Mother and Child* (1949), both of which happen to be among the more successful—or rather, least distressing—of his recent larger sculptures.

Every artist borrows, and those who do so least are not always the better for it. Not the extent of Lipchitz' dependence on influences, but its range is what betrays the difficulties of his art over the last twenty-five years. He has sought stylistic inspiration from Michelangelo, Bernini, nineteenth-century neo-Baroque sculpture, African wood carving, Pergamum, Chaldea, Rodin, Picasso. An artist with a firm sense of direction—as distinct from aspiration—might not find it impossible to fuse influences even more diverse, but a sense of direction is what Lipchitz seems to have been most at a loss for these

past thirty years. Since detaching himself from Cubism he has been unable to develop a principle of inner consistency; none of the different paths he takes seems to lead into the next one; nothing seems to get developed, refined, clarified in going from one work to another. Nor does this unsureness of purpose make itself felt only in the long run; it can also manifest itself in a confusion of intentions within a single work.

One wonders how an artist so unsure of himself can make such an impression of strength. This impression is not false, even if it is not supported by evidence of the courage supposed to go with strength. What the strength, the insistence on demonstrating it, the swagger of brutality, do conceal, I believe, is Lipchitz' failure to orient himself independently in Western and modernist art. He has the superlative and inalienable power to knead matter into massive, simple, and energetic form—unlike Picasso, he has never lost his *touch*. What he does seem to have lost is a sure reliance upon anything inside himself.

1954

Kandinsky

Picasso's good luck was to have come to French modernism directly, without the intervention of any other kind of modernism. It was perhaps Kandinsky's bad luck to have had to go through German modernism first. Whether or not this is part of the real explanation, his success in anticipating the future remained compromised by his failure ever quite to catch up with the present. He was influenced by Cézanne and he was influenced, crucially, by Cubism, but he was never quite able to grasp the pictorial logic that guided the Cubist-Cézannian analysis of appearances—a logic that Matisse and every subsequent master of modernist painting has had to understand and come to terms with in order to realize himself. What were side issues for Cubism became ends in themselves for Kandinsky, and what were really the main issues he, in effect, skipped. Before a new generation of artists could take the path he opened, they had to retrace his steps and to make good, by going through Cubism, what he had omitted. Still, the largest cost was to his own art.

Starting from German Art Nouveau, Kandinsky entered artistic maturity with a style that was a highly original combination of Impressionism and Fauvism. Under the instigation, at least, of Braque's and Picasso's early Cubism, this turned into the stylistic vehicle of an outright abstract art. His best pictures were painted in the years just before and after this turn, between 1907 and 1914, a period coinciding almost exactly with that of Analytical Cubism. Even after becoming completely abstract in intention, Kandinsky's art continued for a time to evoke landscape and even flower subjects, and its allusions to nature do almost as much as anything else to secure the unity and coherence of the individual picture. Lightly modeled

shapes hover, and purely linear motifs circulate, within an illusion of three-dimensional space that, except for its shallowness, is almost pre-Impressionist. There is a Cubist note in the play of "hard" drawing against "soft" brushing, but Analytical Cubism, with its final assertion of a dynamic flatness that conventional modeling or shading could not penetrate, was really more "abstract," more organically nonillusionist than Kandinsky in his freest improvisations. The atmospheric space in which his images threaten to dissolve remains a reproduction of atmospheric space in nature, and the integrity of the picture depends on the integrity of an illusion.

It was after 1920, however, that Kandinsky's lack of Cubist grounding in the nature of pictorial "abstract" space began to reveal itself most unmistakably as a liability. Like many an outsider who sees things more quickly than insiders do, Kandinsky had in 1911 perceived and seized upon those implications of modernist painting which made it possible to envisage a nonrepresentational art that would be pictorial before it would be decorative. Cubism, according to the internal evidence, furnished him with the clearest indication of this possibility; but the nonrepresentational tendency of Cubism was a by-product and not the aim of its reconstruction of the picture surface. Kandinsky's failure to discern this led him to conceive of abstractness as a question down at bottom of *illustration,* and therefore all the more as an end instead of as a means to the realization of an urgent vision—which is all that abstractness as such, like illustration as such, can properly be.

Kandinsky's exceptional contribution was to keep flatness and the nonrepresentational dissociated for a little while longer. Cubist flatness imposed geometrically oriented drawing and design on ambitious painting, but Miró, the Late Cubist, was able to loosen its hold with the help of Kandinsky's "free" contours and his shallow but indeterminate depth; and Gorky and Pollock in America were able to do likewise in their own good time. By 1920, however, Kandinsky himself had accepted

what he thought was Cubist flatness, following the lead more or less of Synthetic Cubism, which, at the same time that it returned to more obviously representational silhouettes, resigned itself to a more obvious flatness. And along with this flatness, Kandinsky accepted geometrical drawing, but without understanding the necessity in the relation between the two. For him the picture plane remained something negatively given and inert, not something that acted upon and controlled the drawing, placing, color and size of a shape or line, and whose flatness was re-created by the configurations upon it, or at least (as with the Old Masters) reinvoked. Geometrical regularity, instead of preserving the tension and unity of the surface by echoing the regularity of its enclosing shape, became for Kandinsky a decorative manner that had little to do with pictorial structure. The surface remained, in effect, a mere receptacle, the painting itself an arbitrary agglomeration of shapes, spots and lines lacking even decorative coherence.

There is a great variety of manner, motif, scheme and configuration in Kandinsky's later works, but it is a mechanical variety, ungoverned by style or by the development of style. The works in themselves remain fragments, and fragments of fragments, whose ultimate significance lies mostly in what they allude to: peasant design, East European color, Klee, the world of machinery—and in the fact that they contain almost nothing spurious. Kandinsky may have betrayed his gifts but he did not falsify them, and his honesty, at his own as well as art's expense, is utterly unique. For this reason alone if for no other, we shall have to go on reckoning with him as a large phenomenon if not as a large artist.

A last question that suggests itself is whether he did not make a mistake in terms of his own development by abandoning representational art when he did. Might he not have produced more work of intrinsic value, and of greater intrinsic value, had he continued to exploit his vision of landscape a while longer? Have not more than a few of even the best of his

early abstract paintings taken on that characteristically faded look which belongs to premature innovations? Such questions are not idle in the case of this artist and this art, the status and value of which are so hard to determine.

1948
1957

Soutine

The Soutine retrospective at the Museum of Modern Art (Fall 1950) provided me with my first view of his art in any real quantity, and I was somewhat disappointed. Astounding capacities were revealed, but only a delayed and incomplete realization of these. Modernist art may be problematic art by definition, but in Soutine's case the problematic seemed to extend too far.

Perhaps he asked too much of art, perhaps he set too high a value on the unimpeded expression of feeling. Certainly, he discounted to an excess the obligation to organize a picture decoratively; and even in the latter part of his life, when he became less high-handed in this respect and produced his most completely satisfying works, the decorative ordering of a picture remained something he submitted to rather than embraced. What he wanted of the art of painting seems to have belonged for a long while to something more like life itself than like visual art. And yet Soutine's equipment as a painter was in certain respects one of the most extraordinary of modern times.

One has to go back to Rembrandt (whom Soutine himself worshipped) to find anything to which his touch—the way he applied paint to a flat surface—can be likened. Vehement, almost brutal, yet always eloquent, that touch is hardly ever less than completely felt. Almost every square inch of the surface of almost every painting of Soutine's that I have seen, the worst as well as the best, is charged with the power of that touch. Other painters have created more opulent textures; Van Gogh's brushstrokes are more definite and harmonious in their expressiveness; but no one has dealt more intimately or feelingly with the specific properties of oil paint—or more pic-

torially. Soutine used impasto for the sake of color alone, never sculpturally or to enrich the surface. His paint matter is kneaded and mauled, thinned or thickened, in order to render it altogether chromatic, altogether retinal. He was not a palette-knife virtuoso; he did not seek "paint quality."

Soutine's touch came as if from heaven, but there were other things in painting—perhaps too many other things—for which he had to struggle well on into his maturity. It was less a struggle to learn than to discipline himself. And it was, to some extent, a struggle to discipline himself in directions not altogether congenial. Given his temperament and gifts, he might have fulfilled himself more largely had he accepted his originality more implicitly and let it lead him. But perhaps it also belonged to his temperament (or his neurosis) to put obstacles in his own way. And there was also his situation.

Like Chagall and Lipchitz, two other artists from Jewish European Europe, Soutine never recovered from the impact of the museum, with which he became really acquainted only after arriving in Paris in 1913, at the age of nineteen. Chagall and Lipchitz had reached there in time to be affected by the first excitement of Cubism. Soutine turned his back on Cubism and refused, at least in words, to like anything but the Old Masters. His most ardent admiration went at first to Tintoretto and El Greco, then to Rembrandt and Courbet. He professed indifference toward Van Gogh but, to quote Monroe Wheeler's catalogue for the Museum of Modern Art show, ". . . it seems evident that Van Gogh's late Provençal landscapes must have emboldened him in his early approach. . . . " Notwithstanding his disclaimers, he seems, moreover, to have been influenced in his first Parisian paintings by a little of everything that had happened in modernist painting up until Cubism—and after 1918, even by German Expressionism. One does not feel this, one deduces it.

Soutine's vision of the heights of painting saw Old Master pathos and naturalism lending themselves to the directness of "pure" painting. Only an outsider and newcomer could have

thought this possible. His attempt to wrest from paint matter itself what other artists got from *relations* was, as far as Western tradition was concerned, utterly exotic and largely futile.

Soutine relied throughout on the traditional, sculptural means of light and dark for the structure of his pictures. Self-sufficient color—Matisse's, Van Gogh's, Monet's—is a matter of relatively flat color. If one wants to retain modeling with its gradations of light and dark, directness or purity of hue has to be sacrificed. One cannot have it both ways. This, however, was exactly what Soutine insisted on for a long while, and the ensuing contradiction was the most immediate cause of his failure to realize consistently in the 1920s.

All through those years he tried, literally, to overpower the medium. Color, contour, and modeling were each asked for a maximum of expressiveness. So was nature itself. The forms of the given and the means of art were alike tortured and tormented; such order as did come forth was, in a totally un-Surrealist way, a dreamlike one. The landscapes of this period, with their canted and skewed *Jugendstil* hills and houses, and their dark green, dark brown, tan-yellow cast, have force and originality, but do not stay in place the way pictures should. They do not "sit" decoratively. Their paint and handling can be savored, but not their unity, and without this we miss that final exhilaration which is the most precious thing in art's gift. Soutine's still lifes, because their subjects impose a greater quietness, are more satisfactory in this respect. The "studies" of dead fowl he did in 1925 and 1926, remembering Chardin, the Dutch and Renoir, achieve intensity without agitation, though here again hardly any of the examples I know attain an altogether reassuring unity. Most of the famous portraits and figure pieces date from this period and I feel that the same lack can be felt in them, however superlative their other qualities. Of all the earlier portraits to be seen at the Museum of Modern Art, the only one to which I could give my full assent was the *Woman in Red* (1922).

In the thirties the conservative implications of Soutine's

approach became much more apparent to himself, and brought more frequent realizations with them. His effort to force a very personal content upon a conventional, therefore impersonal, scaffolding had produced startling works, but had not significantly transformed the scaffolding itself, only wrenched and shaken it. Now the scaffolding was given more of its due, and whatever loss was suffered in intensity was compensated for by a gain in unity. Design was now more carefully related to the frame, and greater clarity of modeling brought with it greater lucidity of color. This was not exactly the first time Soutine had gone to meet tradition more than halfway; the *Carcass of Beef* (1925), in the Albright Gallery in Buffalo, is an almost Frenchified free rendering of Rembrandt that suffers, if anything, from an over-emphasized unity.[1] Here, for once, there is almost a falseness of handling: the uniform glazing creates an oversweet translucency and the effect is like that of the picture of a picture. In the early 1930s, however, Soutine's efforts to compete with tradition on some of its own terms became more controlled and perhaps even more truly sincere. His subtle revisions of Courbet and Cézanne in the wonderful panel painting, *House at Oisème* (1934), remain as intensely Soutine in their relatively gentle felicity as the writhing shapes and turbulent color of his earlier pictures.

Soutine's art has, from first to last, a genuine as well as obvious capacity to move us. But, as I have hinted, this does not always accord with the art in painting. The righthand figure of the two little girls hurrying toward the foreground in *Return from School After the Storm* (1939) has something infinitely and incomparably touching about it—Soutine was, after all, a sublime illustrator. But, almost *because* of its expressiveness, it does not sit quite right as a spot on the surface of this particular picture. I would not claim for a moment that the power of pictorial art to affect us as illustration is incom-

[1] A larger and much superior version of the same subject hangs, fittingly enough, in the Stedelijk Museum in Amsterdam. I saw it only in 1959 and think it Soutine's masterpiece. It is possible he did other pictures of this quality in the 1920s, but I do not know of them.

patible with its power to affect us in other ways, but I do feel that Soutine's passion for illustration was just as often a stumbling block as a source of inspiration.

Mr. Wheeler writes in his catalogue that Soutine's growing mastery of his art in the thirties was accompanied by a gradual growth of boredom and fatigue; that his strongest impulse having been a "ghastly anxiety lest the power and skill of his brush fail to fulfill the vision in his mind's eye," now "in the increase of facility, his zeal to work diminished; brilliance of style took away some of his incentive." Perhaps he could not stand success. Or his original sense of frustration may have come, actually, from an inability to be revolutionary enough, to do enough violence to the given and sanctioned in the true interests of his temperament, and now that he was attaining greater success through greater self-denial the sense of frustration increased. Soutine's tragedy—if it was one—was that he did permit himself *enough* of a personal vision. In this sense he can be considered a victim of the museum.

1951

The School of Paris: 1946

Our understandable and even urgent curiosity about developments in French painting since 1940 has been only meagerly satisfied by a few portfolios of reproductions and, now, by a dozen or so oil paintings at the Matisse Gallery: three apiece by Matisse, Jean Dubuffet, and André Marchand, two by Rouault and one each by Picasso and Bonnard.

Paris remains the fountainhead of modern art, and every move made there is decisive for advanced art elsewhere—which is advanced precisely because it can respond to and extend the vibrations of that nerve-center and nerve-end of modernity which is Paris. Other places (Weimar Berlin, for example) may have shown more sensitivity to immediate history, but it is Paris over the last hundred years that has most faithfully conveyed the historical essence of our civilization.

Since Courbet, French painting's concern with the physical has reflected the conscious and unconscious positivism that informs the bourgeois-industrial ethos, and has perhaps done so more integrally than was possible to any other art. It did not matter that the individual painter happened to be a professing Catholic, a mystic or an anti-Dreyfusard; in spite of himself, his art spoke for positivism or "materialism"; its center of gravity was immediate sensation and it functioned under a drastic reduction of the associations bound up with the visual act.

After 1920 the positivism of the School of Paris, which depended in part on the assumption that infinite prospects of technical advance lay ahead of both society and art, lost faith in itself. It began to be suspected that the physical in art was as historically limited as capitalism itself had turned out to be.

Mondrian looked like the handwriting on the wall. But artists of the caliber of Matisse and Picasso appear to have still felt—at least Picasso continued to do so for a while—that the physical had to be pursued simply because there was nowhere else to go without retreating. The doubts raised at this juncture in the development of modern art are dramatically reflected in Picasso's art after the middle 1920s, and particularly in the neo-Cubist impasse at which it now seems to have arrived.

Positivism, materialism, when they become pessimistic, usually turn into hedonism. During the 1920s most of the leaders of the School of Paris (with Miró among them, if not Mondrian) began to emphasize the pleasure principle with a new explicitness. It was at this time that that delectable painter, Bonnard, came into his own as a great name. The best French painting no longer tried so much to *discover* pleasure as to *provide it.* But whereas the literary Surrealists and the Neo-Romantics, whose pessimism smacked more of cynicism than disillusionment, conceived of pictorial pleasure as piquant illustration, Matisse, Picasso, Braque and those who followed them located it mainly in the exhilarating and more physical facts of luscious color, eloquent surfaces and decoratively inflected design.

Matisse's hedonism, which antedates the 1914 war, can mean something altogether different from the decadence some people think they see in it. One gathers, mostly from reproductions, that he returned during the war to "luxury" painting with a vengeance, after having for several years before 1940 tended toward somewhat ascetic simplifications. The new figure and conversation pieces of his that are to be seen at his son's gallery may have become even thinner and more casual, but his still-life paintings, profiting at last from Picasso's Synthetic Cubism, mark another high point of his art; their controlled sensuousness and careful sumptuousness demonstrate once again how the flesh, too, is capable of virtue and purity.

Picasso, on the other hand, seems to have tried to renounce hedonism since the Spanish civil war. Though his still life

in the present show shares in Paris' wartime preoccupation with food and domestic articles, it strives for the same *terribilità* as do his figure pieces of recent years—and it fails as sadly as do all the other examples of his recent art that I have seen (though only in reproduction). There are many reasons why Picasso clings to the representational, but one of them surely is his desire to answer current history with an art whose evocation of violence and terror will be unmistakable. Yet the inherent logic of his course as an artist drives him toward the abstract, today as much as thirty years ago, and I myself seem to see an expression of this frustrated logic in the helpless, almost vulgar way in which the pitcher in the still life at hand is painted.

The Bonnard, a recent landscape, is more delivered up unto sheer color textures even than Monet's lily-pad pictures; contour and definition are so summary and understated that the effect verges on abstract art. It is a nice painting, but not of the same high order as most of the latest work of Bonnard's that I have seen in what I assume to be adequately faithful reproduction.

Bonnard's hedonism comes from a different period than Matisse's or Picasso's, and therefore from a different experience —so, I feel, does Rouault's. His recent painting at Matisse's betrays its own kind of intensification of sensuousness, difficult though that may seem, but adds nothing to what we already know about his art.

In Marchand, who is presented as one of the best of the younger generation of Parisian painters, the pleasure principle manifests itself more nakedly and perhaps more physically than elsewhere in this show, but also more decadently. His drawing owes almost everything to Picasso, while his color and paint quality mean everything that has come to connote richness and juiciness in French painting since Renoir: brilliant, exquisite, but also meaningless intensities of hue shine through slick and fatty surfaces. Not all the artist's skill and taste, which are what a Paris painter's taste and skill are supposed

to be, can prevent the result from being confectionery—self-evident confectionery.

Jean Dubuffet is not Marchand; nor is he Gischia, Lepicque, Pigneron, Estève or any other of those younger artists of Paris who pay their due to the physical by crossing Picasso's drawing with Matisse's color, and arrive equally at confectionery. Though Dubuffet reveals literary leanings, the literature, I must admit, is of a superior order. To my knowledge, he is the only French painter who has consulted Klee, and he has turned that influence into something monumental and far more physical than would be expected. Furthermore, he has used the license won by Klee's whimsy, derived in part as it is from children's art, for the purpose of a savage attack on the human image. Of his paintings at Matisse's, only one is fully successful, the *Promeneuse au parapluie* (now in Miss Katherine Viviano's collection), a powerful picture into whose thick and tarry surface a heroic graffito is scratched; but the other two of Dubuffet's pictures are still interesting enough to awaken the desire to see everything else he has done. At this distance in space, he seems the most original painter to have come out of the School of Paris since Miró. What seems to me to be particularly significant is that, like many lesser American artists, he should have followed Klee in seeking an escape from the physical into "poetry." It is too early to tell anything definite—and Klee is a deceptive support in the long run—but if Dubuffet's art should consolidate itself on the level indicated by these three examples, then easel painting with explicit "subject matter" may have won a new lease on life.

1946

Contribution to a Symposium

French prestige does account in large part for the success, much greater than the domestic article's, of the latest importations of abstract painting from Paris—and not only of abstract painting—but it doesn't do so altogether.

Despite their seeming convergence, there are crucial differences between the French and the American versions of so-called Abstract Expressionism. In Paris they unify and finish the abstract painting in a way that makes it more acceptable to standard taste (to which I object, not because it is standard—after all, the best taste agrees in the long run—but because it is usually at least a generation behind the best art contemporaneous with it). Adventurous though they may be in their "images," the latest generation of painters in Paris still go in for "paint quality" in the conventional sense, "enriching" their surfaces with buttery paint and films of oil or varnish. And design is tailored so that it hits the eye with a certain patness. Or else the unity of the picture is guaranteed by a semblance of the old kind of illusion of depth as obtained through glazing or through the tempering and value-toning of color. The result is almost always softer, suaver and more conventionally imposing and sumptuous than the "idea" or inherent logic of the new kind of painting would seem to permit. If Abstract Expressionism carries a vision all its own, then that vision is tamed in Paris—and not, as the French themselves may think, disciplined.

The American version of Abstract Expressionism is usually characterized, in failure as well as in success, by a fresher, more open, more immediate surface. Whether it is enamel paint

(Originally part of a symposium called "Is the French Avant-Garde Over-Rated?" and published in *Art Digest*, September 15, 1953)

reflecting light, or thinned paint soaked into unsized and unprimed canvas, the surface manages somehow to *breathe*. There is no insulating finish, nor is pictorial space created "pictorially," by deep or veiled color; it is a question rather of blunt and corporeal contrasts and of optical illusions difficult to specify. Nor is the picture "packaged," wrapped up and sealed in, to declare it as easel painting; the shape of the picture itself is treated less as a receptacle given in advance than as open field whose unity must be permitted to *emerge* instead of being imposed or forced upon it.

All this, of course, makes the American article harder to take. Standard taste is offended by what looks like undue looseness, and as usual, mistakes a new spontaneity and directness for disorder or at best, solipsistic decoration.

Do I mean that the new American abstract painting is superior on the whole to the French? I do. Every fresh and productive impulse in painting since Manet, and maybe every such impulse before Manet, has repudiated received notions of unity and finish—has manhandled into art what seemed until then too intractable, too raw and accidental, to be brought within the scope of aesthetic purpose. This extension of the possibilities of the medium (and of the tradition) is an integral factor in the exaltation to be derived from art, and is what I miss in too much of the latest French painting, which simply does not challenge my sensibility enough. The best pictures of Gorky, Gottlieb, Hofmann, Kline, de Kooning, Motherwell, Newman, Pollock, Rothko (and these are not our only painters) offer a plenitude of presence that those of Fautrier, even those of the Dubuffet of 1945-1948, or of Hartung or Tal Coat (the four I like most among the Paris painters under fifty-five whose work I have seen[1]) seldom match. And when I say "plenitude of presence" I don't mean a newfangled thrill, but something whose equivalent I find in the successful art of the past.

[1] I was temporarily disillusioned with Mathieu at the time I wrote this. Had it been a year earlier or later I would have included his name. Right now (1959) I consider him the strongest of all new European painters.

Our new abstract painting seems to have anticipated the French version by two or three years, but I doubt whether there has been any real acceptance of American influence on the part of the French as yet (and I don't much care). The development of post-Cubist art (say rather, Late Cubist) had brought American and French painting to the same point at about the same time, but we had the advantage of having established Klee, Miró and Mondrian as influences before Paris did, and of having continued (thanks to Hans Hofmann and Milton Avery) to learn from Matisse when he was being disregarded by the younger artists in Paris. Also, André Masson's presence on this side of the Atlantic during the war was of inestimable benefit to us. Unfulfilled though he is, and tragically so, he is still the most seminal of all painters, not excepting Miró, in the generation after Picasso's. He, more than anyone else, anticipated the new abstract painting, and I don't believe he has received enough credit for it.

1953

Art in General

"Primitive" Painting

"Primitive," "Sunday," "naive" painting begins with the Industrial Age. Amid the decay of folk art, picture-making—more exactly, easel painting—provided a new outlet for plebeian "artistic energy." A German scholar—or at least one who writes in German—Nicola Michailow, offers this idea in an article[1] that is a landmark in the field. The practitioners of *Laienmalerei* (layman's painting), as Dr. Michailow calls it, belong mostly to the petty bourgeoisie, that much maligned class which more than any other has inherited the "primeval creative urge of the *Volk*." (Dr. Michailow is writing in Nazi Germany, but the smell of these terms is typically German before it is typically Nazi.) The layman painter is usually too poor or too isolated, or both, to acquire sophistication in his art. That one of the first "primitives" on record was a king of Prussia, Frederick William I (father of another nonprofessional artist, Frederick the Great, flautist and composer), does not conflict with this. High and low in pictorial art in the North Germany of Frederick William's time were almost equally remote from tradition. And the lack of intimacy with tradition is what is decisive in this connection.

But why was it easel painting in particular that became so important in filling the vacuum left by folk art? After all, folk art hardly ever included pictures as such; not since Paleolithic times had European "folk" used color and line for anything other than decoration. Dr. Michailow does not go into this question. I myself would suggest, as part of the answer, the demand for pictures, especially portraits, among the citified middle class emerging in the small towns of the eighteenth century—a demand awakened by the increasing

[1] In *Zeitschrift für Kunstgeschichte*, Nos. 5, 6 (1935).

circulation of engraved reproductions. Thus some of the first "lay" painters were not so "lay"; they were professional to the extent at least that they painted for a market and took their lead from it. And the important stimulus for "primitives" who painted only for their own satisfaction must also have been reproductions. The internal evidence would show that in neither case was this art as underived as both Dr. Michailow and Jean Lipman[2] appear to think. It is highly unlikely that a "naive" artist would have ventured upon pure landscape or still life without being encouraged by precedents.

Dr. Michailow points out that *Laienmalerei* has flourished most in outlying areas of Western civilization: Germany, the Balkans, North America. Our country provided ideal conditions, having been settled by iconoclastic Protestants who possessed hardly any pictorial culture. Nor was there anything in their new environment to remind them, as Germans and Bulgarians might be, of obsolete traditions of pictorial art. Still, most of the pictures reproduced in Mrs. Lipman's book, particularly those by the professional or semiprofessional "limners," betray enough acquaintance with schooled art to make it necessary to distinguish degrees of difference in the traditionlessness of American "primitive" painting. Certainly, Dr. Michailow's thesis as to the cultural nakedness of the layman's painting needs to be drastically qualified. Hardly any "primitive" we know of, in Europe or America, lived beyond the reach of printed matter; pictures were, from the first, part of that matter, and small-town America was all the more bookish for being Protestant. How it was in the Balkans, I do not know.

The efflorescence of "primitive" painting since the First World War—or what seems to be its efflorescence now that we pay more attention to it—may be a somewhat different matter. Like his predecessor, the twentieth century "primitive" tends to be of humble social origin, but temperamental and psychic factors rather than social ones are what usually prevent him

[2] Lipman, *American Primitive Painting* (New York: Oxford University Press, 1942).

from acquiring artistic sophistication, given that correct drawing and shading—meaning realistic, academic drawing and shading—have, with the overripeness of Western naturalism, become so much easier to learn. (Indeed the weight of the factor of native talent or dexterity seems in general to be decreasing in all except the performing arts.) As a rule, "primitive" painters strive for realism, whether in rendering nature or their visions and dreams, and it is by its bungled realism that their work most unmistakably declares itself to be "primitive." In view of the amount of time so many "primitives" spend on their art, as well as the greater accessibility of schooled art in our day, one would expect them to learn the tricks of realistic drawing and shading sooner or later. That most of them never do seems, under the circumstances, more attributable to mental than to social or cultural handicaps. Many of the "primitives" of the past must have been eccentrics, but I doubt whether such a large proportion of them as nowadays. Henri Rousseau—if the evidence is correct—became a full-blown "primitive" only with the dimming of his wits in old age. And Louis Eilshemius, who was a completely accomplished painter in his youth, began to look "primitive" only when his mind deteriorated. There is also the fact that so many latter-day "primitives" take up painting late in life, when age has made them either senile or incapable of learning.

It has always been difficult, anyhow, to draw a clear line between "naive" and alienated art. They are certainly closer to one another than either is to what Jean Dubuffet calls *art brut* (raw art) namely, graffiti and scrawlings on walls and sidewalks, public toilet obscenities, etc., etc. These are produced like gestures, without the intention of making art or interest in anything but direct assertion and communication (and they are almost always linear and monochromatic); whereas, the "primitive" and, more often than not, the insane artist intends to make art. Dubuffet misunderstands his own "discovery" when he lumps *art brut* together with alienated art. But if the art in *art brut* is a matter of accident, many of the real virtues

of "primitive" painting are nearly so; for the strength or charm of this kind of art lies preponderantly in abstract or decorative qualities not knowingly sought by its makers. And the contradiction between their conscious striving for realism and their inability to organize their pictures except by tidying them up decoratively is precisely what keeps their art styleless.

The vogue of the "primitives" is waning, and we do not find as many excellences in their productions as we once did. Rousseau, who made the phenomenon respectable, is by no means a typical example, and many distinctions are still to be made even in his case. The category of "primitive" or "lay" is too narrow for his art, as it may be for the schematic landscapes of Alfred Wallis, the Cornishman, and the only other "primitive" who, in my estimation, can stand comparison with Rousseau. Wallis, at least, was exceptional in that he had a feeling and instinct for pictorial unity strong enough to overcome every consideration of realism that stood between him and style.

1942
1958

Abstract, Representational, and so forth

The tendency is to assume that the representational as such is superior to the nonrepresentational as such; that all other things being equal, a work of painting or sculpture that exhibits a recognizable image is always preferable to one that does not. Abstract art is considered to be a symptom of cultural, and even moral, decay, while the hope for a "return to nature" gets taken for granted by those who do the hoping as the hope for a return to health. Even some of the apologists of abstract art, by defending it on the plea that an age of disintegration must produce an art of disintegration, more or less concede the inherent inferiority of the nonrepresentational. And those other apologists who claim, rightly or wrongly, that abstract art is never entirely abstract, are really conceding the same. One fallacy usually gets answered by another; and so there are fanatics of abstract art who turn the argument around and claim for the nonrepresentational that same absolute, inherent and superior virtue which is otherwise attributed to the representational.

Art is a matter strictly of experience, not of principles, and what counts first and last in art is quality; all other things are secondary. No one has yet been able to demonstrate that the representational as such either adds or takes away from the merit of a picture or statue. The presence or absence of a recognizable image has no more to do with value in painting or sculpture than the presence or absence of a libretto has to do with value in music. Taken by itself, no single one of its

(Originally given, in somewhat different form, as a Ryerson Lecture at the School of Fine Arts, Yale University, May 12, 1954)

parts or aspects decides the quality of a work of art as a whole. In painting and sculpture this holds just as true for the aspect of representation as it does for those of scale, color, paint quality, design, etc., etc.

It is granted that a recognizable image will add conceptual meaning to a picture. but the fusion of conceptual with aesthetic meaning does not affect quality. That a picture gives us things to identify, as well as a complex of shapes and colors to behold, does not mean necessarily that it gives us more as *art*. More and less in art do not depend on how many varieties of significance are present, but on the intensity and depth of such significances, be they few or many, as are present. And we cannot tell, before the event—before the experience of it—whether the addition or subtraction of conceptual meaning, or of any other given factor, will increase or diminish the aesthetic meaning of a work of art. That *The Divine Comedy* has an allegorical and anagogical meaning, as well as a literal one, does not necessarily make it a more effective work of literature than the *Iliad*, in which we really discern no more than a literal meaning. The explicit comment on a historical event offered in Picasso's *Guernica* does not make it necessarily a better or richer work than an utterly "nonobjective" painting by Mondrian.

To hold that one kind of art must invariably be superior or inferior to another kind means to judge before experiencing; and the whole history of art is there to demonstrate the futility of rules of preference laid down beforehand: the impossibility, that is, of anticipating the outcome of aesthetic experience. The critic doubting whether abstract art can ever transcend decoration is on ground as unsure as Sir Joshua Reynolds was when he rejected the likelihood of the pure landscape's ever occasioning works as noble as those of Raphael.

Ambitious, major painting and sculpture continue in our time, as they always did in the past, by breaking with fixed notions about what is possible in art and what is not. If certain works of Picasso as well as Mondrian deserve to be considered

pictures, and certain works of Gonzalez as well as Pevsner deserve to be considered *sculpture*, it is because actual experience has told us so. And we have no more reason to doubt the validity of our experience than the contemporaries of Titian had to doubt theirs.

At this point I feel free, however, to turn around and say things perilously like those which I have just denied any one the right to say. But I will say what I have to say only about the abstract art I already know, not about abstract art in principle.

Free-standing pictorial and sculptural art, as distinct from decoration, was until a short while ago identified wholly with the representational, the figurative, the descriptive. Now it can be properly asked whether, in view of what painting and sculpture have achieved in the past, they do not risk a certain impoverishment by eliminating the representational, the figurative, the descriptive. As I have said, the nonrepresentational is not necessarily inferior to the representational—but is it not too little provided for, nevertheless, by the inherited, habitual, automatic expectations with which we approach an object that our society agrees to call a picture or statue? For this reason, may not even the best of abstract painting still leave us a little dissatisfied?

Experience, and experience alone, tells me that representational painting and sculpture have rarely achieved more than minor quality in recent years, and that major quality gravitates more and more toward the nonrepresentational. Not that most of recent abstract art is major; on the contrary, most of it is bad; but this still does not prevent the very best of it from being the best art of our time. And if the abstract is indeed impoverishing, then such impoverishment has now become necessary to important art.

But may it not be, on the other hand, that our dissatisfaction with abstract art—if it is a dissatisfaction—has its source not so much in our nostalgia for the representational, as in the

relatively simple fact that we are unable to match the past no matter how we paint or sculpt? May it not be that art in general is in decline? But if this is so, the dogmatic opponents of abstract art would be right only by accident, and on empirical, not principled or theoretical grounds; they would be right, not because the abstract in art is invariably a symptom of decline, but simply because it happens to accompany decline at this moment in the history of art, and they would be right only for this moment.

The answer may be even simpler, however—and at the same time more complicated. It may be that we cannot yet see far enough around the art of our own day; that the real and fundamental source of the dissatisfaction we may feel with abstract painting lies in the not uncommon problems offered by a new "language."

From Giotto to Courbet, the painter's first task had been to hollow out an illusion of three-dimensional space on a flat surface. One looked through this surface as through a proscenium into a stage. Modernism has rendered this stage shallower and shallower until now its backdrop has become the same as its curtain, which has now become all that the painter has left to work on. No matter how richly and variously he inscribes and folds this curtain, and even though he still outlines recognizable images upon it, we may feel a certain sense of loss. It is not so much the distortion or even the absence of images that we may mind in this curtain-painting, but rather the abrogation of those spatial rights which images used to enjoy back when the painter was obliged to create an illusion of the same kind of space as that in which our bodies move. This spatial illusion or rather the sense of it, is what we may miss even more than we do the images that used to fill it.

The picture has now become an entity belonging to the same order of space as our bodies; it is no longer the vehicle of an imagined equivalent of that order. Pictorial space has lost its "inside" and become all "outside." The spectator can

no longer escape into it from the space in which he himself stands. If it deceives his eye at all, it is by optical rather than pictorial means: by relations of color and shape largely divorced from descriptive connotations, and often by manipulations in which top and bottom, as well as foreground and background, become interchangeable. Not only does the abstract picture seem to offer a narrower, more physical and less imaginative kind of experience than the illusionist picture, but it appears to do without the nouns and transitive verbs, as it were, of the language of painting. The eye has trouble locating central emphases and is more directly compelled to treat the whole of the surface as a single undifferentiated field of interest, and this in turn, compels us to feel and judge the picture more immediately in terms of its over-all unity. The representational picture, seemingly (though only seemingly), does not require us to squeeze our reactions within such a narrow compass.

If, as I believe, abstract sculpture meets less resistance than abstract painting, it is because it has not had to change its language so radically. Whether abstract or representational, its language remains three-dimensional—literal. Constructivist or quasi-constructivist sculpture, with its open, linear forms and denial of volume and mass, may puzzle eyes attuned to the monolith, but it does not require them to be refocused.

Shall we continue to regret the three-dimensional illusion in painting? Perhaps not. Connoisseurs of the future may prefer the more literal kind of pictorial space. They may even find the Old Masters wanting in physical presence, in corporeality. There have been such reversals of taste before. The connoisseurs of the future may be more sensitive than we to the imaginative dimensions and overtones of the literal, and find in the concreteness of color and shape relations more "human interest" than in the extra-pictorial references of old-time illusionist art. They may also interpret the latter in ways quite different from ours. They may consider the illusion of depth and volume to have been aesthetically valuable *primarily* because it enabled and encouraged the artist to organize such

infinite subtleties of light and dark, of translucence and transparence, into effectively pictorial entities. They may say that nature was worth imitating because it offered, above all, a wealth of colors and shapes, and of intricacies of color and shape, such as no painter, in isolation with his art, could ever have invented. At the same time, these connoisseurs of the future may be able, in their discourse, to distinguish and name more aspects of quality in the Old Masters, as well as in abstract art, than we can. And in doing these things they may find much more common ground between the Old Masters and abstract art than we ourselves can yet recognize.

I do not wish to be understood as saying that a more enlightened connoisseurship will hold that *what*, as distinct from *how*, Rembrandt painted is an indifferent matter. That it was on the noses and foreheads of his portrait subjects, and not on their ears, that he piled the juiciest paint of his last manner has very much to do with the aesthetic results he obtained. But we still cannot say why or how. Actually, my own hope is that a less qualified acceptance of the importance of sheerly abstract or formal factors in pictorial art will open the way to a clearer understanding of the value of illustration as such—a value which I, too, am convinced is indisputable. Only it is not a value that is realized by, or as, *accretion*.

1954

The New Sculpture

Art looks for its resources of conviction in the same general direction as thought. Once it was revealed religion, then it was hypostatizing reason. The nineteenth century shifted its quest to the empirical and positive. The notion of the empirical and the positive has undergone much revision over the last hundred years, and generally become stricter and perhaps narrower. Aesthetic sensibility has shifted accordingly. The growing specialization of the arts is due chiefly not to the prevalence of the division of labor, but to our increasing faith in and taste for the immediate, the concrete, the irreducible. To meet this taste, the various modernist arts try to confine themselves to what is most positive and immediate in themselves.

It follows that a modernist work of art must try, in principle, to avoid dependence upon any order of experience not given in the most essentially construed nature of its medium. This means, among other things, renouncing illusion and explicitness. The arts are to achieve concreteness, "purity," by acting solely in terms of their separate and irreducible selves.

Modernist painting meets our desire for the literal and positive by renouncing the illusion of the third dimension. This is the decisive step, for the representational as such is renounced only in so far as it suggests the third dimension. Dubuffet shows that as long as the representational does not do that, taste continues to find it admissible; that is, to the extent that the representational does not detract from literal, sensational concreteness. Mondrian, on the other hand, has shown us that the pictorial can remain pictorial when every trace or suggestion of the representational has been eliminated. In short, neither the representational nor the third-dimensional

is essential to pictorial art, and their absence does not commit the painter to the "merely" decorative.

Abstract and near-abstract painting has proved fertile in major works, especially in this country. But it can be asked whether the modernist "reduction" does not threaten to narrow painting's field of possibilities. It is not necessary here to examine the developments inside abstract painting that might lead one to ask this. I wish to suggest, however, that sculpture—that long-eclipsed art—stands to gain by the modernist "reduction" as painting does not. It is already evident that the fate of visual art in general is not equated as implicitly as it used to be with that of painting.

After several centuries of desuetude sculpture has returned to the foreground. Having been invigorated by the modernist revival of tradition that began with Rodin, it is now undergoing a transformation, at the hands of painting itself, that seems to promise it new and much larger possibilities of expression. Until lately sculpture was handicapped by its identification with monolithic carving and modeling in the service of the representation of animate forms. Painting monopolized visual expression because it could deal with all imaginable visual entities and relations, and also because it could exploit the post-medieval taste for the greatest possible tension between that which was imitated and the medium that did the imitating. That the medium of sculpture was apparently the least removed from the modality of existence of its subject matter counted against it. Sculpture seemed *too* literal, *too* immediate.

Rodin was the first sculptor since Bernini to try seriously to arrogate to his art some of the essential, rather than merely illustrative, qualities of painting. He sought surface- and even shape-dissolving effects of light in emulation of Impressionism. His art, for all that it contains of the problematical, triumphed both in itself and in the revival of monolithic sculpture that it initiated. That revival shines with names like Bourdelle,

Maillol, Lehmbruck, Despiau, Kolbe, Marcks, Lachaise, Matisse, Degas, Renoir, Modigliani. But, as it now looks, the greatness of this revival was like the final flare-up of something about to die. To all intents and purposes, the Renaissance and monolithic tradition of sculpture was given its quietus by Brancusi. No sculptor born since the beginning of this century (except perhaps the Austrian, Wotruba) appears to be able any longer to produce truly major art in its terms.

Under the influence of Fauve painting and exotic carving (to which painters called his attention), Brancusi drove monolithic sculpture to an ultimate conclusion by reducing the image of the human form to a single geometrically simplified ovoid, tubular, or cubic mass. Not only did he exhaust the monolith by exaggerating it, but by one of those turns in which extremes meet, he at the same time rendered it pictorial, graphic. Then, while Arp and others carried his monolith over into abstract and near-abstract sculpture, Brancusi himself went on toward something still more radical. Once again taking his lead from painters, he began in his wood carvings to open up the monolith under the influence of Cubism. He then produced what are in my opinion his greatest works, and he had, as it were, a Pisgah view of a new kind of sculpture (at least for Europe) that lay altogether outside the orbit of monolithic tradition. I say Pisgah view because Brancusi did not actually pass over into this new kind of sculpture; that was left to painting and painters, and the real way to it was opened not by him, but by the Cubist collage.

The pieces of paper or cloth that Picasso and Braque glued to the surface of the collage acted to identify that surface literally and to thrust, by contrast, everything else on it back into illusionist depth. But as the language of the collage became one of larger and more tightly joined shapes; it grew increasingly difficult to unlock the flatness of its surface by this means. Picasso (before resorting to color contrasts and to more obviously representational shapes) solved—or rather

destroyed—the problem by raising the collage's affixed material above the picture surface, thus going over into bas-relief. And soon after that he subtracted the picture surface entirely, to let what had originally been affixed stand free as a "construction." A new tradition of sculpture was founded, and the fact that it was a new tradition was demonstrated subsequently in the works of the Constructivists, Picasso's own later sculpture, and in the sculpture of Lipchitz, Gonzalez and the earlier Giacometti.

The new construction-sculpture points back, almost insistently, to its origins in Cubist painting: by its linearism and linear intricacies, by its openness and transparency and weightlessness, and by its preoccupation with surface as skin alone, which it expresses in blade or sheet-like forms. Space is there to be shaped, divided, enclosed, but not to be filled. The new sculpture tends to abandon stone, bronze and clay for industrial materials like iron, steel, alloys, glass, plastics, celluloid, etc., etc., which are worked with the blacksmith's, the welder's and even the carpenter's tools. Unity of material and color is no longer required, and applied color is sanctioned. The distinction between carving and modeling becomes irrelevant: a work or its parts can be cast, wrought, cut or simply put together; it is not so much sculptured as constructed, built, assembled, arranged. From all this the medium has acquired a new flexibility in which I now see sculpture's chance to attain an even wider range of expression than painting.

Under the modernist "reduction," sculpture has turned out to be almost as exclusively visual in its essence as painting itself. It has been "liberated" from the monolithic as much because of the latter's excessive tactile associations, which now partake of illusion, as because of the hampering conventions that cling to it. But sculpture is still permitted a greater latitude of figurative allusiveness than painting because it remains tied, inexorably, to the third dimension and is therefore

inherently less illusionistic. The literalness that was once its handicap has now become its advantage. Any recognizable image is bound to be tainted with illusion, and modernist sculpture, too, has been impelled a long way toward abstractness; yet sculpture can continue to suggest recognizable images, at least schematically, if only it refrain from imitating organic substance (the illusion of organic substance or texture in sculpture being analogous to the illusion of the third dimension in pictorial art). And even should sculpture be compelled eventually to become as abstract as painting, it would still have a larger realm of formal possibilities at its command. The human body is no longer postulated as the agent of space in either pictorial or sculptural art; now it is eyesight alone, and eyesight has more freedom of movement and invention within three dimensions than within two. It is significant, moreover, that modernist sensibility, though it rejects sculptural painting of any kind, allows sculpture to be as pictorial as it pleases. Here the prohibition against one art's entering the domain of another is suspended, thanks to the unique concreteness and literalness of sculpture's medium. Sculpture can confine itself to virtually two dimensions (as some of David Smith's pieces do) without being felt to violate the limitations of its medium, because the eye recognizes that what offers itself in two dimensions is actually (not palpably) fashioned in three.

Such are what I consider to be present assets of sculpture. For the most part, however, they abide in a state of potentiality rather than of realization. Art delights in contradicting predictions made about it, and the hopes I placed in the new sculpture ten years ago, in the original version of this article, have not yet been borne out—indeed they seem to have been refuted. Painting continues as the leading and most adventurous as well as most expressive of the visual arts; in point of recent achievement architecture alone seems comparable with it. Yet one fact still suggests that I may not have been altogether wrong: that the new construction-sculpture begins to

make itself felt as most *representative*, even if not the most fertile, visual art of our time.

Painting, sculpture, architecture, decoration and the crafts have under modernism converged once again in a common style. Painting may have been the first to begin closing out historical revivalism, in Impressionism; it may have also been the first, with Matisse and Cubism, to give positive definition to modernist style. But the new sculpture has revealed the unifying characteristics of that style more vividly and completely. Having the freedom of a fine art yet being, like architecture, immersed in its physical means, sculpture has had to make the fewest compromises.

The desire for "purity" works, as I have indicated, to put an ever higher premium on sheer visibility and an ever lower one on the tactile and its associations, which include that of weight as well as of impermeability. One of the most fundamental and unifying emphases of the new common style is on the continuity and neutrality of a space that light alone inflects, without regard to the laws of gravity. There is an attempt to overcome the distinctions between foreground and background; between occupied space and space at large; between inside and outside; between up and down (many modernist buildings, like many modernist paintings, would look almost as well upside down or even on their sides). A related emphasis is on economy of physical substance, which manifests itself in the pictorial tendency to reduce all matter to two dimensions— to lines and surfaces that define or enclose space but hardly occupy it. To render substance entirely optical, and form, whether pictorial, sculptural or architectural, as an integral part of ambient space—this brings anti-illusionism full circle. Instead of the illusion of things, we are now offered the illusion of modalities: namely, that matter is incorporeal, weightless and exists only optically like a mirage. This kind of illusionism is stated in pictures whose paint surfaces and enclosing rectangles seem to expand into surrounding space; and in buildings that,

apparently formed of lines alone, seem woven into the air; but better yet in Constructivist and quasi-Constructivist works of sculpture. Feats of "engineering" that aim to provide the greatest possible amount of visibility with the least possible expenditure of tactile surface belong categorically to the free and *total* medium of sculpture. The constructor-sculptor can, literally, draw in the air with a single strand of wire that supports nothing but itself.

It is its physical independence, above all, that contributes to the new sculpture's status as the representative visual art of modernism. A work of sculpture, unlike a building, does not have to carry more than its own weight, nor does it have to be *on* something else, like a picture; it exists for and by itself literally as well as conceptually. And in this self-sufficiency of sculpture, wherein every conceivable as well as perceptible element belongs altogether to the work of art, the positivist aspect of the modernist "aesthetic" finds itself most fully realized. It is for a self-sufficiency like sculpture's, and sculpture's alone, that both painting and architecture now strive.

1948
1958

Partisan Review "Art Chronicle": 1952

We cannot be reminded too often of how decisive honesty is in art. It does not guarantee anything—the artist has to have something to be honest with and about—yet it is essential and it can never be separated from the procedures of talent. Honesty without talent might be said to be incomplete honesty—like the honesty of "primitive" painting, like the honesty even of Henri Rousseau (Le Douanier), who has lately begun to bore us just a little. Complete honesty has nothing to do with "purity" or naivety. The full truth is unattainable to naivety, and the completely honest artist is not pure in heart.

An object lesson in this respect is offered by the earliest works of Matisse, as seen in his large retrospective at the Museum of Modern Art in New York (Fall and Winter 1951-1952). Like any other artist, Matisse worked at first in borrowed styles; but if he appears to have proceeded rather slowly toward the discovery of his own unique self, it was less out of lack of self-confidence than because of very sophisticated scruples about *his* truth. He had to make sure, before he could move toward independence, that he really felt differently and had different things to say than did those artists whom he admired and by whom he was influenced. He went on doubting himself this way for fifteen years after he had started painting —which was at the late age of twenty-one—and he continued to hesitate long after he had broken with the Impressionist canon of the well-made picture. His hesitations were openly confessed—but they also had a lot to do with the exceptional mastery of his craft that he finally acquired. Matisse became

a master artisan, a handler of color and oil and surface, in a sense that Picasso, for one, never did.

The retrospective show at the Museum of Modern Art, though not as large as that which the Philadelphia Museum gave Matisse in 1948, and duplicating, as it must, a good part of the latter, strikes one as better chosen. It includes, moreover, several of the interiors painted late in 1947 and early in 1948, which were not available for the Philadelphia show, and which perhaps amount to the strongest things Matisse has done since the twenties. The New York show also contains some of his recent designs for the decoration and appurtenances of a Dominican chapel in the south of France; but even more important, it offers the largest amount of Matisse's sculpture this country has yet had the chance to see gathered together in one place. On the other hand, his landscapes, which are one of the most luminous aspects of his entire *oeuvre* (even though he himself professes no special inclination for this genre), continue to be scanted.

The New York show confirms what one had begun to recognize in Philadelphia: that Matisse had not relaxed as much during the twenties as was previously supposed. He may have returned to Chardin and to Manet, to the Impressionist still life of the 1870s, and to firmer and more conventional modeling; he may have turned away from the prospect of an abstract art toward which his development during the 1910s seemed to be leading him, and he may have ceased from spectacular adventuring; but it was far from being a real *détente*. Reviewing and consolidating his affinities with nineteenth century French painting from Corot to Cézanne, he painted with a new subtlety from which the past received new illumination. He, the great exponent of pure color, showed what modeling in light and dark could still achieve, and how much it could still contribute to the new tightness of modern composition— just as he had demonstrated, between 1914 and 1918, how blacks, grays and whites could be made to approximate the effect of flat prismatic color.

The unconscious irony of the frequent references to Matisse as a "mere" decorator lies in the fact that pure decoration is the department in which he has failed most often. Most of what I have seen of his tapestry designs, book decorations, smaller paper cutouts and even of his murals leaves me cool, and only the more persuaded that he is an easel painter from first to last.[1] This truth is obscured—if it actually is—by the unprecedented success with which he has assimilated to easel painting devices that used to seem irredeemably decorative. An excess of the decorative may appear to be responsible for the consistent failure of his easel pictures in the thirties and early forties, when he radically flattened and generalized every painted shape, with a view, apparently, to a more immediate surface impact; but far from being too decorative, these works would have actually benefited, one feels, from being more so— from being more abstract or at least from excluding the human figure. That this might have been the solution for an art of sheer silhouetting like Matisse's in that period, is suggested by the superiority of those of his 1947-1948 interiors from which the human figure is omitted (*Red Interior* and *The Pineapple*). The human form for Matisse, as for Picasso, in those same years, had become unmanageable within a shallow illusion of depth, not only because he accorded it certain privileges of verisimilitude and emphasis that disrupted the unity of the kind of paintings into which it was introduced, but also because the associations of the human form could no longer be controlled *pictorially*.

Matisse's sculpture is further evidence, and the least ambiguous, of how intrinsically little his impulse to art has to do with the decorative. That his sculpture possesses quality, we

[1] At the time of writing, I had not seen—nor were most of them yet in existence—the huge cut-out designs to which Matisse devoted his very last years. For me, some of these constitute, along with some almost equally large Mathieu oils, the supreme achievement of French pictorial art in the 1950s. I say "pictorial" advisedly, because these cutouts confirm my point by being more truly pictorial than decorative, in spite of the fact that Matisse intended several of them to serve mainly decorative ends.

know, but I doubt whether the range and consistency of that quality has been fully appreciated as yet. He is surely one of the very great, if unprolific, sculptors of our time. We may be a little puzzled by the fact that the artist who did more than anyone since Gauguin (not excepting Mondrian) to exclude sculptural effects from painting should at the same time be so much at home in sculpture, and as a modeler too, not a constructor—and a modeler in a rather traditional vein at that—but we may just as well be puzzled by the larger fact that the master painters who began to do sculpture again in the nineteenth century were all modelers, not carvers, and most of them were as antisculptural as Matisse in their painting. Degas and Renoir were Impressionists, and what could be more antisculptural than Impressionism? The explanation, or part of it, may lie in nineteenth-century painting's new preoccupation with certain concrete facts of the medium, which made even pre-modernist artists like Géricault and Daumier more highly conscious of how the edges of a shape cut into the space around it. This was the problem that haunted Cézanne, though he never tried to work it out in sculpture, and Matisse inherited in the end almost as many of Cézanne's preoccupations as the Cubists did.

An exhibition (at Curt Valentin's) of recent works by Gerhard Marcks, the German sculptor, offered a different kind of lesson in honesty. Though Marcks is over sixty, and his name long known, his art came to New York like a new kind of dispensation. Most of the things shown were done since 1942, many of his earlier bronzes having been melted down by the Nazis or otherwise destroyed. Marcks is not a revolutionary phenomenon; he follows where Rodin, Despiau and Kolbe have already led; and he even archaizes a little, as so many lesser contemporary sculptors do, taking certain of his ideas from late medieval German wood carving. But Marck's lack of conspicuous originality matters far less than the stubbornness with which he insists on exactly what is given him by his feel-

ings. The irreplaceability of art that is permeated by *obvious* feeling turns out to be an issue on which I can agree in principle with the opponents of modernism now that I have had my fill of Henry Moore and artists like him. The innovation that is arranged instead of *felt* is neither a real innovation nor authentic art; I am sure that I would prefer Moore as a straightforwardly academic artist. For that matter, I found the earliest and most conventional nude in Marck's show, the bronze *Brigitta* (1935), the best among the seven or eight (at least) superb pieces it contains.

Marcks tends to go astray only when he attempts humor. Here it is a question of feeling *about* feeling, and feeling about feeling often produces sentimentality or, as in this case, cuteness. Still, an artist's successes are never compromised by his failures, and I continue to prefer Marck's "Nordic depth" to the showy morbidness of the recent Giacometti, or the archaic piquancy of Marini.

Barnett Newman's two one-man shows, last year and the year before (at Betty Parsons'), displayed both nerve and conviction. I review them at this late date because I feel that the art public should continue to be reminded of anything by which it has been puzzled (we must all learn that a puzzled reaction can legitimately produce nothing more than a suspended judgment). And also because I feel that works of art which genuinely puzzle us are almost always of ultimate consequence. Newman happens to be an important as well as original painter. His pictures have little to do with Mondrian or geometric abstract art in general, even if they do consist of no more than a few parallel straight lines of paint—sometimes only a single one—running down a wide contrasting field that is often just barely contrasting. Newman's emphasis is predominantly on color, which in his case is sensuous without being soft, and his effect is usually much warmer and more painterly than that which we get from Mondrian or his followers. Newman does not intend to startle or shock, though it

may seem so; he keeps within the tacit and evolving limits of the Western tradition of painting. The result may be neither easel painting nor mural in the accepted sense, but this makes no essential difference. In the presence of these canvases one realizes immediately that he is faced by major art.

Newman took a risk, whether he knew it or not, and he has paid for it in terms of public recognition. But those who resent his work should be given pause by the very violence with which they do so. A vehemently hostile reaction is almost always a sign that habits of taste are being threatened. If it were a question of bad art, or really "not art," one's reaction would tend to be one of contempt rather than of anger. That so many artists in New York who are supposed to be avant-garde were upset by Newman's painting reflects more on them than on him.

Another painter who has affirmed his importance with only two shows (at Charles Egan's) is Franz Kline, who has had a far better reception from his fellow-artists than Newman, even if the museums, the collectors and the newspaper critics continue to be wary (and it would make me distrust my own reactions to Kline's art if they were not). Kline's large canvases, with their blurted black and white calligraphy, have the kind of self-evident tautness which has become identified with modernist painting since Cézanne. He, too, has stripped his art down, in order to be sure of it—but for his own sake, not for the sake of the public. His originality lies in the way in which he maintains a Cubist contact with the edges of his canvas while opening up a seemingly un-Cubist or post-Cubist ambiguity of plane and depth elsewhere. Though presenting signs and marks floating free on a clear and expanding field, his pictures actually repeat—and in fact, succeed most when they do so most—the solid, one-piece Cubist rectangle with its emphatic enclosing shape. Three or four of the paintings Kline has shown already place him securely in the foreground of contemporary abstract art, yet I have the impression that the

powers of this gifted and accomplished artist are still a little inhibited. But perhaps this is precisely what one should feel.

Jackson Pollock's problem has never been one of authenticity; rather, it is to find the means to cope with the literalness of his emotion, which is of a kind that seems foreign at first to pictorial art. And though he may overpower his means at times, he rarely falsifies them; he may turn out bad pictures, but they are hardly ever unfelt ones. His last show (at Parsons') indicates a turn but not a reversal of direction. While there is a note of relaxation, the actual results are no more relaxed than before, and new triumphs are again celebrated. Like Kline's pictures in black and white exclusively but on unprimed and even unsized canvas, Pollock's new pictures hint at innumerable unplayed cards still in his hand—and also perhaps, at the relatively large future that remains to easel painting. Recognizable images appear—figures, faces, fragments of a wolf-like anatomy reminiscent of things seen in Pollock's pre-1947 art; and the design is articulated in a more traditionally illusionist way, so that imagined space does not state itself as uniformly as before throughout the picture. However, everything that Pollock has acquired in the course of his "all-over" phase remains, to endow these works with a kind of density unknown to orthodox easel painting. It is not a question of packing and crowding, but of intensification and economy: every square inch of the surface receives a maximum of charge at the cost of a minimum of physical means. Whereas Pollock had striven over the previous four years for a kind of corporeality by which he could wrest the picture surface, as surface, away from itself, now he seems to want to volatilize the paint alone and render it a fact less local to that surface.

Contrary to the impression some of his friends entertain, this writer does not take Pollock's art uncritically. I have at times pointed out what I believe are some of its shortcomings, particularly with respect to color. Yet the weight of the evidence convinces me—and more than ever after this last show—

that Pollock is in a class by himself. Others may have greater gifts or maintain a more even level of success, but no painter in this period *realizes* so strongly, so truly or so completely. Pollock does not offer samples of miraculous handwriting, he gives us achieved and perfected works of art, beyond accomplishedness, facility or taste. Such pictures as *Fourteen* and *Twenty-Five* in this last show attain a classical kind of lucidity in which there is not only identification of form and feeling, but an acceptance and exploitation of the very circumstances of the medium which limit that identification. Were Pollock a Frenchman, there would be, I feel, no need by now to call attention to my objectivity in praising him; he would already be called *maître* and there would already be speculation in his pictures. Here in this country, the museums, the collectors and the critics will continue—out of fear if not out of incompetence—to refuse to believe that we have at last produced the best painter of a whole generation; and they will continue to distrust both themselves and the things nearest them.

1952

The Crisis of the Easel Picture

The easel painting, the movable picture hung on a wall, is a unique product of the West, with no real counterpart elsewhere. Its form is determined by its social function, which is precisely to hang on a wall. To appreciate the uniqueness of the easel picture, we have only to compare its modes of unity with those of the Persian miniature or the Chinese hanging painting, neither of which matches it in independence of the requirements of decoration. The easel picture subordinates decorative to dramatic effect. It cuts the illusion of a box-like cavity into the wall behind it, and within this, as a unity, it organizes three-dimensional semblances. To the extent that the artist flattens out the cavity for the sake of decorative patterning and organizes its content in terms of flatness and frontality, the essence of the easel picture—which is not the same thing as its quality—is on the way to being compromised.

The evolution of modernist painting, beginning with Manet, is constituted in good part by the evolution toward such a compromise. Monet, Pissarro and Sisley, the orthodox Impressionists, attacked the essential principles of the easel painting through the consistency with which they applied divided colors; the operation of these colors remained the same throughout the picture, every part of which was treated with the same kind and emphasis of touch. The result became an evenly and tightly textured rectangle of paint that tended to muffle contrasts and threatened—but only threatened—to reduce the picture to a relatively undifferentiated surface.

The consequences of orthodox Impressionism did not work themselves out coherently in time. Seurat pushed divisionism to a logical conclusion, making something almost mechanically systematic out of it, but in his desire for clarity of design he

turned divided color away from its inherent tendency toward a relatively undifferentiated surface, and used it for a new kind of light and dark contrast. While still making the picture shallower, he continued to build it on dominant shapes. Cézanne, Van Gogh, Gauguin, Bonnard, Matisse went on reducing the fictive depth of painting, but none of them, not even Bonnard, attempted anything quite so radical in its violation of traditional principles of composition as the middle and later Monet did. For no matter how shallow the picture becomes, as long as its shapes are sufficiently differentiated in terms of light and dark, and kept in dramatic imbalance, it will remain an easel painting. It was precisely at these points that Monet's later practice threatened the easel-picture convention, and now, twenty years after Monet's death, his practice has become the point of departure for a new tendency in painting.

This tendency appears in the all-over, "decentralized," "polyphonic" picture that relies on a surface knit together of identical or closely similar elements which repeat themselves without marked variation from one edge of the picture to the other. It is a kind of picture that dispenses, apparently, with beginning, middle, end. Though the "all-over" picture will, when successful, still hang dramatically on a wall, it comes very close to decoration—to the kind seen in wallpaper patterns that can be repeated indefinitely—and insofar as the "all-over" picture remains an easel picture, which somehow it does, it infects the notion of the genre with a fatal ambiguity.

I am not thinking of Mondrian in particular at this moment. His attack on the easel picture was radical enough, for all its inadvertence, and the paintings of his maturity are ostensibly among the flattest of all easel pictures. But dominating and counter-posed shapes, as provided by intersecting straight lines and blocks of color, are still insisted upon, and the surface still presents itself as a theater or scene of forms rather than as a single, indivisible piece of texture. All-over, "polyphonic" painting, with its lack of explicit oppositions, is perhaps anticipated by Mondrian, but in this sense it is also

anticipated by Picasso's and Braque's Analytical Cubism and by Klee, and even by Italian Futurism (though more as a vivid premonition thanks to Futurism's decorative heightening of Analytical Cubism, than as a source or influence). So that what we have to do with here is not an eccentricity or quirk in the evolution of modernist art. The diversity alone of the places in which "all-over" painting has appeared since the war should attest to that. In Paris the tendency to "polyphonic" painting has already made itself felt in some of Jean Dubuffet's larger canvases, and here and there in the works of several of the other artists shown at the Galerie Drouin. Another at least partial exponent of "all-over" painting is that subtle Uruguayan painter, Joaqúin Torres-Garcia. In this country it has been arrived at more or less independently by artists as different in provenance and temper as Mark Tobey, Jackson Pollock, the late Arnold Friedman, Rudolf Ray, Ralph Rosenborg and Janet Sobel. The larger landscapes of Mordecai Ardon-Bronstein, in Palestine, likewise tend to be "polyphonic" in composition, if only because the subjects Ardon-Bronstein works from are "monotonously" designed in themselves; but what is significant is that he dares to accept this monotony.

I have advisedly borrowed the term "polyphonic" from music, encouraged to do so by the use to which Kurt List and René Leibowitz put it in their music criticism, with particular reference to Schönberg's methods of composition. Daniel-Henry Kahnweiler, in his important book on Gris, has already sought to establish a parallel between Cubism and twelve-tone music, but in such general terms as to be almost beside the point: Mr. Kahnweiler makes it a question simply of restoring order or "architecture" to arts threatened by "formlessness."

The parallel I see is more specific. Mondrian's term, "equivalent," is to the point here. Just as Schönberg makes every element, every sound in the composition of equal *importance*—different but *equivalent*—so the "all-over" painter renders every element and every area of the picture equivalent in accent and emphasis. Like the twelve-tone composer, the

"all-over" painter weaves his work of art into a tight mesh whose scheme of unity is recapitulated at every meshing point. The fact that the variations upon equivalence introduced by a painter like Pollock are sometimes so unobtrusive that at first glance we might see in the result not equivalence, but an hallucinatory uniformity, only enhances the result.

The very notion of uniformity is antiaesthetic. Yet many "all-over" pictures seem to succeed precisely by virtue of their uniformity, their sheer monotony. The dissolution of the pictorial into sheer texture, into apparently sheer sensation, into an accumulation of repetitions, seems to speak for and answer something profound in contemporary sensibility. Literature provides parallels in Joyce and in Gertrude Stein, perhaps even in the cadences of Pound's verse and in the packed stridencies of Dylan Thomas. The "all-over" may answer the feeling that all hierarchical distinctions have been, literally, exhausted and invalidated; that no area or order of experience is intrinsically superior, on any final scale of values, to any other area or order of experience. It may express a monist naturalism for which there are neither first nor last things, and which recognizes as the only ultimate distinction that between the immediate and the un-immediate. But for the time being, all we can conclude is that the future of the easel picture as a vehicle of ambitious art has become problematical. In using this convention as they do—and cannot help doing—artists like Pollock are on the way to destroying it.

1948

Modernist Sculpture,
Its Pictorial Past

The present intimacy between sculpture and painting is not new in itself. They have intervened in one another's development at many times in the past. Now one and now the other has done the leading and the influencing, and neither art has been able to wrest itself free from the influence of the other for very long. Sculpture would seem to have had the ascendancy in the early stages of every naturalistic tradition, the pictorial in its later stages, but in each case the ascendant art continued to some degree to rely upon and wrestle with, notions proper to the other.

According to such meager evidence as we have, sculpture presided over the beginnings of Greek painting, and was "subdued" by the latter only at the end, when Greco-Roman carving reverted to bas-relief for its major statements, and then disappeared finally into the frescoed or tesselated wall. And the pictorial remained very much in command through the earliest phases of medieval art, while sculpture was struggling to become more than architectural ornament. The tubular forms, the linear scoring, even the color of Romanesque carving reveal how much its makers consulted the pictorial art of their time; and the reliefs on the tympani of many twelfth-century French churches can be likened to embossed drawings.

Only when it became Gothic did sculpture overtake painting and become the dominant art—which was also when lifelikeness became a main concern of Christian art in general. Sculpture, free in principle to stand in the round even when it graced a pillar or a niche, could reproduce the three-dimensional more directly than could painting. Painting was at the

same time deprived of its walls and confined to the miniature, or else transferred to the church window, where it became more decorative than pictorial. And though the decoration was of a uniquely lofty and exalted kind, it remained subservient to architecture in a way that sculpture no longer did.

It was the literalness of the medieval imagination that made sculpture congenial to it—to transpose stereometric reality into a stereometric medium instead of a planimetric one put less strain on one's powers of abstraction. There was also the fact—but one which became important only somewhat later on —that the remains of realistic Roman sculpture happened to be far more abundant than those of realistic Roman pictorial art.

Painting reawakens at the beginning of the fourteenth century, but sculpture continues for another two hundred years to teach it how to shade and model, and how to pose and arrange its subjects. In his *Treatise on Painting* (1463) Leon Battista Alberti writes: ". . . I would rather have you copy an indifferent sculpture than an excellent painting. Because from paintings you will gain nothing further than the ability to copy accurately, but from statues you can learn both to copy accurately and represent light and shade." Then and later, painters made little models of clay and plaster not only in order to paint directly from, but also to solve problems of composition—it still being easier to visualize deep space, and volumes in deep space, through sculptural reproduction than through direct observation. Even in Flanders and the Rhineland, where the new painting took more from the miniature than it did in Italy, sculpture continued to act as chief guide of pictorial art.

But after helping, sculpture began inevitably to hinder painting's development of a realism proper to itself. What is even more miraculous in Van Eyck's art than its sheer quality is the suddenness and completeness with which it breaks away from sculptural influences—for example, in a painting like the Philadelphia version of *St. Francis Receiving the Stigmata.* Nevertheless, the Flemish masters who come right after Van Eyck stay as close to sculpture throughout as he himself did

in his *grisaille* panels, and it is only after another hundred years, and in Venice, that a realism is attained which is as consistently pictorial as the realism of the stone carvings at Rheims and Naumburg is consistently sculptural. And only towards the end of the sixteenth century does painting become free enough from the tutelage of sculpture to begin to outdo it in realism. Then color really starts to breathe, and contours to melt. Thereafter, no serious effort is made to remember sculpture in painting until David, in the last quarter of the eighteenth century, feels himself called on to reinvoke classical sculpture in order to rescue painting from an excess of painterliness.

As painting perfected itself in realism, the relations between sculpture and itself became reversed; as far back even as Donatello, painting had begun to insinuate its own kind of realism into sculpture. Yet this was also part of the logic proper to sculpture's own development (according to W. R. Valentiner, sculpture has an inherent tendency to evolve from the architectural to the pictorial). Donatello's art is the achievement it is because, no matter how much the pictorial contributes to it, the contribution is still made on sculpture's own terms; and this also applies more or less to the art of Quercia, Ghiberti and the other master carvers of the fifteenth century in Italy. Only with Michelangelo does the pictorial acquire enough ascendancy over sculpture to begin to limit and adulterate it. Michelangelo's gift for carving does not make it any the less a fact that he realized himself best on a flat surface. The most sculptural of painters, he was also, in the deepest but also most morbid way, the most pictorial of sculptors. Some years ago Wyndham Lewis wrote in *The Listener*: "How Michelangelo's titanic dreams are betrayed when they emerge in marble! What a sadly different thing the Sistine 'Adam' would be in white marble. The Greek naturalism, in some way, was neutralized in the flat. To affect to prefer Michelangelo's sculpture to his other forms of expression, including poetry, is the result of the literary approach."

However, what really spoils Michelangelo's sculpture is not so much its naturalism as, on the contrary, its unnaturalistic exaggerations and distortions, which place themselves more in the context of pictorial illusion than in that of sculptural self-evidence. And even Michelangelo's carved surfaces partake of the pictorial, to the extent that their hard, shiny patina, on top of the voluble modeling, tends to deny the resistant weight of stone. This may help explain why his unfinished carvings are generally his best.

Sculpture languished for the next three centuries under Michelangelo's conception of it—in practice, if not theory, sculpture became largely a question of shading on a blank and neutral ground—something that was not too far from what was involved in glaze painting (as Michelangelo's own paintings are there to testify). A few good and perhaps even great sculptors appeared during that long interval, but they had to cope with an audience whose taste was formed predominantly by pictorial art and sentimental archeology. Baroque sculpture, at its best, attempts to challenge painting on its own ground; afterwards, the most successful sculpture is more likely than not to be found in informal studies or maquettes from which the Michelangeloesque notion of finish is excluded.

When sculpture at last revived in the mid-nineteenth century, it was, ironically enough, under the ministrations of painters who practiced it only occasionally. What is more, they were painterly painters (who, when they made sculpture, modeled and never carved), not sculptural ones on the order of Ingres or David. An increased dose of the poison under which sculpture had sickened in the first place seemed to be required to cure it, and the antidote to the sculptor-draftsman's excessive concern with sharp contours and delicate modeling proved to be the painterly indulgence in blocked-in, summary masses and roughened outlines. From Géricault and Daumier through Degas and Renoir to the younger Matisse, the general level of sculpture done by master painters is higher than that of the work of all but a very few full-time sculptors.

Painterly sculpture culminated, nonetheless, in Rodin, the most professional of professional sculptors. Rodin was reproached for adulterating his art with Impressionist effects, which may be true up to a point (yet not half so true as in Medardo-Rosso's case); even so, bronze and stone itself began to live again under his hands with a life they had not known for centuries. Sculpture learned once again, from Rodin's example and precepts, to respect the original monolith, and Maillol, Despiau, Bourdelle, Lehmbruck, Kolbe, Marcks, Lachaise, the later Lipchitz and even Laurens—all of them indebted to painting as well as to Rodin—began to seek a compactness that was new only because it had been forgotten. And along with compactness, the true monumentality of which sculpture was capable began to replace that merely emblematic kind which the Baroque had installed.

But this recovery of the monolith turned out to be like the last magnificence of a setting sun. The emphasis on it, and the consciousness of the emphasis, were part of an effort to cling to something that was felt, somehow, to be in even greater jeopardy than before. Brancusi, under the influence of Cézannian and Cubist painting as much as anything else, pursued the monolith to an ultimate extreme, to the point indeed where sculpture suddenly found itself back in the arms of architecture. This time, however, it was not sculpture as ornament, but as a kind of art that approached the condition of architecture in itself—as pure architecture or as monument. And in this condition sculpture became accessible once more to flat and linear handling.

Its situation at this juncture might have been like that of early Romanesque sculpture, if Cubist painting—*not* Cubist sculpture—had not been on hand to force the situation still further. The intervention of Cubist painting had the effect of driving sculpture beyond itself, beyond modeling and carving, and transforming it into an art that was neither pictorial—at least not in the accepted sense—nor sculptural, neither bas-relief nor monolith, but something for which the only prece-

dent I know of is the open, painted wood carving of northern New Ireland in the South Seas. How this transformation came about, I try to explain in more detail elsewhere (pages 78 and 140). Suffice it to say here that the fates of sculpture and pictorial art seem more closely intertwined at this moment than ever before in historical art.

1952

Wyndham Lewis Against
Abstract Art

Eliot has called Wyndham Lewis "the greatest prose stylist of my generation—perhaps the only one to have invented a new style." I find this exaggerated, but even if it were not, Lewis would still have paid too dearly for the distinction. The metallic bounce and mechanical rapidity of his prose are made possible by the evasion of any and every challenge to sustained thought or sustained feeling. Nothing, whether on the plane of reason or that of imagination, gets developed in his writing. (This may explain why so many people can read him only in snatches.)

Lewis is not the first presumably serious critic categorically to denounce "extremism"—more specifically, abstractness—in painting and sculpture. And he is not the first, nor will he be the last, from whose rough hands it emerges unilluminated as well as unscathed. This is small failure for a small book. The enterprise of antimodernism, whether in book, magazine, or newspaper column, remains a frustrated one—for Berenson as much as for Robsjohn-Gibbing or Howard Devree—and it must remain that as long as it remains a priori and categorical. One cannot condemn tendencies in art; one can only condemn works of art. To be categorically against a current art tendency or style means, in effect, to pronounce on works of art not yet created and not yet seen. It means inquiring into the motives of artists instead of into results. Yet we all know—or are supposed to know—that results are all that count in art.

Nineteen out of twenty—nay, ninety-nine out of a hundred

(A review of *The Demon of Progress in the Arts,* by Wyndham Lewis, published by Henry Regnery Company in 1955)

—works of abstract art are failures. Perhaps the ratio of success to failure was the same in Renaissance art, but we shall never know, since bad art, even in ages considered to have had bad taste, tends to disappear faster than good art. But even if the proportion of bad to good were higher nowadays, and higher in the field of abstract art in particular, it would still remain that some works of abstract art are better than others. The critic of abstract art is under the obligation to be able to tell the difference. The inability to do, or even try to do so, is what more immediately makes denunciations like Lewis' suspect. And the suspicion is not allayed in this case by the statement that Moore, Sutherland, Bacon, Colquhoun, Minton, Craxton, Pasmore, Trevelyan, Richards and Ayrton form "actually the finest group of painters and sculptors which England has ever known."

Sir Herbert Read, supposedly an all-out champion of "extremism" (which he is not, and it would make no difference if he were), is an incompetent art critic. Lewis, to judge from his contributions to *The Listener*, is a superb one when confining himself to the past (see, for example, his remarks on the superiority of Michelangelo's painting to his sculpture). But nothing of his usual keenness as a critic enters into his polemic against abstract art. It is as if the phenomenon had paralyzed his taste. And while Sir Herbert, who has no taste—not even paralyzed taste—will be furtively, surreptitiously incoherent, Lewis is unabashedly so, and the difference is only limitedly in his favor. Art criticism is equally a victim, and Lewis is capable of traducing the discipline by an equal amateurishness. It is from Sir Herbert, not from Lewis (who has, or had, after all, a *real* as well as practical relation with painting) that we would expect the remark that Cubism was a "borrowing . . . from science."

In spite of his title, Lewis nowhere in his book attacks the "demon of progress" frontally. And just whom could he quote as believing that Mondrian and Pollock were greater painters than Titian and Rembrandt? Like the other denounc-

ers of "extremist" art (Berenson is the only exception I know), rather than consider actual specimens of it, he prefers to animadvert upon its social context, its audience, and the rhetoric of its champions—just as, over here, samples of *Art News* prose are so often brandished as the clinching point against "abstract expressionism."

Lewis explains the popularity of abstract art by its usefulness as a concealment for artists who lack talent and/or training; and by the fact that painting and sculpture cost less to bring before the public than music, drama, dance or literature; and by the further fact that

mass-life today is the worst kind of thing for an appreciation of the arts, or of any cultural product. . . . The absurd things which are happening in the visual arts at present are what must happen when an art becomes almost totally disconnected from society, when it no longer has any direct function in life, and can only exist as the plaything of the intellect.

What truth there is in this is badly and even dishonestly stated (Lewis himself would be hard put to define the role of the "intellect" in either the making or the appreciation of any art). But I am surprised most of all by Lewis' bothering to repeat, with self-satisfied asperity, as if it were a fresh and startling truth, what has been said a thousand times before, and not always with such a banal absence of qualification.

1957

Byzantine Parallels

Of all the great traditions of pictorial naturalism, only the Greco-Roman and the Western can be said to be sculpturally oriented. They alone have made full use of the sculptural means of light and shade to obtain an illusion of volume on a flat surface. And both these traditions arrived at so-called scientific perspective *only* because a thoroughgoing illusion of volume required a consistent illusion of the kind of space in which volume was possible.

The tendency of modernist painting has been to turn the conventions of sculptural naturalism inside out, and to create thereby a kind of pictorial space that would invoke no sense other than that of sight. With tactility excluded, shading and perspective disappear. Modernist sculpture itself, recognizing that it is enjoyed visually in the main, has followed painting in the trend toward the exclusively optical, becoming in its Constructivist manifestations more and more an art of aerial drawing in which three-dimensional space is indicated and enclosed but hardly filled.

Not a preference for the "abstract" as such, but confinement either to flat pictorial or open sculptural space accounts for the progressive elimination of the representational. Anything that suggests a recognizable entity (and all recognizable entities exist in three dimensions) suggests tactility or the kind of space in which tactile experience is possible. Modernist painting and sculpture are alienated not so much from "nature" as from the nonvisual.

Realism, naturalism, illusion have attained extremes in Western art that were reached nowhere else. But nowhere else, either, has art ever become as opaque and self-contained, as

wholly and exclusively art, as it has in the very recent Western past. It is as if this extreme could have been produced only by its opposite.

Once before, however, a system of sculptural illusion in pictorial art underwent a devolution that converted it into a means for attaining effects that were the antithesis of sculptural. In Late Roman and in Byzantine art, the naturalistic devices of Greco-Roman painting were turned inside out to reaffirm the flatness of pictorial space; light and shade—the means par excellence of sculptural illusion—were stylized into flat patterns and used for decorative or quasi-abstract ends instead of illusionist ones. Just as with our modernists, literalness was recovered through the means of illusion itself, and attained its impact and significance from the contradiction. That significance would not have been as great, artistically, had the literalness issued from a pictorial tradition that had been less oriented in the first place toward the sculptural and the illusionist; the power of Cubism and of Byzantine mural art alike implies the wrench, and the "dialectic," by which a long and rich tradition has reversed its direction; it is in part *retroactive* power.

Parallels between Byzantine and modernist art abound in sculpture too. Like modernist construction, Byzantine carving tended toward pictorial, nontactile effects; it concentrated on bas-relief, and made bas-relief itself lower, less rounded and modeled, more undercut and perforated, than it had been in Greco-Roman practice. Simultaneously, the distinction between the decorative and the nondecorative tended to get blurred, whether in painting or sculpture, just as it has been in modernist art. And while the Byzantines never renounced the representational in principle, it is possible to discern in Iconoclasm, despite the fact that its motives were entirely religious, the echo of certain aesthetically felt objections to the figurative. Nor has the advent of the completely abstract easel picture (which is to say, of nonrepresentational art in a representational context), or the more recent supersession of Cubist flatness by an even more ambiguous Impressionist kind, really narrowed

the parallels between modernist and Byzantine pictorial art. Neither Byzantine nor modernist art has rested with the mere dismantling of sculptural illusion. Byzantine painting and mosaic moved from the beginning toward a vision of full color in which the role of light-and-dark contrast was radically diminished. In Gauguin and in Late Impressionism, something similar had already begun to happen, and now, after Cubism, American painters like Newman, Rothko and Still seem almost to polemicize against value contrasts. They attempt to expel every reminiscence of sculptural illusion by creating a counter-illusion of light alone—a counterillusion which consists in the projection of an indeterminate surface of warm and luminous color in front of the actual painted surface. Pollock, in his middle period, worked toward the same effect, and perhaps achieved it more unmistakably with his aluminum paint and interlaced threads of light and dark pigment. This new kind of modernist picture, like the Byzantine gold and glass mosaic, comes forward to fill the space between itself and the spectator with its radiance. And it combines in similar fashion the monumentally decorative with the pictorially emphatic, at the same time that it uses the most self-evidently corporeal means to deny its own corporeality.

The parallels between Byzantine and modernist art cannot be extended indefinitely, but—as David Talbot Rice has suggested in a different context—they may help us discern at least part of the extra-artistic significance of modernism. The Byzantines dematerialized firsthand reality by invoking a transcendent one. We seem to be doing something similar in our science as well as art, insofar as we invoke the material against itself by insisting on its all-encompassing reality. The Byzantines excluded appeals to literal experience against the transcendent, whereas we seem to exclude appeals to anything but the literal; but in both cases the distinction between the firsthand and the secondhand tends to get blurred. When something becomes everything it also becomes less real, and what the latest abstract painting seems to harp on is the ques-

tionability of the material and the corporeal. A radically transcendental and a radically positivist exclusiveness both arrive at anti-illusionist, or rather counter-illusionist, art. Once again, extremes meet.

1958

On the Role of Nature
in Modernist Painting

The paradox in the evolution of French painting from Courbet to Cézanne is how it was brought to the verge of abstraction in and by its very effort to transcribe visual experience with ever greater fidelity. Such fidelity was supposed, by the Impressionists, to create the values of pictorial art itself. The truth of nature and the truth, or success, of art were held not only to accord with, but to enhance one another. All that was necessary was to construe the nature of each with increasing strictness. It developed that exclusively two-dimensional, optical, and altogether untactile definitions of experience conformed alike to the essence of visualized nature and to the essence of art. In this "purity" of the optical, all conflicts between nature and art, it was expected, could be resolved. For a while, in the early years of Impressionism, it did seem as though this might be true. Only later did the terms of the readjustment began to shift toward art instead of nature; and only much later did the stricter construction put upon both art and nature begin to render them not more, but less compatible, than ever before.

Cubism was the first to repudiate in express terms Impressionism's emphasis on the purely optical and seek to restore Western pictorial art's traditional basis in sculptural illusion. But no more than Cézanne could Cubism really withdraw from the Impressionist readjustment; some acknowledgment of that *fait accompli* had become obligatory upon all ambitious painting. The logic of the Impressionist readjustment, no matter how reservedly acknowledged, had to work itself out regardless of the volition of individuals.

Cubism undertook a completely two-dimensional transcription of three-dimensional phenomena, in defiance of everything the Impressionists had learned about light and verisimilitude through light; but by being *sculpturally* exhaustive, by showing in shaded relief the back and sides as well as front of an object, Cubism ended up with an even more radical denial of all experience not literally accessible to the eye. The world was stripped of its surface, of its skin, and the skin was spread flat on the flatness of the picture plane. Pictorial art reduced itself entirely to what was visually verifiable, and Western painting had finally to give up its five hundred years' effort to rival sculpture in the evocation of the tactile. And along with the tactile, imagery and imaging had to be renounced too, insofar as anything taken from the world of nonpictorial space brought with it connotations and associations that the retina could not of itself verify.

With the arrival of outrightly abstract art, it seemed that the picture was deprived of real space and real objects as a model for its own articulation and unity; that henceforth the norms of the medium alone would have to suffice. And in a sense, this has been the case. But in another sense—a sense far less immediately evident—it has not. Western painting has continued somehow to be naturalistic despite all appearances to the contrary. When Braque and Picasso stopped trying to imitate the normal appearance of a wineglass and tried instead to approximate, by *analogy*, the way nature opposed verticals in general to horizontals in general—at this point, art caught up with a new conception and feeling of reality that was already emerging in general sensibility as well as in science.

The Old Masters pursued sculptural effects not only because sculpture still taught them lessons in realism, but also because the post-medieval view of the world ratified the common-sense notion of space as free and open, and of objects as islands in this free and open space. What has insinuated itself into modernist art is the opposed notion of space as a continuum which objects inflect but do not interrupt, and of

objects as being constituted in turn by the inflection of space. Space, as an uninterrupted continuum that connects instead of separating things, is something far more intelligible to sight than to touch (whence another reason for the exclusive emphasis on the visual). But space as that which joins instead of separating also means space as a total object, and it is this total object that the abstract painting, with its more or less impermeable surface, "portrays."

The Impressionists had begun to approach such a notion of space with their weft of color touches in which the discreteness of things tended to dissolve as in a solution. At the same time the Impressionist picture surface became more packed and cohesive by reason of the uniformity with which it was accented throughout. Through this rather heavily, as well as evenly, accented object-surface, the eye penetrated into a fictive space of air and light that was located at a greater remove from the *means* of its representation than anything comparable in Old Master art. In Analytical Cubism, things are shown, more pointedly than in Impressionism, as fragmenting into and re-emerging from circumambient space. In Cubism's Synthetic phase, however, when the surface has finally become the only certainty, images are reintegrated by being drawn out of fictive depth and flattened against the surface as silhouettes, to certify thereby that the picture surface "really" coincides with the seamless spread of the visual field. We no longer peer through the object-surface into what is not itself; now the unity and integrity of the visual continuum, as a continuum, supplants tactile nature as the model of the unity and integrity of pictorial space. The picture plane as a whole imitates visual experience as a whole; rather, the picture plane as a total object represents space as a total object. Art and nature confirm one another as before.

This is the kind of imitation of nature that Cubism handed on to abstract art. Where abstract painting (as in the later works of Kandinsky) fails to convey this Cubist—or at the very least Impressionist—sense of the resistant plane surface as a

likeness of the visual continuum, it tends to lack for a principle of coherence and unity. Then only does it become the mere decoration it is so often accused of being. And only when it becomes mere decoration does abstract art proceed in a void and really turn into "dehumanized" art.

1949

Art in the United States

Thomas Eakins

Eakins seems to try for a hardheaded account of nature that will match the "hard" mathematical devices he often uses to plot the composition and perspective of his pictures. But these devices turn out to be only a framework on which he projects an ideal chiaroscuro. The language of his imagination is revealed as predominantly one of light and dark in which facts are transfigured without being violated. As time passes the mood of Eakins' art becomes less remote from that of the art of such of his contemporaries as Ryder and Newman.

Chiaroscuro, literally and figuratively, was the favorite vehicle of Victorian poetic meaning. (The extremes which chiaroscuro had reached, in verse as well as painting, had as it were to cancel themselves out in the antithesis of chiaroscuro that was Impressionism and, later on, Imagism—an antithesis of which Pre-Raphaelitism in England was an abortive version.) We are aware, in American writers such as Hawthorne, Poe, Melville and even James, as in Longfellow, Bryant, Emerson, Tuckerman and even Whitman, of oppositions which have a retreating, inward-directed force like that of contrasts of light and shade within deep space. Sometimes these oppositions are literally visual: blackness and night are the dominants of the first chapters of *Moby Dick:* the narrator stumbles through pitch darkness to find a Negro prayer meeting being held behind the first door from which a ray of light emerges; this prepares us at a long remove for the contrast of the evil whiteness of the whale. In the American chiaroscuro particularly, light and dark alternate as symbols of the explored and the unexplored, of good and evil.

There was the other kind of American artist, however, the one very much aware of local colors, and given to prosaic and

practical details. A good deal in Eakins argues for identifying him with this kind, but the reservations this involves are precisely what define his strength. The visionary overtones of his art move us all the more because they echo *facts*. This is perhaps the most American note of all. That our best art and literature strike it relatively seldom makes no difference; in this respect they still have to catch up with life.

Eakins revealed a new, if reticent awareness of color, and made his art a little more literally realistic than the academies of his time permitted. For a while he tended, though he perceived them but dimly, toward some of the same ends as Impressionism. He began to model to some extent in shades of color rather than in saturations of gray or brown, and shadows dissolve and gleam in his backgrounds as if about to burst into color. But always a sentiment of the dramatic or of the "psychological" intervenes that only chiaroscuro in the accepted sense can convey.

Eakins had almost no manner; if there is such a thing as a natural, neutral, transparent style which is not academic—a style, say, like that of Goethe's verse (and of his idiom in verse)—then Eakins had it, in his own limited, personal way. And it was a neutral, natural style not so much because it was shared with others as because of the honesty and appropriateness with which he used it, without flourishes, without "retouching," without either elegance or inelegance. It was a plain style but not a pedestrian one.

Eakins' first mature paintings betray French influences that were current in the 1860s: Courbet, Delacroix and above all, Couture. To these he reacted in somewhat the same way that Cézanne did in the very same years: by summarizing his drawing, thickening his paint and opposing light and dark in sharp and simple contrasts. Next came a phase in which local colors were permitted to assert themselves with an unstudio-like intensity, and in this phase Eakins was not far from what Winslow Homer was doing in those same years. The effect of the large and relatively ungraded areas of high color in an

1874 painting that shows the artist and his father hunting is almost modernist, and so is the impression made by *The Biglen Brothers Turning the Stake* of the previous year, with its vivid spots of blue and its throbbing sunlight. Transparent shadows and broken, traveling highlights contribute to the subtle power of his female portraits and interiors of the same decade. Shortly afterwards, when he begins to investigate three-dimensional nature more exhaustively, he loses something, and when he begins to forget his French influences his development changes to one of involution rather than evolution. Eakins reenters academic painting, to make himself a very individual place inside it, but not to bring increment to the art of painting in general.

He was always able to wrest a convincing picture from any subject that showed light falling on or striking through soft fabric. The ridges of paint that follow the unevennesses of flesh and contour in the study of a female nude done in the early 1880s are from the brush of one who remained, in his circumscribed way, a master. But many of the portraits from that time on, especially those of men, succumb for all their honesty, to the social or professional type of the subject. It can be considered fortunate, even so, that the failure of Eakins' genre paintings to win public acceptance had the effect of confining him largely to the portrait; for almost all his later genre paintings, including those truly original examinations of subject which are devoted to prizefighting, lack some conclusive, ultimate intensity of rendered perception, some final emphasis. Despite all withdrawals of ambition, he continued, on the other hand, to produce superb female portraits until the very end; those, for example, of Mrs. Kershaw, Mrs. Eakins and Ruth Harding, in which the being of his sitter is conveyed by lighted surfaces that *displace* shadows rather than emerge from them.

Eakins' realism branched off in a specifically American direction, but he discovered nothing that induced him to broaden or change the fundamental basis of style he had

acquired from Couture. Eakins remains of his place and time: a great provincial artist, one I myself cherish above even Homer and Ryder. (I do not presume to say that others should value him so—this preference is my private affair.) But like Homer and Ryder, he is a glory of American art that cannot be exported—at least not until the English are able to export Samuel Palmer at his academic best, the Italians one or two of their proto-Impressionists, and the Germans their Leibl.

1944

John Marin

If it is not beyond doubt that Marin is the greatest living American painter, he certainly has to be taken into consideration when we ask who is.

At the root of the trouble—the trouble that makes this question worth asking—is the kind of ambition involved in the highest flights of American art, and of American literature too, in this century. If we disqualify Eliot as a confirmed Englishman by now, is our greatest poet Wallace Stevens or Marianne Moore? Aren't both too minor really to be called "great"? None of our best poets, painters, sculptors or composers seems to attain, in this age, that breadth in single works, or that range in their *oeuvres*, which would justify the word. Intense or exquisite their productions may be, but also narrow, partial. "Greatness" connotes something wider and deeper.

Marin may not say enough, and what he says is certainly said without largeness. Such faults as he has are not inclosed and swallowed up by the magnitude of a gift or vision which (as has been said in praise of Balzac) sweeps an artist's shortcomings before it and even renders them essential. And yet what a good painter Marin still manages to be. Just as, when all is said and done, Wallace Stevens and Marianne Moore remain miraculous poets. Crossing Cubism with Fauve color and borrowing from Winslow Homer's water-color technique, Marin made a personal instrument for himself whose fidelity in the registration of evanescent sensations is surpassed in our time only by Klee's water colors, approached perhaps by Paul Nash's, and emulated only in the more realistic of Morris Graves's rendering of animals.

Marin came of full age as an artist in the same decade—1910 to 1920—that saw Stevens and Moore fledge their wings

as poets. Underneath the "Art-and-America" mystique and the art evangelism that, issuing from Alfred Stieglitz' gallery, blew open Marin's gift as it did Marsden Hartley's, there maintained itself a vein of thin but pungent lyricism not unlike Stevens' and Moore's. Within limits set by the circumstances of American art culture in his time as much as by his own temperament or talent, Marin developed and refined an art of genuine originality. The development was not even, or consistent, but today he strikes me as a stronger painter than he ever was.

His original fame rests on his water colors. He still handles water color with greater assurance than oil, but in the last decade or more he has turned increasingly toward the latter, with results that match and as I think, may even surpass his water colors in some respects. These remain as exquisite in their ruggedness as ever; nor does their increasingly conventional naturalism subtract anything; the slashes of abstract line with which Marin tries to put "architecture" and "planes" into what are really Impressionist sensations of atmospheric color are arbitrary more often than not, and those of his "straight" views of nature that dispense with these devices are generally just as well organized as anything else he does. His oils, however, tend now to be stronger, ampler, even more temperamental than even the best of his water colors. Though their paint is laid on with something of the thinness of water color, and the bare priming of the canvas is used as one more color the way the water-colorist uses his paper, they benefit greatly by the more emphatic presence of the oil medium and its support. On canvas, contrasts of opaque color with transparent washes or thin scumbles *build* as well describe—notwithstanding the fact that design is not as "safe" as it is on paper. Marin seems to succeed most often in his oils when the subject presents a large, distinctly cutout shape like a sailing ship, or a definitely organized variation of forms like the opposition or alternation of land and water, or human figures. Then the colors with which he is so well able to depict the

contours as it were of atmosphere find an appropriate center of gravity, no longer appear abstract and imposed, and the effect (otherwise reminiscent of what happens when the later Hartley sculpts sky and clouds) is no longer arty.

"Artiness" was the affliction of all of Stieglitz' protégés. The frames, designed and decorated by himself, that Marin puts around his oils remind us of that. These frames may be charming objects in themselves, but they would hurt any kind of picture, and they have made it impossible so far to get a completely clear view of many of Marin's.

1948

Winslow Homer

It was characteristic of one kind of American that Winslow Homer should have distrusted books, tradition and the art of others, and should have had to learn for himself, painfully, things that most schooled artists of his time could quickly take for granted. It was characteristic of a certain side of New England that he was a solitary. Attached only to his father and one of his brothers, he never married. He had a fear of strangers. He liked the outdoors, fishing and camping. He saw something of the Civil War, lived in New York for a time, went to Europe twice, traveled in the West Indies and spent most of the latter half of his life on the Maine coast. He was small, dapper, reserved and dull. If we are to go by the evidence, he had no inner life apart from that which he put into his pictures. He was able, after a while, to support himself comfortably by his art; it did not sell too well, but not too badly either. By the age of sixty he had become accepted as a great American artist. He died in 1910 at the age of seventy-four.

All this takes nothing away from Homer's consequence as an artist. He may not have attained major quality, but he demonstrated an originality and strength that can stand up under many comparisons. He founded a uniquely American tradition of water-color painting, and in his early oils he developed, independently, certain revolutionary tendencies that converged with those of the first phase of Impressionism in France.

To my taste, the best of Homer's oil paintings are those he did in the beginning, in the 1860s and early 1870s, after he gave up working exclusively as an illustrator in black and white. He started out with warmly toned canvases, in a genre

style like Eastman Johnson's, but these soon set themselves apart by the crispness of their drawing and design, and by a new, if somewhat crude, clarity of color not too unlike that which the great Manet had arrived at only a few years earlier. Homer did not visit Paris until 1867, and it is doubtful whether, during his ten months' stay there, he saw (or if he did see, paid attention to) any pictures by Manet. But I do think he was influenced, whether at first or second hand, by Manet's own teacher, Thomas Couture, who had many American students and whose manner (at least in small pictures) of working with abrupt, broad contrasts of light—and even *white*—and dark was carried to this country shortly before the Civil War. (Couture had a decisive influence on Eakins too.)

When apprenticed in his youth to a lithographer, Homer had copied portrait photographs, and this early intimacy with photography may have also stimulated the sharp and opaque contrasts of light and shade we find in his early oils—contrasts which leave color relatively flat and clear over broad areas, and indicate rather than present three-dimensional form. That Manet and Monet were exploring similar effects in those same years can be adequately explained no doubt by developments altogether confined to the province of painting, but I am still persuaded that photography had its influence upon them too— if only because, in Monet's case, at least, the results of photography were confirmed by his unprejudiced observation of the effects of light in the open.

That Eakins, like Homer (if we except the latter's water colors), produced his best work at the beginning of his career leads one to speculate on whether there was not some new current abroad in the late 1860s and early 1870s which exalted the art of painters committed to a truly radical naturalism; and that the ebbing of this current may have been partly responsible for the fact that in middle age both Eakins and Homer more or less withdrew into themselves. Not that they stopped developing, but the further growth of their art took place within more provincial limits.

It was in the 1880s that Homer adopted something of the sentimental, middle-keyed genre style that had then become popular among post-Barbizon French academic painters, and which took for its principal subjects melancholy landscapes and peasants. Homer's peasants were the English fisher girls he saw at Tynemouth, where he spent most of 1881 and 1882. Afterwards, or even concurrently, he may have come a little under the influence of the Whistlerian tone poem. At any rate, he lowered his color key further, confining himself to cool and neutral tones and emphasizing relatively subtle shifts of light and dark—in reaction perhaps against the violence with which he had previously treated value contrasts. There were certain rewards: scenes of beaches at dusk rendered in deep blues, violets, mauves and tinted grays, with one or more figures of women silhouetted in the foreground. The poetry of these pictures was all the more genuine for its being the unforced concomitant of a manner that betrayed, and through all its changes was always to betray, a certain nostalgia for the literal or even pedestrian.

Homer had his share, nevertheless, of the popular and romantic taste of his time for melodrama. It was at Tynemouth that he seems to have acquired that fascination with the menacing aspects of the sea which was not to leave him for the rest of his life. Perhaps there was some unconscious connection for him (as for Poe) between the sea and sex. One of his frequent subjects in the eighties was women being saved from drowning or shipwreck, with wet clothing clinging to their bodies in a surreptitious approximation of the nude—which he hardly ever attempted to do directly. Later on, the raging surf would hold the center of his attention, with women's figures appearing less often in the foreground. Homer's presumably matter-of-fact vision, like that of Stephen Crane, another "literal" realist, would, when directed out of doors, usually alight on something that moved dramatically, were it but waves or a leaping fish.

Only in the middle 1870s did Homer begin to apply him-

self seriously to water color, the vehicle through which, in the consensus of critical opinion, he made his greatest contribution as an example and influence. And there is no question but that he showed greater sensitivity to the intrinsic assets and liabilities of the medium in his water colors than he did in his oils. By his rapidity and lightness in water color, by his simplifications, and by his exploitation of the transparency of water-thinned pigment and the texture and whiteness of paper, he succeeded in acclimatizing *his* Impressionist vision to a medium that seemed expressly designed for it, but which the French Impressionists (all of whom, except Sisley, had "heavy" hands) had seldom adopted. If this country has contributed anything distinctive to the craft traditions of painting, it is in the water-color style that Homer founded.

It took the brilliant light and color of the West Indies to make plausible to himself the new daring Homer found himself displaying in this medium. He had not intended to innovate. The new brilliance was there in the subject before him; he painted it—just as Monet had reproduced the new brilliance of the Riviera. Occasionally, something of the lambency and discreet splendor of the water colors flashes through into the oils. But he could never quite cure himself of a certain coarseness of execution in oil, a certain brittleness and even acidity of paint quality, a lack of resonance in texture. Perhaps it was because, as Lloyd Goodrich points out, he was self-taught in oil and to some extent always remained a learner there. But he was also self-taught in water color. The explanation of the difference may lie in the curious mixture of contempt and diffidence that Homer seems to feel toward physical substance in general—a contempt which proved less of a liability in water color than in oil, simply because water color was less substantial. Homer's habits of working in his later maturity has its bearing on this difference. He would spend weeks and months pondering a motif, waiting for the right weather and light, but once he had started a picture he would work fast and even impatiently—as if the activity itself of painting were an ob-

struction. It is obvious that water color, which demands as well as permits speed of execution, lent itself better to this procedure.

Homer seems not to have been religious. To all ostensible purposes, he was a materialist on the order of his times. It may seem anomalous that a materialist should have had such disdain for matter. But Homer was a good American and like a good American, he loved *facts* above all other things. A kind of factuality is not least among the merits of his later work, the peculiar strength of which would perhaps have been even diminished by greater concern with the sensuous aspects of his art.

1944

Hans Hofmann

Hans Hofmann's art is recognized increasingly as a major fountainhead of style and ideas for the "new" American painting, but its value, independent of its influence and Hofmann's role as a teacher, is still the object of reservations. His omission from the "New American Painting" show that the Museum of Modern Art sent to Europe (1958-1959) is a case in point (an omission which did more to distort the picture than did the number of highly questionable inclusions). A good share of the blame rests with the public for advanced art in New York, which has its own kind of laziness and obtuseness, and usually asks that a "difficult" artist confine himself to a single readily identifiable manner before it will take trouble with him. (One would think that the exhilaration and satisfaction to be derived from following advanced art were proportionate to the effort of discrimination required, but most of those who do the following do not seem to agree. Having accepted advanced art in principle, they want it to be made easy within its own context, apparently.) But Hofmann himself is also to blame in some part—and actually, the more excellences I find in his art the more I incline to shift the blame toward him.

The variety of manners and even of styles in which he works would conspire to deprive even the most sympathetic public of a clear idea of his achievement. At the same time, such a diversity of manners makes one suspect an undue absorption in problems and challenges for their own sake; or else that this artist too implicitly follows wherever his inventive fertility leads him instead of bending that fertility to his vision. And Hofmann's inventiveness is truly enormous, to the point where he might be called a virtuoso of invention—as only the Klee of the 1930s was before him. But in art one cannot scatter

one's shots with impunity, and Hofmann has paid a certain price, in terms of quality as well as of acceptance. That price is certainly not as large as the one Klee paid in the 1930s, but it may be larger than the one Klee paid in his prime (when his "handwritten" approach and the small formats to which he restricted himself conferred a real unity of style upon all the different "notational" systems he used). And unlike Picasso since 1917, Hofmann has no ostensible main manner to which all his others are kept subordinate; he can work in as many as three or four different manners in the span of a year and give them all equal emphasis.

The notion of experiment has been much abused in connection with modernist art, but Hofmann's painting would seem to justify its use. He is perhaps the most difficult artist alive—difficult to grasp and to appreciate. But by the same token he is an immensely interesting, original and rewarding one, whose troubles in clarifying his art stem in large part from the fact that he has so much to say. And though he may belong to the same moment in the evolution of easel painting as Pollock, he is even less categorizable. He has been called a "German Expressionist," yet little in what is known as Expressionism, aside from Kandinsky's swirl, predicts him. His color and color textures may be "Nordic," but one clutches at this adjective in despair at a resolute originality to which the "Mediterranean" is assimilated. I would maintain that the only way to begin placing Hofmann's art is by taking cognizance of the uniqueness of his life's course, which has cut across as many art movements as national boundaries, and put him in several different centers of art at the precise time of their most fruitful activity. And on top of that, his career as an artist has cut across at least three artists' generations.

Born and educated in Germany, Hofmann lived in Paris on close terms with the original Fauves and the original Cubists in the decade 1904-1914, during which both movements had their birth and efflorescence. He made frequent trips to France and Italy in the twenties, after having founded his school in

Munich. In 1931 he settled permanently in this country. For fifteen years he hardly picked up a brush, but drew obsessively —as he says, to "sweat Cubism out." Only in 1935 or 1936, when he was in his mid-fifties, did he begin to paint again consistently. And only when he was already sixty, at a time when many of his own students had long since done so, did he commit himself to abstraction. His first one-man show in New York was held at Peggy Guggenheim's gallery early in 1944, and since then he has shown in New York annually, as an artist with his reputation to make or break along with artists thirty to forty years younger, and asking for no special indulgence.

Hofmann himself explains the lateness of his development by the relative complacency fostered in him during his Paris years by the regular support of a patron, and by the time and energy he needed afterwards, to perfect himself as a teacher. But I would suggest further, that his Paris experience confronted him with too many *faits accomplis* by artists his own age or only a few years older; that he had to wait until the art movements of those and the interwar years were spent before making his own move; that first he had to get over Fauvism and Cubism, and get over Kandinsky, Mondrian, Arp, Masson and Miró as well.

His own move started with Fauvish landscapes and large still-life interiors that he began painting shortly after 1935. The interiors synthesize Matisse with Cubism in a fully personal way, but are if anything a little too brilliantly wrought. The landscapes, however, especially the darker ones, open up a vision that Nolde alone had had a previous glimpse of, and Hofmann opens it up from a different direction. Their billowing, broadly brushed surfaces declare depth and volume with a new, post-Matisse and post-Monet intensity of color, establishing unities in which both Fauvism and Impressionism acquire new relevance. Although there are already a few Hofmanns from 1939 in which no point of departure in nature can be recognized, the effective transition to abstract art takes place

in the first years of the forties. Figures, landscapes and still lifes become more and more schematically rendered, and finally vanish. What appear to be allusions to Kandinsky's near-abstract manner of 1910-1911 constitute no real debt in my opinion; Hofmann would have arrived at the same place had Kandinsky never painted (though perhaps not if Miró, himself in debt to Kandinsky, had not). Rather than being influenced by Kandinsky, Hofmann seems to have converged with him at several points on the way to abstraction—a way that in his case was much broader, since it ran through the whole of Matisse and the whole of Cubism.

No one has digested Cubism more thoroughly than Hofmann, and perhaps no one has better conveyed its gist to others. Yet, though Cubism has been essential to the formation of his art, I doubt whether any important artist of this postwar era has suffered by it as much as Hofmann has. It is what I would call his Cubist trauma that is responsible, among other things, for the distractedness of his art in its abstract phase. Without the control of a subject in nature, he will too often impose Cubist drawing upon pictorial conceptions that are already complete in themselves; it will be added to, rather than integrated with, his redoubtable manipulations of paint. It is as if he had to demonstrate to himself periodically that he could still command the language with which Braque and Picasso surprised him fifty years ago in Paris. Yet the moments of his best pictures are precisely those in which his painterly gift, which is both pre- and post-Cubist, has freest rein and in which Cubism acts, not to control, but only to inform and imply, as an awareness of style but not as style itself.

To the same painterly powers are owed most of the revelations of Hofmann's first abstract period, before 1948. In a picture like *Effervescence* (1944), he predicted an aspect of Pollock's "drip" method and at the same time predicted Clyfford Still's anti-Cubist drawing and his bunching of dark tones. In *Fairy Tale* (of the same year) he expanded and deepened a hint taken unawares from Masson in a way that

anticipated Pollock's great *Totem No. 1* of a few months later. In the tempera-on-gesso work, *Cataclysm,* of 1945, still another aspect of Pollock's later "drip" manner was anticipated ("drip" is inaccurate; more correct would be "pour and spatter"). These works are the first I know of to state that dissatisfaction with the facile, "handwritten" edges left by the brush, stick or knife which animates the most radical painting of the present. The open calligraphy and "free" shapes that rule in "abstract expressionism" were foretold in many other pictures Hofmann did before 1948, and especially in numerous gouaches and water colors in which paint is wielded with a disregard of "construction" that represents the most inspired possession of it. Most of these pictures are more important as art than as prophecy, but it is only in the light of what they did prophesy that people like myself have learned to appreciate them; ten years ago and more, when they were first shown, they were too new.

In certain other pictures, however, Hofmann anticipated himself alone. *Summer Glory* (1944) and *Conjurer* (1946) declare the impasto'd, nonlinear manner which, in my view, has been his most consistently successful one since 1948. Here color determines form from the inside as it were; thick splotches, welts, smears and ribbons of paint dispose themselves into intelligible shapes the instant they hit the surface; out of the fullness of color come drawing and design. The red and green *Flowering Desert* (1954) is done in this manner, and so are many much smaller paintings in which warm greens predominate, as they do also in a masterpiece like *Le Gilotin* (1953)—(which, in drying, has unfortunately lost most of its brilliance)—and in the *Bouquet* (1951).

It is when Hofmann tries to reinforce contrasts of color and shape with taut contour lines, and when he trues his shapes into a Cubistic but irrelevant regularity, that his art tends to go off in eccentric directions. Given that the originality of his color consists often in oppositions of intense hues of the same degree of warmth and even of the same value; that a

cool color like blue or an ambiguous one like green will be infused with unaccustomed heat; and that such things can tax the eye the way an unresolved chord taxes the ear—given all this, design becomes a very precarious matter in which it is safer to stop too soon rather than too late. To insist on line or edge can be excessive or disruptive. And sometimes the energy of Hofmann's line can be more nervous, more machined than pictorial, and it can force an illegitimately sculptural effect. Or, as more recently, an overloaded effect is created by the compulsion to articulate every square inch of the surface with chromatic and graphic detail. For Hofmann's overriding weakness has nothing to do essentially with drawing, but lies in a tendency to push a picture too far in every direction—in the endeavor to achieve, it would seem, an old-fashioned synthesis of "drawing" and "color"—a grand-manner synthesis. This is an ambition that identifies him with Picasso's generation and his own chronological generation of artists and separates him from the generation he actually paints with. But it separates him only insofar as it distracts him—and in his bad pictures, not his good ones.

But if not all of his bad pictures are due to misplaced draughtsmanship, neither are all of his good ones a function of color first and foremost. There are many oils on paper, gouaches and water colors in which Hofmann's Cubism develops a Matissean rather than Constructivist grace of line. There are paintings like *The Prey* (1956) in which thick pigment is handled calligraphically. And there is the large and superbly original *Undulating Expanse* (1955), which, along with four or five other and smaller paintings in the same series of studies—all inspired by the possibility of an architectural commission—is rapidly and almost transparently brush-drawn on bare white priming. These pictures strike one of the freshest notes to be detected anywhere in the painting of the last five years; but it is, alas, characteristic of Hofmann not to have pursued further an idea that another artist would have built a whole career on. Pictures like these confirm, at any rate, one's

impression that his first impulses are usually his best ones; when he fails it is most often because he forgets what he himself has drummed into his students: that science and discipline which have not become instinct are cramping rather than enabling factors.

A good deal of what is so rashly called "abstract expressionism" amounts essentially to a kind of Late Cubism (which takes nothing away from it in principle). In some of his best work Hofmann is almost as much a Late Cubist as Gorky or de Kooning. In another and even better part of it, however, he points to and enters a way that is fully post-Cubist, and when he does so he follows his deepest bent, whether he himself recognizes it or not, and fulfills his most personal vision. Klee and Soutine were perhaps the first to address the picture surface consciously as a responsive rather than inert object, and painting itself as an affair of prodding and pushing, scoring and marking, rather than of simply inscribing or covering. Hofmann has taken this approach further, and made it do even more. His paint surfaces *breathe* as no others do, opening up to animate the air around them. It is by their open, pulsating surfaces that Hofmann's very best pictures surpass most of Kandinsky's, as I feel they do. And it is thanks in part to Hofmann that the "new" American painting in general is distinguished by a new liveness of surface, which is responsible in turn for the new kind of "light" that Europeans say they find in it.

But that part of the "new" American painting which is not Late Cubist distinguishes itself further by its freedom from the quasi-geometric truing and fairing of lines and edges which the Cubist frame imposes. This freedom belongs with Hofmann's open surfaces as it does not with de Kooning's or Kline's, and his hesitancy in fully availing himself of this freedom—despite the fact that he himself had such a large hand in winning it—must be attributed to his reluctance to cut himself off from Cubism as a base of operations. It is a reluctance that

seems, as I have already suggested, to account (more than any-thing else) for the incoherence in the development of Hof-mann's art. But, as I cannot insist enough, this detracts noth-ing from the mastery displayed in its masterpieces.

1958

Milton Avery

Milton Avery grew up as a painter in the days of the American Scene movement, with its advocacy of an art that would concentrate on American life and shun esoteric influences. Avery set his face against this, yet the atmosphere created by that movement may have helped confirm him in his acceptance of himself. However misguided and even obscurantist the American Scene tendency was, it did at least urge in principle that the American artist come to terms with the ineluctable conditions of his development; it did remind him that he could not jump out of his skin; and it did prepare for the day when he would stop bewailing the fact that he lived where he did.

In any case, Avery started off from American art before the American Scene was heard of; in Hartford, where he grew up, he looked harder at Ryder and some of the American Impressionists than at anything in French art. And when he went on to assimilate certain French influences the outcome was still some of the most unmistakably and authentically American art that I, for one, have seen.

Avery himself would be the last to see any aesthetic value in Americanness as such. If his art is so self-evidently American it is because it so successfully bodies forth the truth about himself and his condition, not because he has ever made an issue of his national identity. And it may also be because he developed, owing to circumstances he only half-chose, within what was to a great extent a non-European frame of reference. There are, moreover, different kinds of Americanness, and Avery's kind may be more apparent than others at this moment only because it had had less of a chance, before the advent of Fauvism, to express itself in ambitious, sophisticated painting.

Frederick S. Wight, in his text for the catalogue of Avery's retrospective at the Baltimore Museum in December 1952, put his finger on one of the most salient traits of Avery's art: its insistence on nature as a thing of surface alone, not of masses or volumes, and as accessible solely through eyes that refrained from making tactile associations. Avery's is the opposite of what is supposed to be a typical American attitude in that he approaches nature as a subject rather than as an object. One does not manipulate a subject, one *meets* it. On the other hand, his employment of abstract means for ends—which, however, subtly or subduedly naturalistic, are nevertheless intensely so— is nothing if not American. I see something similar in four other American artists who belong to twentieth-century modernism: Dove, Arnold Friedman, Hartley and Marin. And it is significant that except for Friedman these painters, though they all flirted with Cubism once it was on the scene, continued to find in Fauvism the kind of modernism most congenial to themselves—which is also true of Alfred Maurer, if in a different way.

The original French Fauves were usually ready to sacrifice the facts of nature for a happy decorative effect; whereas these Americans tended to let the decorative effect go when it threatened to depart too much from the facts. It was in the facts primarily that they found inspiration, and when they did not find it there they were liable (at least Dove, Marin and Hartley were) to succumb to artiness. There was a certain diffidence in this attitude: unlike Matisse, the American Fauves did not proclaim themselves sovereigns of nature. But there was also a certain courage: they clung to the truth of their own very personal experience, however intimate, modest, or unenhance-able that truth was. This applies to Avery in particular. No matter how much he simplifies or eliminates, he almost always preserves the local, nameable identity of his subject; it never becomes merely a pretext. Nor is art ever for him the peculiarly transcendent issue it often becomes for Hartley and Marin.

There is no glamor in Avery's art; it is daring, but it is not

emphatic or spectacular in its daring. In part this may have to do with the concrete elements of his painting: the absence of pronounced value contrasts on the one hand, and of intense color on the other; the neutral surface that betrays neither "paint quality" nor brushwork. But it has even more to do with his temperament, his diffidence. Fifteen years ago, reviewing one of his shows at Paul Rosenberg's in *The Nation*, while I admired his landscapes, I gave most of my space to the derivativeness of the figure pieces that made up the bulk of the show, and if I failed to discern how much there was in these that was not Matisse, it was not only because of my own imperceptiveness, but also because the artist himself had contrived not to call enough attention to it.

I still quarrel with Avery's figure pieces, or at least with most of them. Too often their design fails to be total: figures are not locked securely enough in place against their backgrounds, which are so often blank ones. And for all the inspired distortion and simplification of contour, factual accidents of the silhouette will intrude in a way that disrupts the flat patterning which is all-important to this kind of painting. It is as though Avery had trouble handling displaceable objects when they exceeded a certain size, and found his certainty only in depicting things that had grown into the places they occupied and which provided foregrounds and backdrops that interlocked of their own accord. In other words, he is generally at his best in landscape and seascape.

It is difficult to account for the individuality of Avery's art. In detail it echoes many other painters—Matisse, Dufy, Hartley (who was himself influenced by Avery in the end), even Marin —but these echoes do not lead toward Avery's specific results, his pictorial unities. It is not a question of schools or styles, or even of sensibility, but of something even more personal. There is the sublime lightness of Avery's hand on the one side, and the morality of his eyes on the other: the exact loyalty of these eyes to what they experience. The question has to do with *exactly* how Avery locks his flat, lambent planes together;

with the *exact* dosage of light in his colors (all of which seem to have some admixture of white); with *exactly* how he manages to keep his pictures cool in key even when using the warmest hues; with *exactly* how he inflects planes into depth without shading, and so on. Of course, all successful art confronts us with this factor of exactness, but rarely does the necessity of exactness cover as much as it does in Avery's case.

Nature is flattened and aerated in his painting, but not deprived in a final sense of its substantiality, which is restored to it—it could be said—by the artistic solidity of the result. The picture floats but it also coheres and stays in place, as tight as a drum and as open as light. Through the unreal means most specific to pictorial art, the flat plane parallel to the surface, Avery conveys the integrity of nature better than the Cubists could with their own kind of emphasis on flat parallel planes. And whereas Cubism had to eventuate in abstraction, Avery has developed and expanded his art without having either to court or ward off that possibility. As it happens, he is one of the very few modernists of note in his generation to have disregarded Cubism. It would be hazardous to say that he has not been affected by it in any way, but it certainly has not had an important part in his formation, and he has flouted the Cubist canon of the well-made picture almost as much as Clyfford Still has.

Like almost every other modernist reaction against Impressionism, Avery's Fauvism has but drawn a further consequence of it. His art is an extremer version of a world from which sculpture and all allusions to the sculptural have been banished, a world in which reality is solely optical. But what marks off Avery's painting within modernism itself is its explicit rejection of the decorative—a rejection given its point, as it is in Matisse's case, by the fact that Avery's means are so very decorative in themselves. If decoration can be said to be the specter that haunts modernist painting, then part of the latter's formal mission is to find ways of using the decorative against itself. It is as though Late Impressionism and Fauvism have come on

the order of the day again precisely because, being so much more antisculptural and therefore exposed to the decorative than Cubism, they dramatize the problem by increasing the tension between decorative means and nondecorative ends.

Matisse and the later Monet overcame decoration by their success in achieving the monumental; they established size as well as scale as an absolute aesthetic factor. Avery seems never to have considered this solution. Perhaps it would have taken him too far away from his conception of nature, which could be rendered only through the easel, not the wall, painting; a large picture can give us images of things, but a relatively small one can best re-create the instantaneous unity of nature as a *view*—the unity of that which the eyes take in at a single glance. (This, even more than their revulsion against the academic "machine," seems to me to account for the size of canvas, averaging two feet by one and a half, that the Impressionists favored.) Though Avery converses with decoration in a way that would have shocked Pissarro, and in going from sketch to finished canvas distorts nature expressively, he is moved nevertheless by a naturalism not too unlike that which guaranteed Pissarro, as it did not Monet, against the pejoratively decorative.

That the younger "anti-Cubist" abstract painters who admire Avery do not share his naturalism has not prevented them from learning from him any more than it has prevented them from admiring him. His art demonstrates how sheer truth of feeling can galvanize what seem the most inertly decorative elements—a tenuous flatness; pure, largely valueless contrasts of hue; large, unbroken tracts of uniform color; an utter, unaccented simplicity of design—into tight and dramatic unities in which the equivalents of the beginning, middle and end of the traditional easel picture are fully sensed. His painting shows once again how relatively indifferent the concrete means of art become where force of feeling takes over.

Painters and even collectors have paid more attention, so far, to Avery than critics or museum people have, and his

reputation is not yet a firmly established one. Perhaps it is because he has been so badly selected and shown by his dealers. But it may also be because of that subtleness to which his exactness is so important. When subtleness as such becomes an important issue, the usual implication is that the art in question does not excel by its range. And the question does suggest itself whether Avery's art, for all its real variety, does not tend to be somewhat narrow in its *impact*. Such a limitation might explain why Avery, like Marin, and like Paul Nash in England, has proved unexportable so far. But one hesitates to accept this explanation, just as one hesitates to accept the idea of unexportability in general. There are certain seascapes Avery painted in Provincetown in the summers of 1957 and 1958 that I would expect to stand out in Paris, or Rome or London just as much as they do in New York.

1958

David Smith

Ten years ago the hopes for sculpture were very bright. Renewed in vitality since Rodin and having found a fresh point of departure in modernist painting, it seemed about to enter upon a great inheritance. The new, quasi-pictorial modes born of the Cubist collage and bas-relief construction had, in liberating sculpture from the monolith, given it access to a vast new field of subject matter; and the range of style and subject open to it seemed to be expanding in the same measure as that in which the range open to ambitious painting seemed to be narrowing. It looked then as though sculpture might shortly become the leading vehicle of visual art. Certainly there was enough sculptural talent on hand to make this appear a real possibility.

These hopes have faded. Painting continues to hold the lead, by its greater breadth of statement and by its continued energy. Sculpture has become a field where, as hopes have turned into illusions, inflated reputations and false renaissances abound: there are Moore, Marini and the postwar Giacometti: and there is the "awakening" of British sculpture at the hands of Butler, Chadwick, Paolozzi, Turnbull, *et al.*

The monolithic, more traditional sculpture of older artists like Marcks or Wotruba continues to move and convince as the "advanced," linear, and thin-planed art of the British followers of Gonzalez and Dubuffet does not. It is symptomatic of more than a local situation that modernist sculpture in America should have succumbed so epidemically to "biomorphism," and that then, after all the decorative improvising of plant, bone, muscle and other organic forms, there should have come such a spinning of wires and such a general fashioning of cages—so that the most conspicuous result of the diffusion of the use of

the welding torch among American sculptors has turned out to be garden statuary, oversized *objets d'art* and monstrous costume jewelry.

Modernist sculpture's present malady, here and abroad, is artiness—whether it is the archaic artiness of Moore, Marini and Giacometti, the Cubist or *art brut* artiness of the younger British sculptors, or the expressionist-surrealist artiness of the Americans. Artiness is usually the symptom of a fear lest the work of art not display its identity as art sufficiently and be confused with either a utilitarian or a purely arbitrary object. This danger, to which abstract sculpture is far more exposed than abstract painting, appeared only with the first examples of Constructivist sculpture; and Constructivist sculpture, with its look of machinery, seems nowadays to strike much more terror than before into the hearts of both artists and connoisseurs. The exceptions among the artists are precisely those who form the few exceptions to the general disappointment that has been modernist sculpture over the past decade. The most notable among these is David Smith, whom I do not hesitate to call the best sculptor of his generation.

Smith was perhaps the first one to transplant to this country the art of aerial drawing in metal, and to use the welding torch and materials like steel and the newer alloys. And he was perhaps also the first to attempt a kind of sculptural collage, without precedent either in Picasso or Gonzalez, that involved found and even contrived machine parts. But the means in art never guarantee the ends, and it is for the individual and underived qualities of Smith's art that we praise it, not for its technical innovations.

That he shows everything he finishes, and has had a high frequency—at least in the past—of failures, has exposed his art to many misconceptions. That he works, moreover, in a diversity of manners—not only in going from one work to another, but also, apparently, within one and the same piece—does not make it easy to form a clear idea of his achievement. Given, on top of this, his almost aggressive originality, we can understand

why the art public and its mentors, while not exactly refusing their admiration, have not yet taken to his work in a way that would bring prizes, commissions, or the purchase of important pieces by museums and other public or semi-public agencies. I have the impression, however, that if the nonacademic sculptors in this country were polled, Smith would come out as the rival most highly regarded by the overwhelming majority of them.

Smith is one of these artists on the order of Balzac who not only can afford their mistakes, but even need them. Original art arrives more often than not by way of errors of taste, false starts and overrun objectives. His inability or unwillingness to exercise self-criticism may permit Smith to indulge in illustrative cuteness or decorative whimsicality, or to descend to petty effects, but it encourages him at the same time to accept the surprises of his temperament. We get the sense of a headlong, reckless artist who is confident of his ability to redeem in another piece whatever may go wrong in the one at hand.

To define Smith's shortcomings is also to explain his advantages. His chronic weakness has lain in his tendency to develop and elaborate a work beyond the point to which the momentum of his inspiration has carried it. In some part it is because he too can be afraid that the result might not look enough like art, but in larger part it has to do with the nature of his gift. Characteristic virtues entail characteristic faults. The copiousness of Smith's invention, the scale and generosity of his powers of conception and execution, are what more than anything else impel him to multiply details, explore every idea to its limits, and act unconsideredly on every impulse. Yet where he succeeds the effect is enhanced by the sense we get of a flow whose further, momentarily unactualized abundance and power reverberate through that which is already actualized.

In recent years Smith has become steadier and more consistent, and realization comes more frequently. Periods of expansion in which new ideas were investigated, with highly

uneven results, used to be followed by shorter periods of consolidation. Now Smith appears able to proceed more directly from conception to realization. It is as if his sensibility had become purified and refined. But the change is in our own sensibilities too; familiarity with his art persuades us increasingly of its premises, which now seem to develop more obviously out of those of previous art; much that looked like *gaucherie* turns out to be a redefinition of elegance, economy and strength, and of their fusion in sculpture. Once Smith's art could be plausibly called "baroque"; now it is equally plausible to call it "classical." Even at its most elaborate, the lines and surfaces in which it is "written" remain clean and direct; there is never any fuzzing and blurring of contours, or brazing or manipulation of surface textures to obtain painterly on top of pictorial effect. Wherever else Smith may fail, he remains direct.

The speed with which Butler, Chadwick and the other exponents of Britain's "sculptural renaissance" have won acceptance is owed largely to their having started out as "classical." But to this too is owed the ultimate insipidity of their art. Here "classical" means a canon of forms and taste taken abjectly from Gonzalez, Picasso, Matisse and Miró, and a result which pleases because it does not offend eyes that have learned to like Cubist art. Smith's case has been quite different. The trued and faired Cubist look of his "handwriting" turns out to be something he has developed for himself, out of his own necessities, not something accepted in advance.

The spareness and tenseness, the elegance and strength of his recent *Tank Totem* figure-pieces are completely different in feeling and kind from the expected, nervous yet nerveless elegance we most often find in Butler and Chadwick. And the same is even truer of the rugged felicity achieved by almost every one of the dozen-odd sculptures in Smith's *Agricola* series. Smith may be oriented toward the same quarter of style as Butler and Chadwick are—the quarter mapped out by Picasso, Gonzalez and the earlier Giacometti—but he has been

turned toward it by his own vision and his own originality. And his art has had to create in part the taste by which it is enjoyed; whereas Butler and Chadwick have followed the path of least resistance and the indications of a taste already established.

Smith continues to develop, with the energy of a young artist. What one hopes for now is that he receive commissions giving him the chance to display to the full that capacity for heroic sculpture which is his more than any other artist's now alive. Otherwise his achievement will remain less than complete.

1956

"American-Type" Painting

Advanced painting continues to create scandal when little new in literature or music does (sculpture is a different question). This would be enough of itself to indicate that painting is the most alive of the avant-garde arts at the present moment, for only a substantial and meaningful newness can upset right-thinking people. But why should painting monopolize this kind of newness? Among a variety of reasons, I single out one that I feel to be most to the point: namely, the relative slowness, despite all appearances to the contrary, of painting's evolution as a modernist art.

Though it may have started toward modernism earlier than the other arts, painting has turned out to have a greater number of *expendable* conventions imbedded in it, or at least a greater number of conventions that are difficult to isolate in order to expend. It seems to be a law of modernism—thus one that applies to almost all art that remains truly alive in our time—that the conventions not essential to the viability of a medium be discarded as soon as they are recognized. This process of self-purification appears to have come to a halt in literature simply because the latter has fewer conventions to eliminate before arriving at those essential to it. In music, the same process, if not halted, seems to have slowed down because it is already so far advanced, most of the expendable conventions of music, having proved relatively easy to isolate. I am simplifying drastically, of course. And it is understood, I hope, that conventions are overhauled, not for revolutionary effect, but in order to maintain the irreplaceability and renew the vitality of art in the face of a society bent in principle on rationalizing everything. It is understood, too, that the devolu-

tion of tradition cannot take place except in the presence of tradition.

Painting continues, then, to work out its modernism with unchecked momentum because it still has a relatively long way to go before being reduced to its viable essence. Perhaps it is another symptom of this same state of affairs that Paris should be losing its monopoly on the fate of painting. By no one, in recent years, have that art's expendable conventions been attacked more directly or more sustainedly than by a group of artists who came to notice in New York during and shortly after the war. Labeled variously as "abstract expressionism," "action painting" and even "abstract impressionism," their works constitute the first manifestation of American art to draw a standing protest at home as well as serious attention from Europe, where, though deplored more often than praised, they have already influenced an important part of the avant-garde.[1]

These American painters did not set out to be advanced. They set out to paint good pictures that they could sign with their own names, and they have "advanced" in search of qualities analogous with those they admired in the art of the past. They form no movement or school in any accepted sense. They come from different stylistic directions, and if these converge it is thanks largely to a common vitality and a common ambition

[1] I believe Robert Coates of *The New Yorker* invented "abstract expressionism," at least in order to apply it to American painting; it happens to be very inaccurate as a covering term. "Action painting" was concocted by Harold Rosenberg in *Art News*. "Abstract impressionism" denotes very inaccurately certain after-comers, none of whom are dealt with in this piece. In London, I heard Patrick Heron refer in conversation to "American-type painting," which at least has the advantage of being without misleading connotations. It is only because "abstract expressionism" is the most current term that I use it here more often than any other. Charles Estienne calls the French equivalent *"tachisme"*; Michel Tapié has dubbed it *"art informel"* and *"art autre."* Estienne's label is far too narrow, while both of Tapié's are radically misleading in the same way that "action painting" is. Since the Renaissance began calling medieval art "Gothic," tendencies in art usually have received their names from enemies. But now these names seem to be more the product of misunderstanding and impotence than of outright hostility, which only makes the situation worse.

and inventiveness in relation to a given time, place and tradition. Their work evinces uniform stylistic traits only when compared on the broadest terms with that of artists who work, or worked, in other times, places or relations. The pictures of some of these Americans startle because they seem to rely on ungoverned spontaneity and haphazard effects; or because, at the other extreme, they present surfaces which appear to be largely devoid of pictorial incident. All this is very much seeming. There is good and bad in this art, and when one is able to tell the difference between them he begins to realize that the art in question is subject to a discipline as strict as any that art obeyed in the past. What puzzles one initially—as it puzzled one initially in every new phase of modernism in the past—is the fact that "abstract expressionism" makes explicit certain constant factors of pictorial art that the past left implicit, and leaves implicit on the other hand, certain other such factors that the past made explicit. The nature of some of these factors will emerge below, but meanwhile let it suffice to repeat that "abstract expressionism" makes no more of a break with the past than anything before it in modernist art has.

Major art is impossible, or almost so, without a thorough assimilation of the major art of the preceding period or periods. In the 1930s and the early 1940s New York artists were able to assimilate and digest Klee, Miró and the earlier Kandinsky to an extent unmatched elsewhere either then or previously (we know that none of these three masters became a serious influence in Paris until after the war). At the same time Matisse's influence and example were kept alive in New York by Hans Hofmann and Milton Avery in a period when young painters elsewhere were discounting him. In those same years Picasso, Mondrian and even Léger were very much in the foreground in New York—Picasso to such an extent as to threaten to block the way and even the view. Of the utmost importance to those who were to overcome Picasso after learning from him was the accessibility of a large number of early Kandinskys in

what is now the Solomon Guggenheim Museum. All in all, this marked the first time that a generation of American artists could start out fully abreast—and perhaps even a little bit ahead—of their contemporaries elsewhere.

But I doubt whether they would have been able to acquire the artistic culture they did without the opportunity for unconstrained work that most of them got in the late 1930s and early 1940s from the Federal Art Project. Or whether they could have launched themselves so well when they began showing without the small but sophisticated audience provided by the students and graduates of Hans Hofmann's art school in New York. This country's distance from the war was another favorable circumstance, and along with it the presence here during the war years of artists like Mondrian, Masson, Léger, Chagall, Ernst and Lipchitz, together with a number of European critics, dealers and collectors. The proximity of these people, if not their attention, gave these new American painters the sense, wholly new in this country, of being in the center of art in their time.

What real justification there is for the term "abstract expressionism" lies in the fact that some of these painters began looking toward German, Russian or Jewish expressionism when they became restive with Cubism and with Frenchness in general. But it remains that every one of them started from French art and got his instinct for style from it; and it was from the French, too, that they all got their most vivid notion of what major, ambitious art had to *feel* like.

The first problem these young Americans seemed to share was that of loosening up the relatively delimited illusion of shallow depth that the three master Cubists—Picasso, Braque, Léger—had adhered to since the closing out of Synthetic Cubism. If they were to be able to say what they had to say, they had also to loosen up that canon of rectilinear and curvilinear regularity in drawing and design which Cubism had imposed on almost all previous abstract art. These problems were not tackled by program; very little in "abstract expres-

sionism" is, or ever was, programmatic; individual artists may have made "statements" but there were no manifestoes; nor have there been "spokesmen." What happened, rather, was that a certain cluster of challenges was encountered, separately yet almost simultaneously, by six or seven painters who had their first one-man shows at Peggy Guggenheim's Art of This Century gallery in New York between 1943 and 1946. The Picassos of the thirties and, in lesser but perhaps more crucial measure, the Kandinskys of 1910-1918 were then suggesting new possibilities of expression for abstract and near-abstract art that went beyond the enormously inventive, but unfulfilled ideas of Klee's last decade. It was the unrealized Picasso rather than the unrealized Klee who became the important incentive for Americans like Gorky, de Kooning and Pollock, all three of whom set out to catch, and to some extent did catch (or at least Pollock did) some of the uncaught hares that Picasso had started.

Often, the artist who tries to break away from an overpowering precedent will look at first to an alternative one. The late Arshile Gorky submitted to Miró in the latter thirties as if only in order to escape from Picasso, but while exchanging one seeming bondage for another, he made a number of pictures in which we are now able to discern much more independence than we could before. Kandinsky, whose earlier paintings Gorky scrutinized for hours on end in the first years of the forties, had even more of a liberating effect; and so too, did Gorky's more frequent adoption of the landscape instead of the figure or still life as a starting point. And a short while later, André Breton's personal encouragement began to give him the self-confidence he had lacked until then. But again, and for the last time, he reached for an influence—that of Matta, with whom he had also come into personal contact during the war years. Matta was, and perhaps still is, a very inventive draftsman and, occasionally, a daring no less than flashy painter. His ideas became more substantial, however, in

Gorky's more paint-wise hands, which endowed those ideas with new and very "American" qualities of color and surface, transforming and adding so much that their derivation became conspicuously beside the point. Finding his own way out of Picassoid space, Gorky learned to float flat shapes on a melting, indeterminate ground in a difficult stability that was both like and unlike Miró's. Yet, for all his late-won independence, Gorky remained a votary of French taste and an orthodox easel-painter, a virtuoso of line and a tinter rather than a colorist. He became one of the greatest painters that this country and this time produced, but he finished rather than started something, and the younger painters who try to follow him have condemned themselves to a new kind of academicism.

Willem de Kooning, who was a mature artist long before his first show at Charles Egan's in 1948, is closest to Gorky among the other initiators of "abstract expressionism"; he has a similar culture and a like orientation to French taste. He may be even more gifted as a draftsman, and he is certainly more inventive. At the same time he enjoys both the advantages and the liabilities of an aspiration larger, perhaps, than that of any other living artist. De Kooning's apparent aim is a synthesis of tradition and modernism that would grant him more flexibility within the confines of the Late Cubist canon of design. The dream of a grand style hovers over all this—the dream of an obviously grand and an obviously heroic style.

De Kooning's figurative paintings are haunted as much as his abstract ones are by the disembodied contours of Michelangelo's, Ingres's and even Rubens' nudes. Yet the dragged off-whites, the grays and the blacks in one phase, and the vermilions, yellows and mint greens in another, which insert these contours in shallow depth continue to remind one of Picasso by their application and inflection. There is the same more or less surreptitious shading of every plane, and a similar insistence on sculptural firmness. No more than Picasso can de Kooning tear himself away from the figure and that modeling of it for which his sense of contour and chiaroscuro so

well equip him. And there is perhaps even more Luciferian pride behind de Kooning's ambition than there is behind Picasso's: were he to realize all his aims, all other ambitious painting would have to stop for a generation since he would have set both its forward and its backward limits.

De Kooning has won quicker and wider acceptance in this country than any of the other original "abstract expressionists"; his need to include the past as well as to forestall the future seems to reassure a lot of people who still find Pollock incomprehensible. And he does remain a Late Cubist in a self-evident way that none of the others, except Gorky and perhaps Motherwell, approaches. The method of his savagery continued to be almost old-fashionedly, and anxiously, Cubist underneath the flung and tortured color, when he left abstraction for a while to attack the female figure with a fury more explicit than has animated any of Picasso's violations of physiognomical logic. Equally Late Cubist has been his insistence on *finish,* which has been even more of an obstacle in his case than in Gorky's. Perhaps neither de Kooning nor Gorky has ever reached, in finished and edited oils, the heights they have in fugitive, informal sketches, in drawings and in rapidly done oils on paper.

In some ways Hans Hofmann is the most remarkable phenomenon of "abstract expressionism," as well as the exponent of it with the clearest title so far to the appelation of "master." Active and known as a teacher here and in pre-Hitler Germany, Hofmann did not begin showing consistently until 1944, when in his early sixties, which was only a short time after his art had turned outspokenly abstract. He has since then developed as part of a tendency whose next oldest member is at least twenty years younger than himself. It was natural that Hofmann should have been the most mature one in the beginning, but it is really his prematureness rather than his maturity that has obscured the fact that he was the first to open up certain areas of expression that other artists have gone on to exploit with more spectacular success. Hofmann strains to pass

beyond the easel convention, and Cubism along with it, even as he strains to cling to them. For many reasons having to do with tradition, convention and habit, we automatically expect pictorial structure to be presented through contrasts of light and dark; but Hofmann, who assimilated the Fauve Matisse before he did Cubism, will juxtapose shrill colors of the same pitch and warmth in a way that, if it does not actually obscure their value contrast, at least renders it jarring and dissonant. This effect will often be reinforced by his drawing: a sudden razor-sharp line will intervene where least expected—or too often where least needed; or thick gobs of paint, without support of a firm edge, will seem to defy every norm of the art of painting. But Hofmann is never so lucid as when he consigns a picture to thicknesses of paint, nor, I am willing to hazard, has any artist of this century outdone him in the handling of such thicknesses. Where he fails most often is, on the contrary, in forcing the issues of clarity and "synthesis," and in offering draftsman's tokens of these that are too familiar.

Like Klee, Hofmann works in a variety of manners, no one of which he has tried to consolidate so far. He is, if anything, all too ready to accept bad pictures in order to get into position for good ones; which makes it look as though he were conspiring with himself to postpone the just recognition of his art—of his noble easel-painting art, which offers to those who know how to look all the abundance of incident and event that belongs traditionally to the easel picture.

I couple Adolph Gottlieb and Robert Motherwell, for all their dissimilarity, only because they both stay closer to Late Cubism, without quite belonging to it, than do any of the artists still to be discussed. It is too generally assumed that the "abstract expressionists" start from little more than inspired impulse, but Motherwell stands out among them, despite many appearances to the contrary, precisely because of his reliance on impulse and direct feeling—and also because of his lack of real facility. But though he adheres to the simplified, schematic kind of design established by Matisse and Picasso, he is funda-

mentally less of a Cubist than either de Kooning or Gorky. Nor does he depend as much on taste as is commonly assumed. Motherwell is, in fact, among the least understood, if not the least appreciated, of all the "abstract expressionists."

There is a promising chaos in him, but not of the kind popularly associated with the New York group. Some of his early collages, in a sort of explosive Cubism like that of de Kooning's more recent paintings, have with time acquired an original and profound unity in which seeming confusion resolves itself into an almost elementary orderliness. And between 1946 and 1950, Motherwell did a number of large pictures that will remain among the masterpieces of "abstract expressionism." Several of these, with broad vertical bands of flat black or ochre played off against white or repeats of black and ochre, show how triumphantly the decorative can become utterly dramatic in the ambitious easel painting of our time. Yet Motherwell has also turned out some of the feeblest works done by any of the leading "abstract expressionists," and an accumulation of these in the early 1950s has deceived the art public as to the real scale of his achievement.

Gottlieb has in a sense been an even more uneven artist. His case is almost the opposite of Motherwell's: capable perhaps of a greater range of controlled effects than any other of the group, he has, I feel, lacked the nerve or the presumptuousness to make this plain to a public that got in the habit of accusing him of being influenced by artists whose work he was hardly acquainted with, or whom he himself had influenced in the first place. Over the years, in a characteristically sober way, Gottlieb has made himself one of the surest craftsmen in contemporary painting: one who can, for instance, place a flat and irregular silhouette, that most difficult of all shapes to adjust in isolation to the rectangle, with a force and rightness no other living painter seems capable of. Some of his best work has come since he abandoned his "pictographs" for paintings called "imaginary landscapes" or "seascapes" that have usually proved too difficult for Cubist-trained eyes. The one serious ob-

jection I have to make to Gottlieb's art in general—and it is related perhaps to the lack of nerve, or rather nerviness, I have just mentioned—is that he works too tightly, too patly, in relation to the frame, whence comes the "set," over-inclosed, static look that diminishes the original power of many of his pictures. But power as such, Gottlieb has in abundance. Right now he seems the least tired of all the original "abstract expressionists," and one who will give us a lot more than he has given us so far. In the future Gottlieb's status will, I feel sure, be less contested than that of some other artists in the group under discussion.

Pollock was very much of a Late Cubist as well as a hard and fast easel-painter when he entered into his maturity. The first pictures he showed—in murky, igneous colors with fragments of imagery—startled people less by their means than by the violence of temperament they revealed. Pollock had compiled hints from Picasso, Miró, Siqueiros, Orozco and Hofmann to create an allusive and altogether original vocabulary of Baroque shapes with which he twisted Cubist space to make it speak with his own vehemence. Until 1946 he stayed within an unmistakably Cubist framework, but the early greatness of his art bears witness to the success with which he was able to expand it. Paintings like the *She Wolf* (1943) and *Totem I* (1945) take Picassoid ideas and make them speak with an eloquence and emphasis that Picasso himself never dreamed of in their connection. Pollock cannot build with color, but he has a superlative instinct for resounding oppositions of light and dark, and at the same time he is alone in his power to assert a paint-strewn or paint-laden surface as a single synoptic image.

It may be a chronological fact that Mark Tobey was the first to make, and succeed with, easel pictures whose design was "all-over"—that is, filled from edge to edge with evenly spaced motifs that repeated themselves uniformly like the elements in a wallpaper pattern, and therefore seemed capable of repeating the picture beyond its frame into infinity. Tobey

first showed his "white writings" in New York in 1944, but Pollock had not seen them when he did his own first "all-over" pictures in the late summer of 1946, in dabs and ribbons of thick paint that were to change at the end of the year into liquid spatters and trickles. Back in 1944, however, he had noticed one or two curious paintings shown at Peggy Guggenheim's by a "primitive" painter, Janet Sobel (who was, and still is, a housewife living in Brooklyn). Pollock (and I myself) admired these pictures rather furtively: they showed schematic little drawings of faces almost lost in a dense tracery of thin black lines lying over and under a mottled field of predominantly warm and translucent color. The effect—and it was the first really "all-over" one that I had ever seen, since Tobey's show came months later—was strangely pleasing. Later on, Pollock admitted that these pictures had made an impression on him. But he had really anticipated his own "all-overness" in a mural he did for Peggy Guggenheim at the beginning of 1944, which is now at the University of Illinois. Moreover when, at the end of 1946, he began working consistently with skeins and blotches of enamel paint, the very first results he got had a boldness and breadth unparalleled by anything seen in Sobel or Tobey.

By means of his interlaced trickles and spatters, Pollock created an oscillation between an emphatic surface—further specified by highlights of aluminum paint—and an illusion of indeterminate but somehow definitely shallow depth that reminds me of what Picasso and Braque arrived at thirty-odd years before, with the facet-planes of their Analytical Cubism. I do not think it exaggerated to say that Pollock's 1946-1950 manner really took up Analytical Cubism from the point at which Picasso and Braque had left it when, in their collages of 1912 and 1913, they drew back from the utter abstractness for which Analytical Cubism seemed headed. There is a curious logic in the fact that it was only at this same point in his own stylistic evolution that Pollock himself became con-

sistently and utterly abstract. When he, in his turn, drew back, it was in 1951, when he found himself halfway between easel painting and an uncertain kind of portable mural. And it was in the next year that, for the first time since arriving at artistic maturity, he became profoundly unsure of himself.

The years 1947 and 1948 constituted a turning point for "abstract expressionism." In 1947 there was a great stride forward in general quality. Hofmann entered a new phase, and a different kind of phase, when he stopped painting on wood or fiberboard and began using canvas. In 1948 painters like Philip Guston and Bradley Walker Tomlin "joined up," to be followed two years later by Franz Kline. Rothko abandoned his "Surrealist" manner; de Kooning had his first show; and Gorky died. But it was only in 1950 that "abstract expressionism" jelled as a general manifestation. And only then did two of its henceforth conspicuous features, the huge canvas and the black and white oil, become ratified.

Gorky was already trying his hand at the big picture in the early 1940s, being the first in this direction as in others. The increasing shallowness of his illusion of depth was compelling the ambitious painter to try to find room on the literal surface of his canvas for an equivalent of the pictorial transactions he used to work out in the imagined three-dimensional space behind it. At the same time he began to feel a need to "escape" from the frame—from the enclosing rectangle of the canvas—which Cézanne and the Cubists had established as the all-controlling coordinate of design and drawing (making explicit a rule that the Old Masters had faithfully observed but never spelled out). With time, the obvious reference of every line and even stroke to the framing verticals and horizontals of the picture had turned into a constricting habit, but it was only in the middle and late 1940s, and in New York, that the way out was discovered to lie in a surface so large that its enclosing edges would lay outside or only on periphery of the artist's field of vision as he worked. In this way he was able to

arrive at the frame as a *result,* instead of subjecting himself to it as something given in advance. But this was not all that the large format did, as we shall see below.

It was in 1945, or maybe even earlier, that Gorky painted black and white oils that were more than a *tour de force.* De Kooning followed suit about a year or two later. Pollock, after having produced isolated black and white pictures since 1947, did a whole show of them in 1951. But it was left to Franz Kline, a latecomer, to restrict himself to black and white consistently, in large canvases that were like monumental line drawings. Kline's apparent allusions to Chinese or Japanese calligraphy encouraged the cant, already started by Tobey's case, about a general Oriental influence on "abstract expressionism." This country's possession of a Pacific coast offered a handy received idea with which to explain the otherwise puzzling fact that Americans were at last producing a kind of art important enough to be influencing the French, not to mention the Italians, the British and the Germans.

Actually, not one of the original "abstract expressionists" —least of all Kline—has felt more than a cursory interest in Oriental art. The sources of their art lie entirely in the West; what resemblances to Oriental modes may be found in it are an effect of convergence at the most, and of accident at the least. And the new emphasis on black and white has to do with something that is perhaps more crucial to Western painting than to any other kind. Value contrast, the opposition of the lightness and darkness of colors, has been Western pictorial art's chief means, far more important than perspective, to that convincing illusion of three-dimensionality which distinguishes it most from other traditions of pictorial art. The eye takes its first bearings from quantitative differences of illumination, and in their absence feels most at loss. Black and white offers the extreme statement of these differences. What is at stake in the new American emphasis on black and white is the preservation of something—a main pictorial resource—that is suspected of being near exhaustion; and the effort at preservation is un-

dertaken, in this as in other cases, by isolating and exaggerating that which one wants to preserve.

And yet the most radical of all the phenomena of "abstract expressionism"—and the most revolutionary move in painting since Mondrian—consists precisely in an effort to repudiate value contrast as the basis of pictorial design. Here again, Cubism has revealed itself as a conservative and even reactionary tendency. The Cubists may have discredited sculptural shading by inadvertently parodying it, but they succeeded in restoring value contrast to its old pre-eminence as the means to design and form as such, undoing all that the Impressionists and the Late Impressionists, and Gaugin and the Fauves, had done to reduce its role. Until his very last pictures Mondrian relied on light and dark contrast as implicitly as any academic artist of his time, and the necessity of such contrast went unquestioned in even the most doctrinaire abstract art. Malevich's *White on White* remained a mere symptom of experimental exuberance, and implied nothing further—as we can see from what Malevich did later. Until a short while ago Monet, who had gone furthest in the suppression of value contrast, was pointed to as a warning in even the most adventurous circles, and Vuillard's and Bonnard's *fin de siècle* muffling of light and dark kept them for a long while from receiving their due from the avant-garde.

It was maybe a dozen years ago that some of Monet's later paintings began to seem "possible" to people like myself, which was at about the same time that Clyfford Still emerged as one of the original and important painters of our time—and perhaps as more original, if not more important, than any other in his generation. His paintings were the first *serious* abstract pictures I ever saw that were almost altogether devoid of decipherable references to Cubism; next to them, Kandinsky's early filiations with Analytical Cubism became more apparent than ever. And as it turned out, Still, along with Barnett Newman, was an admirer of Monet.

The paintings I remember from Still's first show, in 1946, were in a vein of abstract symbolism, with "archaic" as well as Surrealist connotations of a kind much in the air at that moment, and of which Gottlieb's "pictographs" and Rothko's "dream landscapes" gave another version. I was put off then by Still's slack, wilful silhouettes, which seemed to defy every consideration of plane or frame; the result looked to me then—and perhaps would still look so—like a kind of art in which everything was allowed. Still's subsequent shows, at Betty Parsons', were in what I saw as a radically different manner, but they still struck me as being utterly uncontrolled. The few large and vertically arranged area-shapes which made up the typical Still of that time—and really continue to make up the typical Still of today—were too arbitrary in contour, and too hot and dry in color as well as in paint quality, for my taste. I was reminded, uncomfortably, of amateur Victorian decoration. Not until 1953, when for the first time I saw a Still of 1948 alone on a wall, did I begin to get an intimation of his real quality. And after I had seen several more of his pictures in isolation that intimation became large and definite. (And I was impressed, aside from everything else, and as never before, by how upsetting and estranging originality in art could be; how the greater its challenge to taste, the more stubbornly and angrily taste would resist it.)

Turner, really, was the one who made the first significant break with the conventions of light and dark. In his last period he bunched value intervals together at the light end of the color scale, to show how the sky's light or any brilliant illumination tended to obliterate half tones and quarter tones of shading and shadow. The picturesque effects Turner arrived at made his public forgive him relatively soon for the way he had dissolved sculptural form. Besides, clouds, steam, mist, water and atmosphere were not expected to have definite shapes, and so what we now take for a daring abstractness on Turner's part was then accepted in the end as another feat of naturalism. The same applies to Monet's close-valued late painting. Iri-

descent colors please banal taste in any event, and will as often as not be accepted as a satisfactory substitute for verisimilitude. But even when Monet darkened or muddied his color, the public of his time still did not seem to object. It may be that the popular appetite for sheer or close-valued color revealed by this popular acceptance of Turner's and Monet's late phases signified the emergence of a new kind of pictorial taste in Europe, in reaction perhaps against Victorian color. Certainly, what was involved was an uncultivated taste that ran counter to high tradition, and what may have been expressed was an underground change in Western sensibility. This may also help explain why the later painting of Monet, after having for such a long time made the avant-garde shudder, should now begin to stand forth as a peak of revolutionary art.

How much conscious attention Still has paid to this aspect of Monet's painting I do not know, but Still's uncompromising art has its own kind of affinity with popular or bad taste. It is the first body of painting I know of that asks to be called Whitmanesque in the worst as well as the best sense, indulging as it does in loose and sweeping gestures, and defying certain conventions (like light and dark) in the same *gauche* way that Whitman defied meter. And just as Whitman's verse assimilated to itself quantities of stale journalistic and oratorical prose, Still's painting assimilates to itself some of the stalest and most prosaic painting of our time: in this case, the kind of open-air painting in autumnal colors (and they prevail regardless of season) that may have begun with Old Crome and the Barbizon School, but which has spread among half-trained painters only since Impressionism became popular. Though of an astounding homogeneity, this kind of painting is not "primitive"; its practitioners usually draw with a semblance of academic correctness. Every one of them is intent, moreover, and intent in a uniform way, on an Impressionistic vividness of light effect that lies beyond their uniformly inadequate command of the capacities of oil color, which is due in turn to their inability ever to learn how to take into account the limitations

of oil color. These painters try to match the brightness of sunlight with incrustations of dry paint, and seek to wrest directly, from the specific hue and density and grain of a pigment, effects of open-air lighting that, as the Impressionists themselves have shown, can be obtained or approximated, only through *relations*. The process of painting becomes, for these half-trained artists, a race between hot shadows and hot lights in which both lose; the result is inevitably a livid, sour picture with a brittle, unpleasant surface. Examples of this kind of landscape abound in the outdoor shows around Washington Square and in Greenwich Village restaurants, and I understand that they abound in Europe too. (I can see how easy it is to fall into "sweet and sour" color when lights and darks are not put in beforehand, and especially when the paint is reworked and re-covered constantly in the effort to increase its brightness, but I cannot for the life of me understand why the results should be so uniform and why the legion of those who devote most of their time to this sort of art can never learn anything more than they do.)

Still is the only artist I know of who has managed to put this demotic-Impressionist kind of painting, with its dark heat and dry skin (dry under no matter how much varnishing or glazing) into serious and sophisticated art. And he has even taken over some of the drawing that goes with this species of "buckeye," to judge from the frayed-leaf and spread-hide contours that wander across his canvases like souvenirs of the great American outdoors. These things can spoil a picture or render it weird in an unrefreshing way, but when such a picture does succeed it represents the rehabilitation of one more depressed area of art.

But what is most important about Still, aside from his quality, is that he shows abstract painting a way beyond Late Cubism that can be taken, as Pollock's cannot, by other artists. Still is the only "abstract expressionist" to have founded a school, by which I mean that at least two of the many painters he has stimulated and influenced have not lost their independ-

ence thereby. Barnett Newman is one of these, and Newman might have realized himself in much the same way had he never seen a Still. Though Newman runs bands of color which are generally dimly contrasted, in either hue or value, across or down "blank" areas of paint, he is not interested in straight lines or even flat surfaces; his art has nothing whatsoever to do with Mondrian's, Malevich's, or anything else in geometrical abstraction. His thin, straight, but not always sharp-edged lines, and his incandescent color zones are means to a vision as broad as any other expressed in the painting of our day. Still may have led in opening the picture down its middle, and in the interlocking of area-shapes, but Newman, I think, has influenced Still in turn in the matter of a fortright verticality as well as in that of an activated, pregnant "emptiness." And at the same time Newman's color functions more exclusively as *hue*, with less help from differences of value, saturation or warmth.

Newman's huge and darkly burning pictures constitute perhaps the most direct attack yet on the easel convention. Mark Rothko's rejection of that convention is less aggressive. That his art appears, moreover, to be indebted as much to Newman as to Still (Rothko has, in effect, turned the former's vertical line sideways) detracts absolutely nothing from its independence, uniqueness or perfection. Nor does the fact that the originality of Rothko's color, like the originality of Newman's and Still's, manifests itself first of all in a persistent bias toward warmth; or even that, like Newman (though it is Rothko who probably did the influencing here), he seems to soak his paint into the canvas to get a dyer's effect and avoid the connotations of a discrete layer of paint on *top* of the surface. (Actually, the two or three banks of somber but glowing color that compose the typical Rothko painting achieve the effect they do because they are scumbled over other colors.) Where Rothko separates himself most perhaps from Newman and Still is in his willingness to accept something from French art *after* Impressionism; his way of insinuating certain contrasts

of warm and cool, I feel, does betray a lesson he learned from Matisse. But this, again, explains very little. The simple and firm sensuousness, and the splendor, of Rothko's pictures belong entirely to himself.

A new kind of flatness, one that breathes and pulsates, is the product of the darkened, value-muffling warmth of color in the paintings of Newman, Rothko and Still. Broken by relatively few incidents of drawing or design, their surfaces exhale color with an enveloping effect that is enhanced by size itself. One reacts to an environment as much as to a picture hung on a wall. But still, in the end one does react to the picture as a picture, and in the end these pictures, like all others, stand or fall by their unity as taken in at a single glance. The issue is raised as to just where the pictorial stops and the decorative begins, and the issue is surmounted. Artiness may be the great liability of these three painters but it is not the artiness of the decorative.

What is most new, and ironical, is the refusal of Newman's and Rothko's linearity to derive from or relate in any way to Cubism. Mondrian *had* to accept his straight lines, and Still has had to accept the torn and wandering ones left by his palette knife. Rothko and Newman have refused, however, to take the way out of Cubist geometry that Still shows them. They have preferred to *choose* their way out rather than be compelled to it; and in choosing, they have chosen to escape geometry through geometry itself. Their straight lines, Newman's especially, do not echo those of the frame, but parody it. Newman's picture becomes all frame in itself, as he himself makes clear in three special paintings he has done—paintings three to four feet long but only two to three inches wide, that are covered with but two or three vertical bands of color. What is destroyed is the Cubist, and immemorial, notion and feeling of the picture edge as a confine; with Newman, the picture edge is repeated inside, and *makes* the picture, instead of merely being *echoed*. The limiting edges of Newman's

larger canvases, we now discover, act just like the lines inside them: to divide but not to separate or enclose or bound; to delimit, but not limit. The paintings do not merge with surrounding space; they preserve—when they succeed—their integrity and separate unity. But neither do they sit there in space like isolated, insulated objects; in short, they are hardly easel pictures—and because they are hardly that, they have escaped the "object" (and luxury-object) associations that attach themselves increasingly to the easel picture. Newman's paintings have to be called, finally, "fields."

So, too, do Still's, but they make a different point, and one easier to grasp. The Old Masters had kept the frame in mind because it was necessary, whether they wished it or not, to integrate the surface and remind the eye that the picture was flat; and this had to be done in some part by insisting on the shape of the surface. What had been a mere necessity for the Old Masters became an urgency for Cézanne when his pictures began flattening themselves of their own accord. He had to resort to drawing and design that was more geometrical, or regular, than that of the Old Masters because he had to deal with a surface made hypersensitive by the draining of the sculptural illusion behind it. Edges could be prevented from breaking through this tautened surface only by being kept regular and near-geometrical, so that they would echo the shape of the frame more insistently; to the same end it was also useful to orient edges, whether regular or not, on clearly vertical or horizontal axes corresponding to those of the frame's top, bottom and sides. This was the system that the Cubists inherited, but which Late Cubism converted into an inhibiting habit. Still's great insight was to recognize that the edges of a shape could be made less conspicuous, therefore less cutting, by narrowing the value contrast that its color made with the colors adjacent to it. This permitted the artist to draw and design with greater freedom in the absence of a sufficient illusion of depth; with the muffling of light-and-dark contrasts, the surface was spared the sudden jars or shocks that might result from "complicated-

ness" of contour. The early Kandinsky may have had a glimpse of this solution, but if he did it was hardly more than a glimpse. Pollock had had more than that: in several of his huge "sprinkled" canvases of 1950—*One* and *Lavender Mist*—as well as in *Number One* (1948), he had literally pulverized value contrasts in a vaporous dust of interfused lights and darks in which every suggestion of a sculptural effect was obliterated. (But in 1951 Pollock had turned to the other extreme, as if in violent repentance, and had done a series of paintings, in linear blacks alone, that took back almost everything he had said in the three previous years.)

It was left to Still not only to define the solution but also to make it viable. This—along with Still's personality—may explain the number of his followers at present. It may also explain why William Scott, the British painter, said that Still's art was the only completely and originally American kind he had ever seen. This is not necessarily a compliment—Pollock, who is less "American," despite all the journalism to the contrary, has a larger vision, and Hofmann, who was born and brought up abroad, is capable of more real variety—but Scott meant it very much as a compliment.

When they started out, the "abstract expressionists" had had the traditional diffidence of American artists. They were very much aware of the provincial fate lurking all around them. This country had not yet made a single contribution to the mainstream of painting or sculpture. What united the "abstract expressionists" more than anything else was their resolve to break out of this situation. By now, most of them (along with the sculptor, David Smith) have done so, whether in success or failure. Whatever else may remain doubtful, the "centrality," the resonance, of the work of these artists is assured.

When I say, in addition, that such a galaxy of strong and original talents has not been seen in painting since the days of Cubism, I shall be accused of chauvinist exaggeration, not

to speak of the lack of a sense of proportion. But I make no more allowance for American art than I do for any other kind. At the Biennale in Venice in 1954, I saw how de Kooning's exhibition put to shame not only the neighboring one of Ben Shahn, but that of every other painter his age or under in the other pavilions. The general impression is still that an art of high distinction has as much chance of coming out of this country as a great wine. Literature—yes, we know that we have done some great things in that line; the English and French have told us so. Now they can begin to tell us the same about our painting.

1955
1958

The Late Thirties in New York

Eighth Street between Sixth and Fourth Avenues was the center of the New York art life that I became acquainted with in the late 1930s. There, the WPA art project and the Hofmann school overlapped. The big event, as I saw it, was the annual show of the American Abstract Artists group. Yet none of the figures who dominated this scene—Arshile Gorky, John Graham, Willem de Kooning, Hans Hofmann—belonged to the Abstract Artists, nor did any of them have big jobs on the project, and only Hofmann himself was connected with his school. Gorky and de Kooning I knew personally; Hofmann I admired and listened to from afar; Graham I did not even know by sight, and only met in the middle forties after he had renounced (so he said) modernism, but I was aware of him as an important presence, both as artist and connoisseur. The people I saw most of were Leonore (Lee) Krasner, then not yet married to Jackson Pollock, and fellow-students of hers at Hofmann's. Rather an outsider, I did not know about everything that was going on, and much of what I did know I could not fully understand. Then, for over two years (1941-1943), while an editor of *Partisan Review*, I was almost entirely out of touch with art life.

Abstract art was the main issue among the painters I knew in the late thirties. Radical politics was on many people's minds, but for these particular artists Social Realism was as dead as the American Scene. (Though that is not all, by far, that there was to politics in art in those years; some day it will have to be told how "anti-Stalinism," which started out more or less as "Trotskyism," turned into art for art's sake, and thereby cleared the way, heroically, for what was to come.) In those days Fifty-seventh Street was as far away as prosperity;

you went there to see art, but with no more real relation to its atmosphere than a tourist had. None of the people I knew had yet had a show in New York; many of them had not yet had even a single example of their work seen by the public. A little later I met George L. K. Morris, who was a leader of the American Abstract Artists; he lived uptown and bought art, but my impression was that his attitude toward Fifty-seventh Street was almost as distant. The Museum of Modern Art may have bridged the gap somewhat, but still it belonged more to the "establishment" and "uptown" than it did to "downtown." Everybody learned a lot at the museum, especially about Matisse and Picasso, but you did not feel at home there. Alfred Barr (that inveterate champion of minor art) was betting on a return to nature in those years, and a request of the American Abstract Artists to hold one of their annuals in the museum was turned down with the intimation that they were following what had become a blind alley.

The artists I knew formed only a small part of the downtown art world, but appeared to be rather indifferent to what went on locally outside their immediate circle. Also, most of them stood apart from art politics if not from political politics. Worldly success seemed so remote as to be beside the point, and you did not even secretly envy those who had it. In 1938 and 1939, I was attending evening life classes run by the WPA, and when I thought of taking up painting as seriously as I had once half-hoped to do before I went to college, the highest reward I imagined was a private reputation of the kind Gorky and de Kooning then had, a reputation which did not seem to alleviate their poverty in the least.

Many of the artists I knew did read the New York art magazines, but only out of the superstitious regard for print that they shared with most other people; they did not really take seriously what they read. Art publications from France, and *Cahiers d'Art* above all, were another matter; these kept you posted on the latest developments in Paris, which was the only place that really mattered. For a while Parisian painting

exerted perhaps a more decisive influence on New York art through black-and-white reproductions than through firsthand examples, which may have been a blessing in disguise, for it permitted some Americans to develop a more independent sense of color, if only thanks to misunderstanding or ignorance. And in any case you could have learned more about color from Hofmann, as long as it was just a question of learning, than from Picasso, Miró or Klee. In fact, as it now looks to me, you could learn more about Matisse's color from Hofmann than from Matisse himself. Among the things most disappointing to many of us in the new French painting that came here right after the war was precisely its color, in which we saw even Matisse's example being used to enfeeble personal expression.

Picasso's arabesque manner of the early and middle thirties, with its heavy, cloisonnéd color, was an obsessive influence from 1936 until after 1940, and maybe even later. But Mondrian, Léger, Braque and Gris were also in the foreground of attention. And almost everybody, whether conscious of it or not, was learning from Klee, who provided the best key to Cubism as a flexible, "all-purpose" canon of style. Abstract and quasi-abstract Cubism (which I see as part of what I like to call Late Cubism, even though abstract Cubism had already emerged in the work of Picabia, Delaunay, MacDonald-Wright and others before 1914) reigned at the annual exhibitions of the American Abstract Artists, which were highly important for the exchanging of lessons, and from which some abstract painters learned at least what they did *not* want to do. Hans Hofmann, in his classes and in a series of public lectures held in 1938-1939, reminded us, however, that there was more to high painting than Cubist design. (For myself, just beginning to be able to see abstract art, these lectures were crucial.) At the same time no one in the country, then or since, understood Cubism as thoroughly as Hofmann did.

Looking back, I feel that the main question for many of the painters I knew was how much personal autonomy one

could achieve within what began to look like the cramping limits of Late Cubist abstraction. To depart altogether from the Cubist canon seemed unthinkable. And it was as if the answer or solution had to wait upon a more complete assimilation of Paris. Not that Paris was expected to deliver the whole answer, but that New York had to catch up with her in order to collaborate in delivering it. It seems to me that this is why Miró became a crucial factor at that time. His example and his procedures were seen as opening a new way *inside* Late Cubism; contours still had to be faired and to be closely adjusted to the frame, but at least they no longer had to be wedged in place. The influence of Matisse, more pervasive and general, and therefore less direct, also came into play; to this influence (as well as to Hofmann), artists as different as Pollock and Rothko were indebted for that loosening up of the painted surface which was to be the most immediate common trait of the new American painting. The same influence was largely responsible, moreover, for the specifically "abstract expressionist" version of the *big* picture; Matisse's huge *Bathers by a River* (1916-1917), now in the Chicago Art Institute, hung for a long time in the lobby of the Valentine Gallery, where I myself saw it often enough to feel able to copy it by heart. On the other hand, Kandinsky's early abstract paintings, which could be seen in unusual quantity at the Museum of Non Objective Art (now the Guggenheim), were not to come forward as an influence tangential to Late Cubism until the first half of the forties, when they had a liberating effect on Gorky analogous to that which they had already had on Miró some twenty years earlier.

I think that one of the principal differences between the situation of advanced painting on Eighth Street in the late thirties and that elsewhere—a difference which helps explain the rise of American painting in the forties—was that Matisse, Klee, Miró and the early Kandinsky were being taken more seriously on Eighth Street at that time than anywhere else. We must remember that the last three were not really accepted

in Paris until after the war, and that in the twenties and thirties Matisse's influence acted more as a depressant than stimulant on Left Bank painting. It could be said that, by 1940, Eighth Street had caught up with Paris as Paris had not yet caught up with herself, and that a handful of then obscure New York painters possessed the ripest painting culture of the day.

Whether Gorky, Graham, de Kooning or Hofmann were aware that the problem and the challenge was to overcome the provincialism that had been the fate of American art until then, I cannot tell. Perhaps the fact that all four were foreign-born had something to do with their diffidence in the matter. Gorky, who was obsessed with the notion that culture was European by definition, who constantly revisited the old as well as the modern masters, and carried a little book of Ingres reproductions in his pocket, said once in my hearing that he would be satisfied if only he could achieve a "little bit" of Picasso's quality. De Kooning, who was already a complete and independent force by the mid-thirties, and perhaps the strongest and most original painter in the country at that time, sounded as though his awe of Paris was unqualified. Even Hofmann, though less intimidated by culture as such, seemed, from his lectures and the reports of his students, to imply that the brightest light would continue to come from the east. (It would have been hard to surmise at that time, though maybe it should not have been, that Hofmann's own art was still in process of maturing.)

It was only during and shortly after the war that I became aware of the presence of Robert Motherwell and Jackson Pollock, of Adolph Gottlieb, Barnett Newman, Mark Rothko and Clyfford Still. By 1943, Pollock, I know, was taking it for granted that any kind of American art that could not compete on equal terms with European art was not worth bothering with. And I have the impression that Gottlieb and Rothko, perhaps following Milton Avery's lead, had felt challenged even earlier by the necessity of breaking away from

French tutelage; and so in their separate ways had Newman and Still.

On Eighth Street this question does not seem to have been raised until much later, when Eighth Street had turned into Tenth Street. And though the independence—and more than the independence, the leadership—of American art began to be proclaimed there in the early 1950s more loudly than elsewhere, an implicit loyalty to what was an essentially French notion of "good" painting persisted on Tenth Street as it did not among most of the painters named in the foregoing paragraph. Gorky, de Kooning, then Bradley Walker Tomlin and the later Franz Kline seemed to stand for that notion, which was why, as it seems to me, they were celebrated and imitated downtown as Pollock never was.

What Tenth Street inherited from Eighth, along with some of the latter's personalities, was an obsession with culture —with the culture of painting and with culture in general. But whereas on Eighth Street this obsession had had to do with relevant particulars, on Tenth (with its artists' club) it became a concern largely with trappings and forms and labels; the respectability of culture was what was sought rather than its substance. Eighth Street's original effort to overcome provincialism was continued in a way that served only to reconfirm it. If Eighth Street in the late thirties and early forties meant catching up with Paris, Tenth Street in the fifties has seen New York falling behind itself.

1957
1960

Literature

T. S. Eliot: A Book Review

Without forgetting Aristotle, Johnson, Coleridge, Lessing, Goethe, certain Frenchmen of the nineteenth century, Ezra Pound, or the early Kenneth Burke, I dare to suggest that T. S. Eliot may be the best of all literary critics. The first credentials of a critic are his taste, but to praise another's taste amounts really to saying it agrees with one's own, and therefore I would prefer not to claim that Eliot excels by his taste. I would say, rather, that he excels by his insights into the evidence of taste, and by his loyalty to the relevant. One does not have to agree with Eliot everywhere in order to appreciate and be enlightened by that loyalty; indeed, when the "content" of his criticism is put aside, the virtues of its temper or "form"—which consist precisely in its relevance—become all the more conspicuous.

In an essay of 1923 called "The Functions of Criticism," Eliot writes that ". . . a critic must have a very highly developed sense of fact." His elucidation in the same essay of what he means by this is not very helpful—about all that I can glean is that facts about a work of art are preferable to interpretations of it. But if the implications of Eliot's practice itself are evidence, it is legitimate to interpret himself to himself as saying that the prime fact about a work of literary art is not what it *means*, but what it *does*—how it works, how successfully it works, as art. In the consistency with which Eliot's method seeks out this order of fact there is something almost scientific.

Of course, aesthetic judgments cannot be proved or demonstrated; their supporting evidence can be pointed to, but can never compel our assent the way the evidence for logical or empirical propositions can. Yet in choosing the kind of evidence to point to in order to support his judgments, the literary or art critic is—at least ideally—just as much under the obliga-

tion to be relevant as the scientist is. It is, therefore, not so surprising that the great age of positivism should have produced the supreme literary critic. And that it should have also produced the art criticism of Roger Fry and even Clive Bell's excessive simplifications. The notion of "significant form" was very much in the English air around 1914, and I cannot help thinking that this attempt to isolate the essential factor in the experience of visual art had some effect on the young Eliot. "Pure" poetry antedates "pure" painting (significantly, Fry translated and annotated Mallarmé) but "pure" art criticism antedates "pure" literary criticism; the serious art critic is under greater pressure to be pertinent simply because his digressions tend to stick out more; he deals with a more opaque medium, and he cannot linger as plausibly on Mona Lisa's smirk as the literary critic can on Hamlet's neurosis.[1] Eliot, as literary critic, refused to take shelter behind this difference. So did Pound—but if Eliot alone fulfilled himself as a critic, it was because his sense of relevance was infinitely more constant, more "scientific."

A new and expanded edition of Eliot's *Selected Essays* is the occasion for these remarks. Rereading the earliest essays, those from *The Sacred Wood*, I am no longer so cowed, and I find more to disagree with. Yet I continue to be provoked and stimulated. Even where Eliot is, as I think, wrong, he continues to cast light—more light than most other critics do where they are not wrong. This is perhaps the highest compliment that can be paid a critic.

With the passing of time the characteristic gravity of Eliot's manner has become a little stilted, and its intimidating overtones more recognizable for what they are. Little of this mars his substance, however, until he begins to turn his attention to nonliterary subjects—that is, until the middle 1920s,

[1] Of course, anybody can go to music criticism for the same lesson in even more exemplary form. But I have the impression that much less attention was paid to music and to music criticism than to art and art criticism in the circles Eliot frequented when he was writing the essays that are gathered together in *The Sacred Wood*.

when he stops being a "pure" literary critic. I don't think it is any animus against self-conscious religion or against a self-consciously conservative political stance that makes me conclude that Eliot's criticism, like his poetry, begins to fall off in quality at about the same time.

It might be better, however, if the merits of Eliot's poetry were taken a little less on faith. I have the paradoxical impression that he has been less spontaneous as a poet than as a critic. A suspicion of the *tour de force*, of offstage manipulation, hovers over much of his verse; he has not half the natural and indefatigable gift for it of a Yeats or an Auden. (It makes no difference that a half dozen or so of his poems will continue to haunt me as little else I have read does. This has to do with the time at which I began reading poetry. There are things in Eliot's verse I shall never be able to see objectively because they became part of myself too long ago. But haven't critics grown up since then for whom this is not true?)

Helen Gardner's *The Art of T. S. Eliot* contains much that is acute and enlightening. Miss Gardner reads closely and well, and with one notable exception, extracts no more from what she reads than she can vouch for in her *experience* of what she reads. She has that correct instinct of all true lovers of art which leads them to take delight precisely in that which art suspends beyond the reach of discourse or explicitness. But her book is marred by what I consider to be a radical error of judgment; she regards the *Four Quartets* as Eliot's supreme achievement, and seems to find no fault with them in any respect.

"Burnt Norton" is the only one of these poems that I myself feel to be truly successful as art. The other quartets strike me as inflated versions of a state of mind that received more apt, as well as more direct, expression in "Ash Wednesday." The beginning and culmination in one of Eliot's late manner, "Ash Wednesday" reveals an integrity and a *progression* of feeling that are rare elsewhere in his poetry, so

much of which, successful and unsuccessful, turns out to be "mood music." But after "Ash Wednesday," and after the "Ariel" poems, there is an increasing use of filler; Eliot's metrical effects, open from the first to Swinburnian rhythms, lapse more frequently into singsong or mere intricacy, and he loses all capacity for convincing rhyme (see, for example, the *cantabile* sections of the *Four Quartets*). And as we know, weaknesses and uncertainties of technique are almost always symptoms of something more fundamental.

Perhaps the deepest source of Eliot's recent failures was already to be detected in his earlier, and earliest, successes. His montage sequences, with their abrupt shifts of focus, are important gains for the art of verse, but they also compensate for an inability to advance an action or a feeling through what I would call incremental transitions. This is not an inability peculiar to Eliot among the leaders of modernism in his generation. Yeats does not suffer from it, but writers like Pound, Wyndham Lewis and William Carlos Williams do—and do so almost pathologically. Whether in verse or prose, Pound proceeds—if he proceeds at all—by fits and starts; the increasing reliance of his verse on present-participular constructions betrays what is really a kind of inertia of imagination; his best original poetry, like his best criticism, has never been sustained enough to amount to more than passages. Nor can Williams, who seems almost equally incapable of traveling with consecutiveness in a fixed direction, claim more than a few completely fulfilled poems.

These failings on the part of the great modernists (the significance of which, and the reasons for which, are far more than personal) have been noticed before. What has not been noticed enough is how these failings have been dissimulated, and assimilated, in modernist criticism, where it has come to be assumed that the unity and development of a work of literary art can be satisfactorily established merely by exhibiting technical, topical, schematic, or purely logical connections between its various parts. And it is as though it made no serious differ-

ence whether the writer himself or his exegete did the exhibiting—as if all that counted was to get it on record.

The collective title of the *Quartets* can be taken to indicate that Eliot has organized each of them on an analogy with the sonata form in music, and Miss Gardner appears to think that it will suffice to point this out in order to convert this analogy into a successful artistic reality. Art happens, however, to be a matter of self-evidence and feeling, and of the inferences of feeling, rather than of intellection or information, and the reality of art is disclosed only in experience, not in reflection upon experience. In music no less than in literature, form makes itself real through the attention-holding and emotion-involving coherence with which an infinitely divisible number of moments precede and succeed one another. This coherence, which can be called *dramatic* or climactic coherence, because each discrete moment is one either of anticipation or culmination, cannot be argued into existence; it is either there or not there in the experiencing of a work of musical or literary art. Nor can any of the devices of form create coherence automatically; dramatic coherence is either there or not there in the substance of feeling, or inspiration—or whatever one chooses to call it—from which the work takes its departure in the first place; devices of form and structure are only aspects or instruments of this substance.

The question of form in literature boils down to that of a right succession of parts. Where such rightness is achieved, form and content become truly inseparable. Inseparability is not to be confused, however, with identity. Unity of form does not necessarily imply logical unity of subject, however successful as art the work under discussion may be, and what is true of content or subject is not necessarily binding upon form—or at least not for the purposes of criticism. This whole question is begged by those who claim artistic wholeness and logical coherence for Pound's *Cantos* simply because each canto is confined to one or two topics which are returned to in subsequent cantos. To argue this way is like saying that the artistic

unity of *The Divine Comedy* is assured by the logical unity of the medieval notion of the after-world. Too much of modernist criticism reduces itself, underneath its "close" reading, to fallacies as elementary as this.

The so-called obscurity of modernist literature has, of course, a lot to do with the new stress on exegesis. When the overt meaning of a work can no longer be taken for granted, criticism is forced—or seems forced—to undertake the explication of the text of the work before doing anything else. But experience has shown us by now that the drift and shape of an "obscure" poem or novel can be grasped for the purposes of art without being "worked out." Part of the triumph of modernist poetry is, indeed, to have demonstrated the great extent to which verse can do without *explicit* meaning and yet not sacrifice anything essential to its effect as art. Here as before, successful art can be depended upon to explain itself. This is not to deny that we have had to get used, over more than a quarter of a century, to modernist poetry in order to see this. And it is not to deny, either, that exegesis and "close" reading have brought certain benefits. Only they have proved to have surprisingly, or disappointingly, little bearing on that order of fact to which I previously referred in praising Eliot's own criticism: the kind of fact which is decisive for literature insofar as it is art.

1950
1956

A Victorian Novel

It is characteristic of the more robust Victorian novelists that both their characters and their scenes get out of hand. The obvious formal considerations came last for such a writer as Trollope, and he was always ready to sacrifice the planned shape of a work of fiction to the resistances and deflections met in the writing of it. As with Dickens, a character that insisted strongly enough could snatch more than its allotted space.

By the curious vitality one of its characters arrogates to himself, *The American Senator* ascends to a realm Trollope may not have anticipated its entering, and becomes one of the most curious and interesting novels in English. That it has received so little appreciation so far must be attributed to its faults of structure, rocked as that structure is from side to side by three parallel narratives which barely relate to one another in any but an anagogical sense that, like all anagogy, is illusive.

The primary and "serious" story in *The American Senator* is the halting romance—halting, perhaps, because it takes place in Purgatory—of Reginald Morton and Mary Masters, a Victorian set piece that is only partly redeemed by its incidentals. Reginald is a studious recluse, a member of the gentry, embittered for some inadequate reason, chaste, intense, pipe-smoking, Byronic-proud—a Brontë type in whom Trollope is not sufficiently interested to rescue from what was already fictional desuetude, and whom he lets walk through his part. Larry Twentyman, a mildly prosperous young farmer, is frantically in love with Mary, daughter of the local lawyer and compendium of the negative virtues. She prefers Reginald, who is much more romantic in spite of his being forty. It was virtually impossible in Trollope's time—and maybe it still is—for any one stationed under the upper middle class to appear romantic

unless he had committed a crime, or was a bona fide artist. Larry is far from qualified on either score. Nevertheless, as a character in fiction he has all the vitality his rival lacks. Larry's troubles are organic and cannot be solved by a clearing up of misunderstandings; he is in his fix for good, and the pathos of that fix, which is not exclusively Victorian, is lingered over. He lives in the limbo reserved by the English (as it seems to a foreigner) for those who are not quite gentlemen or ladies, but are not altogether plebeian either. Trollope observes with real cruelty: "There was a little bit of dash about him—just a touch of swagger—which better breeding might have prevented." Reginald animadverts through clenched teeth on Larry's billycock hat (a kind of derby), and the wrong as well as the right people call him by his first name.

The real anguish of Larry's hopeless suit is caused by the suspicion that snobbery is at the bottom of his rejection by Mary. Trollope—and it attests to his great novelist's instinct— is willing to allow for, but not admit, the suspicion, and he tries to invalidate it by having Mary's vulgar stepmother express it comically, and also by making Reginald's maternal grandfather a Canadian innkeeper—for which reason Reginald too is exposed to certain slights. But the suspicion only flowers the more; Trollope pours too much independent life into certain of his characters, and the harangues of Mary's stepmother in her effort to persuade Mary to accept Larry are the liveliest speeches in the novel. Of course, the author assents to Mary's snobbish motives, and knows his readers do too—not in principle perhaps, but certainly in practice, and Trollope was the fiction-writer he was because he knew how to qualify principle in the name of practice. And he also knows, and his readers know, that another two hundred and fifty pounds a year would have made Larry a gentleman, swagger and all.

The secondary plot of *The American Senator*, Lady Arabella Trefoil's hunt for a husband within the lists of English social form, takes place in Hell, and is the richest vein of the book, as episodes in Hell usually are. Since class relations are

not involved, only criticism of the upper class on its own terms, Trollope writes here with a freer and more savage hand.

For him, the depravity of life in "Europe" is nothing so esoteric as it was for James, and it does not have to be revealed by the stripping away of veils. The baseness of the Trefoil family is presented with what James—as a professional—might, moreover, have thought an excessive literalness; yet the scenes in which father, mother and daughter are closeted with one another amount to some of the most brilliant passages of fiction-writing I have ever read in English.

One of Trollope's assets is that he is more interested in evil as a phenomenon than as a principle. And, of course, he does not have that aversion to the specific which acts for the later James as a shaping rule of art. It may be a virtue in James that he saves the reader from the local experience of evil and transforms its revelation into a cathartic exercise, but it is not a defect of Trollope's art that he seems to do the opposite and pander to our appetite for facts. It speaks for that art—and not at all for Trollope's heart or elevated social awareness—that we receive a more fundamental criticism of society from his works than he himself intended. And he is able to be such a good artist, and such a good critic of society, precisely because he is a connoisseur of things as they are, with an avidity for social facts and acts as facts and acts.

Nearing thirty and poor for her position, Lady Arabella lives by and on her social connections. The circumstances of her life give her little other alternative as a solution than a rich and wellborn husband. And Trollope would perhaps have held her entitled to one, if only her need were not so desperate. His rule, like life's itself, seems to be that to want anything too desperately is to lose the right to it. But it is hard to tell whether Lady Arabella's bad character is a function of her predicament or vice versa. Her father "rather liked being hated by women and did not want any man to be in love with her—except as far as might be sufficient for the purposes of marriage." Aside from finding a rich husband, her own main

ambition, a far more common one than Trollope seems to realize, is to be "one who might be sure to be asked everywhere even by the people who hated her." When Lady Arabella first appears she is engaged to John Morton, squire of Bragton, a diplomat, and Reginald's cousin. But catching sight of the sporting Lord Rufford, who is a much more spectacular prize, she changes course and (to pursue the metaphor of the hunting field) rides into what is eventually a horrible situation. The lord, one of those stupid, successful and attractive persons who are indispensable to any human society, almost proposes to Arabella in a moment of exuberance, and her attempt to use the rules of Victorian social form to press him into accepting the consequences of an actual proposal leads her through a circle of Inferno called humiliation. The code of moral justice obligatory for most novelists requires that she lose the lord, but it rewards her for her momentary impulse of pity toward John Morton on his deathbed, by granting her a wellborn and upright husband who is *not* rich. Arabella's story, ending upon an unexpectedly cheerful note, is entered under the heading of satirical comedy.

The morality is almost openly one of money. In Trollope, sinners, as well as mere victims, almost always suffer from financial or social insecurity, and they are recruited, for both categories of suffering, from either the lowborn rich or the wellborn poor. Limitations are imposed by circumstances rather than character, and the moral of Trollope's fiction seems to be that people should abide by the limitations of social circumstance. (In drafting his novels, he would assign an income in exact figures to most of his characters, as part of their essential conception.)

But the character in *The American Senator* that gets most out of hand is the American senator himself, who as a foreigner neither has nor needs social definition. The Honorable Elias Gotobed, senator from the state of "Mickewa," is visiting England to study "conditions" in that country. A highly marginal one to start with in terms of plot and action, his role becomes

248

even more so, paradoxically, as his anagogical importance grows. And yet his story, which takes us into the Paradise that completes the Purgatory and Hell of the other two narrative strands, gives the novel much of its unique irony and depth. What begins as a rather standard nineteenth-century caricature of the Yankee swells gradually into a figure of Reason incarnate, stalking and scolding the English land. The senator's twang fades and his cigar dwindles, and in the end all that is left of him is pure morality and pure logic.

Trollope's attitude here is unusually ambiguous. Starting out as a caricature, the senator gradually turns into the mouthpiece of the author himself, but not without setting up stresses and strains that are almost more than the novel form can bear. The criticism of things English that is attributed to Senator Gotobed is designed at first to characterize the senator himself rather than to point to that which is criticized. But Trollope soon begins, obviously, to agree with the criticism, and it becomes very difficult in the end to distinguish between those of the senator's words which reflect on himself and those which are seriously meant to reflect on England. The senator may appear a bit simple-minded to those who acquiesce in what seem the necessary anomalies of any social order, but in the end his simple-mindedness turns into something that defies ridicule and reminds the sophisticated of insensitivities of their own. (It may be that, through the senator, Trollope was giving vent, unawares no doubt, to his feelings about the poor critical reception his books were beginning to get in the latter 1870s.)

As a supposedly typical, representative American, the senator has an ideology (Trollope does not use that word, but it is what he means), and this ideology is compounded of Jeffersonianism, Abolitionism, Radical Republicanism, Rationalism, Utilitarianism, etc., etc. The combination turns out to be something far more radical than the author himself apparently realized; it is not at all a characteristically American set of ideas, even for the purposes of satire. The senator's rhetoric is truly typical only in a fondness for large, abstract words, not

in what the words actually say. He delivers himself of phrases like "the demand for progressive equality which is made by the united voices of suffering mankind"; and marveling at the docility of the English lower classes, he disagrees with the proposition "that one man should be rich and another poor is a necessity in the present imperfect state of civilization. . . ." He sounds far more like an old-fashioned, self-educated English socialist than a post-Civil War Midwest Republican.

The senator is the type, also, of the anti-aesthetic man whose eye is so intently on the ball, on the universal and abstract, as to make him obtuse to particularities, shadings, tones and moods, no less than to the reactions of the persons he talks to. This type can be depressing, but it can also compel our respect, at least to the extent that we feel guilty about our usual absorption in the petty. Though Trollope relishes the petty, and we are grateful to him for it, he feels this guilt, and when he has the senator attack his own beloved sport of fox hunting, he allows him to do so on grounds well taken. (And since fox hunting can be defended only aesthetically, he files his rebuttal by writing several superb hunting scenes.)

The senator provokes much resentment by his outspoken amazement at the injustices and anomalies of the English social order, and by siding with a disreputable farmer in his litigation with Lord Rufford over the crops eaten by the latter's game pheasants. After finishing his study of English "conditions," which he has prosecuted with an utter conscientiousness, the senator delivers a lecture in London at which he tells a packed and distinguished audience just what he has found wrong with England: namely, the irrationality of its inhabitants. His listeners riot and he is unable to finish. "He had not much above half done yet. There were the lawyers before him, and the Civil Service, and the railways, and the commerce of the country, and the laboring classes." But no matter, he already floats high above the rest of the Trollopian world, escorted by its reluctant admiration. By virtue of being consistently exaggerated in one direction, the senator finally transcends the gro-

tesque and comic, and becomes endowed with the highest seriousness. His Americanness is revealed as a kind of moral imperialism—the kind for which the world knows us. It is quite different from the Americanness of Henry James's pilgrims, who carry their innocence to Europe humbly, and their Columbianism—if they have it—furtively. Even so, the senator does betray a few Jamesian twinges, just to show that he is not altogether a simple, silly, holy, irrelevant being; he goes out of character—and it is one of the many blemishes of this novel —by writing home of his admiration for the "easy grace" and "sweet pleasant voices and soft movements" of aristocratic Englishmen, and confessing that there is a "pleasure in associating with those here of the highest mark which I find hard to describe."

Except for the senator's apotheosis, the novel ends weakly. Reginald discovers that he loves Mary, and they are wed. Poor Larry's fate is left suspended, as if it were on the author's conscience. Lady Arabella is sent off to do penance in Patagonia, where her husband has been assigned a diplomatic mission of little importance; her story had seemed to be working up to some much more exciting dénouement that would have left it ringing in one's memory, and Patagonia is simply not enough. We are left with the senator. Trollope's inferiority to Dickens lies in his surplus of realism, in that satisfaction with the "normal machinery of experience" of which Sadleir, his biographer, approvingly accuses him. His fiction answers too well, at times, an important but crippling demand made on the novel; that it be a recital of events more interesting in themselves and their texture than in their resolution.

1944

Bertolt Brecht's Poetry

There is a kind of modernist poetry that gets its special character from an infusion of folk or popular attitudes. Very much there in Apollinaire, Lorca, Mayakovsky, even Cummings, this vein is already perceptible in Rimbaud and Laforgue, not to mention Corbière. Anti-literary and anti-rhetorical, it exploits the attitudes of non-aulic literature for the sake of tang, honesty and irreverence, as against the formality and weight of "book" literature. In countries such as Spain and Russia, where folk culture still leads a somewhat independent life, this kind of modernist poetry tends to be racy and exuberant; in countries like France, England and ours, where everything folk has become antiquarian, it is more apt to be "popular," wistful or impudent, and keep to a minor key. But it always includes humor and sometimes, as with Lorca, a justifiable quaintness, both of which are the effect in part of the transposition of what was originally naive or "lowbrow" into a "highbrow" key.

Though German literature has been affected by all the modernist movements, it has not yet produced a poetry of this kind, not even in Gottfried Benn, whose verse might be considered the closest thing in German to Apollinaire's. The reason lies in certain features of the historical development of German literature that set it apart among the great literatures of the West. Even in Spain and Russia, as well as in France and the English-speaking countries, folk poetry and the banal verse of popular songs are remote enough from educated literature to make a difference in kind as well as degree. (In a country like ours this difference has become even greater lately, now that Robert Service, Ella Wheeler Wilcox, even Eddie Guest, and the other popularizers or spoilers of minimally

educated verse have been left without successors.) In Germany, however, folk poetry has become so much a tributary of high literature, owing, among many other things, to the fact that Romanticism intervened at a relatively early stage in the evolution of high literature in Germany, that folk and educated poetry still cannot be really contrasted or opposed to one another. Nor until rather lately could as sharp a line be drawn even between lowbrow and highbrow, as distinct from that between educated and folk, as elsewhere.

This state of affairs not only helps to account for the special character of German modernism, but also helps explain why it has never been quite as much cut off from general, best-selling culture as modernism has been elsewhere. There is also the fact that the Germans simply did not produce enough literature in the past; that is, they do not have enough classics to oppose to ambitious contemporary writing; they suffer, literally from a shortage of reading matter (which is why they translate so much). Thus, no matter how intransigently German avant-garde movements may have started out, they all tended to be accepted rather quickly by a public always hungry for *belles lettres* (and also always eager to improve itself). A book of poems by Rilke could sell 60,000 copies in Weimar Germany; Stefan George and his circle, with all their disdain for the "herd," could legislate taste to that same herd, and before Hitler, Germany was the best market in Europe for advanced literature as well as advanced art.

A German poet could not resort to the demotic or even to "experiment" in the same way a French or English-speaking poet could in order to escape from "literature." "Literature" lurked on almost every level where the German language was used without being abused (even poets who wrote in the regional dialects were to be taken seriously). Bertolt Brecht's decisive originality lies in the fact that he is a German poet who has succeeded in finding his way out of "literature" without resorting to avant-garde devices. He joins the modernist and Rimbaudian tradition not by breaking with traditional

habits of logic, language or form, but simply by shifting and mixing these, and by invoking the forms, habits, and associations of popular and folk poetry for purposes other than their "organic" ones. In Brecht the whole of the German literary past, its educated as well as its folk past, is turned against itself. Nor is his verse difficult or obscure; except for an occasional illogical-seeming rhyme, shift of beat or enjambment, it takes few technical liberties. It is not at all the kind of verse we would expect from an Expressionist playwright in the heyday of Expressionism. What is new in it is not what we ordinarily associate with the new in modernist poetry.

Parody is the core of Brecht's art, and with it a kind of plain simplicity that is tempered by parody. Parody usually finds its end and content in that which is parodied; Brecht's parody goes beyond itself by going beyond its objects. The cadences of the German ballad, which are inextricably associated with the countryside and a pre-industrial way of life, are charged with urban irreverence and metropolitan irony, but it is from the incongruity rather than the irony that there springs the poignant, understated power of much of the poetry in *Hauspostille,* the collection of poems that Brecht published in 1927. It is a kind of incongruity impossible in English, where the sole effect would be either quaint or humorous. The English ballad form belongs altogether to archeology; when revived by Coleridge, Keats, Rossetti, Scott and Morris, its typical archaic subjects were revived along with it, and this served to ward off incongruous associations. Brecht is able to do something quite different because the German ballad was still being authentically created in the nineteenth century. Today, it remains almost a serious form, too recently dead to be quaint, and when Brecht was young it was still being used by several German poets whose verse is more sophisticated than John Masefield's.

The other popular or traditional modes that Brecht uses retain a similar vitality in their German context. The hymn,

the sermon, the war song, the prayer—Brecht acclimatizes all these, along with Goethe and Schiller, to shady neighborhoods. For the opposed poles of his earlier poetry are less the naive or quaint as against the sophisticated, than the dangerous and disreputable as against the safe and respectable—the slums as against the countryside and suburbs.

In Brecht's *"Legende vom Toten Soldat"* (Legend of the Dead Soldier) the beat, many turns of phrase, and even the subject would be plausible in an eighteenth-century ballad; so many German ballads are about soldiers and death in war. Only Brecht's mock simplicity here violates the ballad convention, being a *prosaic*, not a *poetic* simplicity. And after the macabre clowning, the incongruity is almost all that remains poetic—but profoundly so:

> *Und als der Krieg im fünften Lenz*
> *Keinen Ausblick auf Frieden bot*
> *Da zog der Soldat seine Konsequenz*
> *Und starb den Heldentod.*

> *Der Krieg war aber noch nicht gar*
> *Drum tat es dem Kaiser leid*
> *Dass sein Soldat gestorben war:*
> *Es schien ihm noch vor der Zeit. . . .*

> And as the war in its fifth spring
> Afforded no prospect of peace
> The soldier drew the logical conclusion
> And died a hero's death.

> But the war was not quite over yet
> The Kaiser felt sorry
> To have his soldier dead:
> It seemed premature to him. . . .

With his doggerel rhythms, his dry, banal idiom and all, Brecht raises the ballad convention to a less compromised dignity than it had known for a long while before, even in Germany. It is really parody in reverse. By being overex-

tended, balladic understatement acquires a new kind of depth and point.

Only a few of the poems in *Hauspostille* (Homilies for the Home) are not parodies in one way or another. Everything is grist for Brecht's mill: the Lutheran hymn, the Bible versicle, nursery rhymes, spells, prayers, waltz and jazz songs—which last he succeeds in converting to his purpose mainly because colloquial German happens to be less remote from literary language than is colloquial English or French. But even the jazz song becomes ballad-like in Brecht's hand, its refrain being given a plaintiveness that breaks through the supposedly exotic form in a way familiar to the German ear. Nor is it any accident that so many of the modes Brecht parodies are associated with music; he himself is very much interested in music, and he has collaborated with composers with a frequency and success quite unusual for an ambitious modernist poet even in German-speaking countries, where intimacy between serious poetry and music has been not only much more usual, but also more up-to-date than elsewhere. Not only have a number of Brecht's "ballads" been set to viable tunes, but some of his best verse is to be found in the librettos he wrote for operas by Kurt Weill.

By grafting his poetry upon conventions that lay outside the usual orbit of "book" literature, Brecht has gained for it an edge and a kind of contemporaneity rare in elevated modern writing—or rare until lately. I cannot help thinking that Auden may have learned something from Brecht about how to convert slang, modish phrases, the flat axioms of Marxism, the clichés of intellectual journalism, into serious verse. Auden, too, parodies nursery rhymes and prayers, ballads and popular song. What he does with these is quite different—and politer —than what Brecht does, but he seems to move in a similar direction.

There emerges from the anonymity and parody in the *Hauspostille* poems a highly personal and consistent style. Its characteristics are dryness and simplicity; a deliberate, there-

fore aggressive affectation of restraint and understatement; sudden shifts of tone and transpositions of key, discords, dissonances. Matter-of-factness unfurls into Biblical grandiloquence; the sententious passage collapses into a banal expression or a trivial image; the rhyme, or the main stress, will fall on an auxiliary verb or an enclitic; the horrible or the squalid alternates with the idyllic, the brutal with the sentimental, the cynical with the naive, the honestly cynical with the falsely naive. There is a process of inflation and deflation; anticlimaxes succeed one another until the universe of affect is flattened out and everything becomes equivalent. All possible catastrophes and all imaginable banalities are assimilated:

Ich, Bertolt Brecht, bin aus den schwarzen Wäldern.
Meine Mutter trug mich in die Städte hinein
Als ich in ihrem Leibe lag. Und die Kälte der Wälder
Wird in mir bis zu meinem Absterben sein.

In der Asphaltstadt bin ich daheim. Von allem Anfang
Versehen mit jedem Sterbsakrament:
Mit Zeitungen. Und Tabak. Und Branntwein.
Misstrauisch und faul und zufrieden am End.

Ich bin zu den Leuten freundlich. Ich setze
Einen steifen Hut auf nach ihrem Brauch.
Ich sage: es sind ganz besonders riechende Tiere
Und ich sage: es macht nichts, ich bin es auch. . . .

Gegen Morgen in der grauen Frühe pissen die Tannen
Und ihr Ungeziefer, die Vögel, fängt an zu schrein.
Um die Stunde trink ich mein Glas in der Stadt aus und schmeisse
Den Tabakstummel weg und schlafe beunruhigt ein.

Wir sind gesessen ein leichtes Geschlechte
In Häusern, die für unzerstörbare galten
(So haben wir gebaut die langen Gehäuse des Eilands Manhattan
Und die dünnen Antennen, die das Atlantische Meer unterhalten.)

Von diesen Städten wird bleiben: der durch sie hindurchging, der
 Wind!
Fröhlich machet das Haus den Esser: er leert es.
Wir wissen, dass wir Vorläufige sind
Und nach uns wird kommen: nichts Nennenswertes.

Bei den Erdbeben, die kommen werden, werde ich hoffentlich
Meine Virginia nicht ausgehen lassen durch Bitterkeit
Ich, Bertolt Brecht, in die Asphaltstädte verschlagen
Aus den schwarzen Wäldern in meiner Mutter in früher Zeit.

I, Bertolt Brecht, come from the black forests.
My mother carried me into the cities
While I lay in her body. And the coldness of the forests
Will stay in me until I die.

I am at home in the asphalt city. From the very beginning
Provided with every mortal sacrament:
With newspapers. And tobacco. And brandy.
Distrustful and lazy and satisfied in the end.

I'm friendly to people. I wear
A hard hat according to their custom.
I say: these are funny-smelling animals.
And I say: it doesn't matter, I'm one too. . . .

Toward morning in the gray dawn the evergreens piss
And their vermin, the birds, begin to cry.
About that hour I empty my glass in the city and throw
My cigar butt away and fall asleep, troubled.

We have sat, a trivial generation
In houses that were supposed to be indestructable
(Thus did we build the long cells of the island of Manhattan
And the thin antennae that talk to the Atlantic sea.)

Of these cities there will remain: that which passed through them,
 the wind!
The house makes the eater happy: he empties it.
We know that we are transient.
And after us there will come: nothing worth mentioning.

In the earthquakes that are to come I shall not, I hope,
Let my cigar go out because of bitterness
I, Bertolt Brecht, strayed into the asphalt cities
From the black forests, in my mother long ago.

This is from the poem "*Vom Armen B.B.*" (About Poor
B.B.) in which, as one can see, the manners and mannerisms of
a variety of literary and nonliterary attitudes are juxtaposed,

with a kind of expectedness amid unexpectedness that is typically Brecht's. Some touches may be a little too stagey and obvious in their unstaginess. But I think that the instinct and "feel" with which Brecht handles the German language makes one forget this, as it makes one forget more obvious *gaffes* elsewhere in his verse, where the irony can be labored at times and the understatement overdone. All in all, the failures in Brecht's earlier poetry are remarkably few, and it is hard to find a really bad poem in *Hauspostille*.

Brecht writes "popular" out of his impatience with the formalities, both of life and of literature. Neither in the *Hauspostille* poems nor in the plays he wrote during the same period, does he attack the specific kind of society he happens to be living in. He is against established society in general, and while his pariahs and gutter people complain, they do not criticize. Only one value survives Brecht's early nihilism: that of comradeship pure and simple, which is found at its purest and simplest on the fringes of society, among outcasts: in army platoons, in ship's crews, in the bohemias of tramps and criminals and misfits, where human solidarity is less tinged with self-interest. "Through thick and thin together," was a slogan Brecht took seriously in his youth, when he sang above all, the faithfulness of women who shared the degradation of their mates. And his share of German wanderlust sent his muse traveling to the horizontal as well as vertical limits of European society. Like other young artists of Weimar Germany, he was fascinated not only by low life but also by the movie America of gangsters and cowboys, and by "outpost" life in general. With his pen, and in a costume borrowed from Kipling but remodeled according to Rimbaud, he traveled overseas to tropical hells, nameless deserts, uncharted oceans.

Brecht commemorated, as well as shocked, a humbled nation that thought to see all its other values collapsing along with its currency. Germany felt herself a pariah among the nations, and Brecht—like many other Germans of his time—

coped with that feeling by identifying it with all mankind. He got attention early on. His plays were produced, some of them with success. He scandalized many Germans, but they understood what he was saying; a community of mood gave his verse as well as his drama carrying power, and made his nihilism look more than literary. Though no German writer of the time proved to have less of a taste for fascism, the themes with which the younger Brecht was preoccupied were then being lived out by many of the actual or future leaders of Hitler's movement. The German Right, along with right-thinking Germans, disliked Brecht as much as it did the other Expressionists, but this was not enough to cut him off from a public. Brecht's was definitely not a case of the *lonely* poet; nor did he then or since show the least inclination to cling to isolated positions.

There was, of course, more to the younger Brecht than his nihilism, just as there is more to him today than his Stalinism. His origins and upbringing continue to have their effect. He was raised a Lutheran, his rhetoric has always had a religious tinge, and the attitudes of Protestant morality are to be felt as much in his nihilism as, later on, in his Stalinism. His chronic bad temper and sourness are not the result solely of unrequited egotism; they also belong to one who finds inade-quate compensation for the difficulties of life in its constant, sensuous pleasures. It is not merely to be sacrilegious that Brecht so often parodies liturgical forms. He means to have his tongue in his cheek when he says "sin," but it does not stay there. He is conscious of *sin* the way a believer is, however differently he may explain it. The notion horrifies and fascin-ates him, as it did Baudelaire, because it retains its traditional effect; what satisfies him in Stalinism is its reinvention of absolute evil. Brecht is never less a parodist than when he imitates Luther or the Old Testament, which are sources as much as objects of his style—the style of his temperament as well as of his rhetoric.

Protestant self-righteousness has its uses for a Communist sympathizer who insists on living in non-Communist countries even when exiled from his own. But until 1927, Brecht rejected Lenin as well as the Kaiser and bourgeois society. One of the poems in *Hauspostille* is about the Red Army:

> . . . *In diesen Jahren fiel das Wort Freiheit*
> *Aus Mündern, drinnen Eis zerbrach.*
> *Und viele sah man mit Tigergebissen*
> *Ziehend der roten, unmenschlichen Fahne nach.* . . .
>
> *Und mit dem Leib, von Regen hart*
> *Und mit dem Herz versehrt von Eis*
> *Und mit den blutbefleckten leeren Händen*
> *So kommen wir grinsend in euer Paradeis.*

In those years the word freedom fell from mouths in which ice would crack. And many were seen with tiger jaws following the red, inhuman flag. . . .

And with our bodies hardened by rain, and with our hearts seared by ice, and with our bloodstained empty hands, thus we come, grinning, into your paradise.

The tradition of the poet who starts out as a reckless rebel and ends up as a pillar of society tends to be more frequently confirmed in Germany than elsewhere, and Brecht has followed this tradition in his own way. His conversion to Bolshevism, which was like a change of personality, meant a return to responsibility. Abandoning his previous insouciance, he adopted an attitude so earnest as almost to be suspect. He began to see, beyond the ends of poetry as art, the obligation to show the poor and the ignorant how to change the world.

It may be that the example of his own pre-Communist past helped persuade him that verse and drama of a high order could be made palatable to mass audiences. He devised the theory of a new and anti-, not merely non-Aristotelian, kind of drama which he called "epic." Instead of involving the spectator emotionally as the old drama did, "epic" drama would sober and cool him into an objectivity that would enable

him to view the dramatic action from the standpoint of his own real interests. "Epic" drama would prevent the spectator from losing consciousness of his own situation through identification with the roles acted on the stage; rather than grip—this kind of drama would teach. The theory of it is enunciated by Brecht with such careful and deliberate dogmatism that there hovers over it a suspicion of straight-faced clowning—a suspicion not infrequently present on other occasions when Brecht tries to out-Bolshevik the Bolsheviks. It is as if he were parodying, this time, Marx and Lenin as well as Aristotle. But these new aesthetic ideas of Brecht's seem to have been tolerated for a time, if not actually supported, by the German Communist party. "Social realism" still lay in the future, and at that moment Stalin's line on art was as wide open to the left as his political line.

Although Brecht had already made his turn toward Communism in 1927, when the *Dreigroschenoper* was staged, the first phase of his poetry can be said nevertheless to culminate in that opera's superb libretto. His style and manner began to change in a "Bolshevik" direction only afterwards, in the choruses and recitatives with which his *Lehrstücken* of the late twenties and early thirties are interspersed. There, he first began to use unrhymed free verse, supposedly because it accorded better with the rhythms of plain talk and dispensed with such embellishments as might dissemble the austerity of Bolshevik method. In the directions accompanying the texts of these "didactic pieces," Brecht emphasizes the necessity of a "dry" delivery. Poetry was to become stripped and bare—prosaic. The principles of its organization were to be no longer metrical or musical, but forensic and rhetorical, in the service of a message that was designed to change the lives of those who heard it. A fair specimen of this new "dry" style is the poem, "*Lob der Partei*" (Praise of the Party), from the play, *Die Massnahme*:

Der Einzelne hat zwei Augen
Die Partei hat tausend Augen.

Die Partei sieht sieben Staaten
Der Einzelne sieht eine Stadt.
Der Einzelne hat seine Stunde
Aber die Partei hat viele Stunden.
Der Einzelne kann vernichtet werden
Aber die Partei kann nicht vernichtet werden
Denn sie ist der Vortrupp der Massen
Und führt ihren Kampf
Mit den Methoden der Klassiker, welche geschöpft sind
Aus der Kenntnis der Wirklichkeit.

The individual has two eyes
The party has a thousand eyes.
The party sees seven states
The individual sees a city.
The individual has his hour
But the party has many hours.
The individual can be destroyed
But the party cannot be destroyed
Since it is the vanguard of the masses
And carries on its struggle
With the methods of the classical teachers, which are derived
From knowledge of actuality.

Even here Brecht cannot prevent himself from parodying
the Old Testament, and Stalin in the bargain, whose own style,
with its catechism-like alternation of question and answer,
derives from religious liturgy. More, however, than verbal
memories are involved for Brecht in this new—because inad-
vertent—kind of parody. Lenin's precepts have been converted
into an eternal standard of conduct and habit of faith—like
Lutheranism and in competition with it—and are no longer
simply directives for a historically circumscribed kind of action
intended to realize a historically determined aim. The "didactic
pieces," the *Lehrbücher* or "Textbooks," with their playlets,
dialogues, and aphorisms, even the radio choral celebrating
Lindbergh's flight, form a morality literature, hornbooks of
Bolshevik piety, "Imitations of Lenin." Yet, for all his sobriety,
and for all the strenuous earnestness and literalness of his new

manner, Brecht continued to be a complete poet in the old-fashioned sense which he pretended to repudiate. When he put Lenin's dicta into verse they became parables, and their context became mythological. Whatever doubt this may have thrown on the revolutionary efficacy of the result, it was certainly in harmony with the style of devotion that Stalinism instilled in its faithful. Indeed, Brecht can be said to be the only writer to have wrested from genuine Stalinism anything that is or resembles genuine high art.

Hitler and exile made him more dependent than ever upon the Communist party's apparatus for an audience and perhaps even a livelihood. With the coming of the Popular Front, he submitted to the Social Realism that went with it. As he himself says more or less, in an extenuating note to the "antifascist" play, *Senora Carrera's Rifles*, he pigeonholed his "epic" theories. While the tautness of the "epic" manner slackened in his prose, in his verse he returned to something like the *Hauspostille* style. There is a sort of synthesis: the cadences remain loose but rhyme comes back, and the "dryness" becomes less dry; the tone grows uneven, as if to reflect a loss of certainty. Brecht begins to lament again, and to inveigh instead of "teach." Yet he remains as quick and sure in his feeling for language as an animal in its instincts. He can still write a poem like *"Verschollener Ruhm der Riesenstadt New York"* (Faded Renown of the Metropolis of New York):

. . . Ach, diese Stimmen ihrer Frauen aus den Schalldosen!
So sang man (bewahrt diese Platten auf!) im goldnen Zeitalter!
Wohllaut der abendlichen Wasser von Miami!
Unaufhaltsame Heiterkeit der über nie endende Strassen schnell
 fahrenden Geschlechter!
Machtvolle Trauer singender Weiber in Zuversicht
Breitbrüstige Männer beweinend, aber immer noch umgeben von
Breitbrüstigen Männer!

Oh the voices of its women coming from the phonographs!
Thus did they sing (preserve these discs) in the golden age!
Melody at evening of the waters of Miami!

Unceasing cheerfulness of the generations that speed along never-
ending streets!
Mighty sorrow of singing women weeping in their trustfulness over
Big-chested men, yet continuing to be surrounded by
Big-chested men!

Here Brecht is once more an outspoken parodist, though it
would be hard to specify just which of several elegiac manners
he is parodying—which is precisely why the poetry remains so
much his own, even when the humor misfires, as it threatens to
at every other moment in a poem like this.

Brecht is far better known as a playwright than as a poet,
and the plays with which he made his reputation were in prose.
Poetry seems to have been a side issue at first. Yet it was largely
due, I feel, to the fact that he was a poet, and wrote verse with
conscience, that he developed as boldly and uniquely as he did.
We have become too accustomed to taking it for granted that
drama can dispense entirely with poetry. In Brecht's case, it is
poetry that fires both prose and verse; his instincts and habits
as a poet enforce the shape, measure, and incisiveness which
belong to almost everything he writes. His gift is, above all,
the gift of language, and that gift provides the right kind of
vehicle for what seems to me the most original literary tempera-
ment to have appeared anywhere in the last twenty years.

1941

Kafka's Jewishness

Kafka, the *writer,* could do with a little more placing. And to this end it would be useful to inquire a good deal further into his Jewishness, but as it relates to his writing alone rather than to his personality or neurosis. Jewishness accounts for as much in his art as Frenchness accounts for in Flaubert's art, but whereas Frenchness is given as the condition of Flaubert's art, Jewishness becomes the condition of Kafka's mainly to the extent that it emerges as its subject. To the extent that the Jewish condition becomes the subject of Kafka's art, it *in*forms its form—becomes in-dwelling form. Through his *Dichtung*—literally, his imaginings and musings—Kafka wins through to an intuition of the Jewish condition in the Diaspora so vivid as to convert the expression of itself into an integral part of itself; so complete, that is, that the intuition becomes Jewish in style as well as in sense.

Kafka's fiction and his poetry in prose look idiosyncratic just as much because they are Jewish as because they are his. They form the only example I know of an integrally Jewish literary art that is fully at home in a modern Gentile language. Unlike Heine, Kafka surrenders nothing of his Jewish self-possession in order to possess German. And yet his strangeness is no stranger in German than Kleist's narrative prose is (which says more perhaps about German than about Kafka). Kafka's real strangeness lies in his modalities, in his fictions of time, place, movement, character—not in his rhetoric. And in these modalities lies the abiding tenor, the drift of his art.

Time moves differently for Kafka than for any other storyteller we now read. His heroes live in fear of decisions already taken, of outcomes already settled, but not exactly in time. Resolution, dénouement, doom never quite arrive, because they

have always been present. Everything seems to have been signed, sealed and delivered long ago, only the long ago exists in some mysterious dimension where everything takes place at once and on the same level of importance. It is this dimension with its fusion of near and far, of the exceptional and the humdrum, of the ultimate and the immediate, of eternity and the instant, that leaks through everywhere into Kafka's fictional world. The very tone of Kafka's prose answers this dimension. In the few places where that tone rises, it is only in an eloquence that is ironic—where the facts seem to ask for a summing up that can never be more than inadequate to them. Kafka seems intent on ascertaining everything that is relevant to the case at hand, but the principle of relevancy is always escaping him, and the movement of his fiction, to the extent it does move, could be said to dwell more in the search for this principle than in anything else. And while he appears always to desire transparency and the deflation of mysteries, the raw material he kneads remains in the end what it was in the beginning: a tissue of likenesses that seem impenetrable to the rational mind.

Nothing in Kafka is located according to any of the objective coordinates of time, place, history, geography or even mythology or religion. The data are all underived, are simply given, as in fairy tales or the Arabian Nights. And so is their order, which consists in repetition. Kafka's usual hero is committed as well as resigned to routine, but the tellable—Kafka's art, in effect—begins only with the disruption of routine, and proceeds mostly through attempts to return to routine that are attempts to convert disruption itself into an aspect of routine. The action consists largely in the formation, elaboration and abandonment of hypotheses that never quite manage to fit the case; it is as if the trend itself, the very grain, of reality refuted them.

The resemblances between Kafka's fictional world and the one we enter when dreaming have been pointed out, and well pointed out. Nevertheless, enough is left over to justify our look-

ing for resemblances in other places—after all, we do not reason very much in our dreams. A minimal acquaintance with Jewish tradition suggests an alternative that, once glimpsed and pursued, excludes every other. The treadmill of routine and logic, or rather of reasonableness, in which Kafka's heroes find their only safety and only intelligible reality bears at many points a resemblance, distorted and undistorted, to an institution to which all of Diaspora Jewry looked during two thousand years for the shape and identity as well as the security of its life. I mean that body of law, and the mental activity by which it is created, that are called *Halacha*. Designed to cover the whole life of the pious Jew, Halacha is the logical derivation of rules of conduct and ritual, and the derivation upon derivation of these through the Oral Law, from the Pentateuch, which is the Written Law or Torah. Halacha sanctifies human existence by encasing it in a routine deemed pleasing to God. Not only does it codify morality, but it invests the texture of daily life with more than practical significance by weaving into it the ritualized repetition of acts and words which relate that texture both directly and indirectly to the divine, as well as to a closed-off past in which the dealings between God and the Jews as a nation created precedent and "made" history.

For the Jew who lives in tradition—the Orthodox Jew—history stopped with the extinction of an independent Jewish state in Palestine two millennia ago, and will not start up again until that state is restored by the Messiah. In the meantime, Jewish historical existence remains in abeyance. While in exile, Jews live removed from history, behind the "fence," or "Chinese Wall," of Halacha. Such history as goes on outside that "fence" is profane history, Gentile history, which belongs more to natural than to human history, since it involves no dealings with the divine, therefore shows no real novelty. This kind of history is at best meaningless to the Jew, at worst, a threat to his sanctifying routine or his physical person. Genuine history will start up again, with its genuine novelty, only when the

Jewish nation is again in a position to have more than indirect or routine dealings with God.

Within the last century and more, Gentile history has begun to intervene in Diaspora Jewish life in a new way by "emancipating" Jews, which means by "enlightening" as well as by recruiting them as citizens. But this turns out not to have rendered Gentile history any the less hostile, whether to Orthodox or to assimilated Jews. Gentile history may, it is true, have become much more interesting to the latter sort of Jew for and in itself, but this has not really made it gentler or less a part of nature. Therefore emancipated Jews must still resort to some version of Halachic safety and stability, or rather immobility. And if this new Halacha can no longer be derived from religious sanctions, then the Jewish "way of life," which for such a long time has been a quintessentially middle-class one, will have to do, with its petty concerns, its parochial absorption in the here and now, and its conformism. Routine, prudence, sobriety are enjoined for their own sake, as ends in themselves, and for the sake purely of security.

This new, secular Halacha wipes out the Jewish past. It assumes an anxiety about the future which can leave little room in one's attention for *any* kind of past—and all the less room because the past now includes the Diaspora past, which happens to be nearer, more real and far more uncomfortable, than the traditional, i.e., Old Testament, past. The emancipated Jew exchanges one kind of confinement for another, and perhaps the new kind induces even more claustrophobia than the old did. The old, hallowed Halacha at least remembers the history which created the precedents from which it receives its authority, whereas the new, secular Halacha knows only that there may have been history in the past, but prefers not to recognize it. Nor does the new Halacha even promise that ultimate satisfaction to the Jewish yearning for history which the old Halacha does. The emancipated Jew longs for history more deeply and at the same time more immediately than the Orthodox Jew; he feels more suffocated outside it; nevertheless, it is

he himself who must deny history to himself because he continues to fear it, at bottom, just as much and even more than the Orthodox Jew, who is able at least to feel indifferent toward it for the time being—as he feels indifferent toward everything Gentile.

This whole complex of feelings is bodied forth, shaped, even explained in Kafka's fiction, and in turn it helps explain the latter's form. Kafka's own awareness of what he intuits about the Jewish condition through his fiction also explains why he became a Zionist. Jews like Karl Marx tried to flee the Jewish condition by foreseeing or hoping for the imminent conversion of the Gentiles to a kind of humanity to which Jews could more easily assimilate themselves. Kafka, the Jew of Prague, was more loyal to his experience, which presented the Gentile world and Gentile history as a trap for the likes of him and his, and nothing else but a trap. And how right he was, for his time and his place. Instead of being closed inside a wide-open Gentile world, the new Halacha of the emancipated Jew turned out, less than twenty years after Kafka's death, to be wide-open inside a *closed* Gentile world.

For what is also unique about Kafka, the Jew who writes in German, is that he marries art to prophecy, in accordance with the example set, at a long remove in time and language, by the Jewish poet-prophets. And the prophecy is put into likenesses, into extended metaphors and parables. The Gentile menace in Kafka's time and place is figured forth, along with other menaces, in the scratched "entries" (like anti-Semitic obscenities) of barbaric mountain-dwellers that appear on the stones trimmed for the new temple, whose construction is so auspicious otherwise; in the nomads who devour living animals (in contravention of Mosaic law!) under the windows of a hidden and helpless, or at least passive, emperor; in the unknown animal-enemies of the "Burrow"; and in the cats that prey on Josephine's mice nation. In the light of what history means to a Jew like Kafka, the "Hunter Gracchus" fragments, "Dr.

Bucephalus," "The Tower of Babel" and other short pieces that seemed in their opacity to be the purest of pure poetry lose some of their "purity," but without losing any of their force as art.

Gentile, post-Exilic history is shown to be capricious as well as remote; it belongs, with the barbarians and nomads that are its agents, to external nature, an external nature that is full of inscrutable restlessness. Servants, janitors, coachmen, innkeepers, passing strangers, who are Gentile by definition—all these figures show forth its irrationality as well as hostility. (But women, though they seem almost all to be Gentile, seem also to belong to an external nature that is parodoxically at rest.)

These likenesses of Gentiles *are* as well as represent. They *are* the plebeian, "folkish" Gentiles, whom the Jew fears more than he does the "authorities." The "authorities" at least observe certain forms; the "folk," left ungoverned, would massacre Jews on the spot. But because this kind of Gentile *is* as well as represents, Kafka's feelings, as those of an emancipated and enlightened Jew, and also those of a genuine artist, are ambivalent toward him; it is not inconceivable that the plebeian Gentile might suddenly turn into an ally, whereas that possibility is absolutely excluded in the case of the "authorities," if only because they are so remote and only represent, and never *are*.

The Jewish meaning of Kafka's fiction by no means exhausts it, just as its extractable meaning in general does not. Kafka uses allegory more successfully than it has been used for several centuries in European literature, but we can still be moved by his art without knowing what it "means." If it succeeds, it does so, as all art must, by going beyond interpretation or paraphrase. And also by going beyond its prophetic rightness and wrongness. No more here than anywhere else does art, as art, depend upon its accuracy as anything other than art. I find it advisable to say this at this point because, having gone into the extraordinary amount of extra-artistic truth Kafka's

fiction does contain, I may have created the impression that that truth is integral to its success as art.

The contrary is almost equally the case. For I would hold that the Jewish truth in Kafka, or the truth of his Jewishness, also accounts for some of the frustrations of his art.

He is not alone among the great modernist writers who find it difficult to charge their matter with dramatic movement (which has little to do with "tension" or "fatefulness"). But dramatic movement is made doubly difficult in Kafka's case by his "Halachic" sensibility, which tends to move by logic, by exposition, rather than by narrative. This may be why I myself usually prefer his shorter pieces to his novels and long short stories. Where the exposition, or at most the gradual shifting, of a situation provides the main action, that action had best be short. The stealthy, sliding, overlapping, backing-and-filling progression in time and awareness that is so typical of Kafka's fiction can weary or oppress the reader—especially since he may already have been made a little oppressed to start with by the realization that he has entered a world in which nothing ever gets truly resolved, in which any decisive, conclusive event would be both highly incongruous and anticlimatic, because no particular event or series of events can suffice to dissolve the enormous weight of doubt, ignorance and apprehension that Kafka calls up with almost his first sentence. States of being are what count most in Kafka's fiction, ongoing states such as can have no beginning or ending, but only middles. Because middles limit choice, Kafka's heroes are seldom in the position to make moral decisions—or even to act in character. Their difficulties are almost always practical ones, and the steps by which they try to cope with them are almost always dictated by considerations of expediency. If Kafka's fiction admitted resolutions, they could be only melodramatic ones: his heroes could, with very few exceptions, win out only at the last moment, and only by destroying completely the fabric of the kind of reality in which they are imbedded. For that reality, and that reality alone, is their enemy.

To the extent that Kafka's art succeeds, it demonstrates once again the untenability of the current assumption that the final criterion of the value of literary art is the depth to which it explores moral "problems." Kafka's central characters must struggle against the trend and order of reality simply in order to survive; they are not granted the luxury of moral dilemmas. Moreover, the premises of Kafka's vision require certain conclusions so strictly that it takes very little narrative business to act them out; what prolongs narration is not events, but reasoning, anxious, worried reasoning. Kafka himself may have been aware of how tautological his imagination was in this respect—aware enough to feel disappointed in his effort to create fiction that would work and sound like fiction. One speculates on whether this had anything to do with his request to Max Brod to burn his manuscripts after his death.

Kafka, I think, wanted more than anything else to be an artist, a writer of fiction not of oracles. And a writer of prose, not of hybrid poetry. If some of the things he wrote are poetic in the highest sense, it is in part because they are so deliberately and profoundly antipoetic. Explicit, conscious poetry was on the way, as Kafka might have seen it, to a falsification of reality —and not only of Jewish reality. But might not all art, "prosaic" as well as "poetic," begin to appear falsifying to the Jew who looked closely enough? And when did a Jew ever come to terms with art without falsifying himself somehow? Does not art always make one forget what is literally happening to oneself as a certain person in a certain world? And might not the investigation of what is literally happening to oneself remain the most human, therefore, the most serious and the most amusing, of all possible activities? Kafka's Jewish self asks this question, and in asking it, tests the limits of art.

1956

Index